STEP BY STEP ART SCHOOL

OILS

Linesville Community
Public Library
Linesville, PA. 16424

STEP BY STEP ART SCHOOL

OILS

Linesville Community
Public Library
Linesville, PA. 16424

PATRICIA SELIGMAN

For copyright reasons this edition is for sale only within the U.S.A.

This edition published 1988 by

CHARTWELL BOOKS, INC. A Division of BOOK SALES, INC. 110 Enterprise Avenue Secaucus, New Jersey 07094

Prepared by The Hamlyn Publishing Group Limited Michelin House, 81 Fulham Road, London SW3 6RB, England

Copyright [©] The Hamlyn Publishing Group 1988

All rights reserved. No part of this publication may be reproduced, stored in a retrieval system or transmitted in any form or by any means, electronic, mechanical, photocopying, recording or otherwise, without the prior written permission of the Hamlyn Publishing Group Limited.

ISBN 1-55521-311-1

Produced by Mandarin Offset in Hong Kong

Contents

Linesville Community Public Library Linesville, PA. 16424

Chapter 1	Introduction	10	Chapter 6	Broken Paint	86
	The Supreme Paint Choosing a Subject Composing your Picture	12 14 16		Techniques Scumbling, Dry Brush, Stippling	88
Chapter 2	The First Mark Equipment	18 20		Step by Steps Crabs Constable	90 94
•	Paints	22			34
	Diluents, Mediums and		Chapter 7	Texture	100
	Varnishes Painting Surfaces Brushes Other Equipment	24 26 28 32		Techniques Knife Painting Spattering Sgraffito, Tonking	102 102 104 105
Chapter 3	Making the Most of Your Paints	34		Step by Steps Melon and Pomegranates	106
	Recommended Basic Palette	36			112
	Colour Behaviour Mixing Colours	38 40	Chapter 8	Creating Depth	118
	Interpreting Colour	42		Techniques	
Chapter 4	Basic Techniques	44		Staining, Glazing	12()
	Techniques Getting Ready to Paint Applying the Paint	46 48		Trompe l'Oeil	122 126 132
	Step by Steps		Chapter	The Human Figure	120
	Misty Mountains Yellow Tulips	50 54	Chapter 9	G	138
	Peppers and Lemons	60		• • •	140 144
Chapter 5	Light and Shade	66			148
	Techniques Blending Techniques	68		Index	154
	Wet in Wet Optical Blending	70 71		Acknowledgements	156
	Step by Steps Kettle Hat and Denim Jacket Pool House	72 76 80			

Chapter 1

Introduction

Despite the alchemy of modern chemistry, nothing has been invented to challenge the supremacy of oil paints. Once you have tried these paints, with their individual textures and exquisite colours, even though you might stray into other media you are still likely to come back to oils again and again. Even the most experienced artists are constantly surprised by oil paints – their versatility ensures a lifetime's fascination.

Today oil paints are more convenient and accessible than ever before. Modern technology has ironed out many of the former shortcomings of the medium, making the paints easier to use for artists of all abilities. No longer has the artist to gather wild damsons and stew them for hours to reduce the fruit to something usable as paint, or catch a wild boar to tweak out a few bristles to make a brush. But more than this, modern oil colours are now manufactured in such a way that many of their idiosyncracies have disappeared — drying time and texture, which used to vary widely between colours, have been evened out. For the beginner this makes life much easier.

All paints, however, have their individual characteristics and it is worthwhile getting to know them. This path of discovery can be fascinating, particularly with a friendly voice and eye to guide you. In this book we take up the role of guide, escorting the keen painter through the steps which lead to sufficient knowledge to make a painting of which you can be proud. So, in the course of this book, the basic techniques and skills of oil painting will be laid out before you, giving the beginner the necessary guidance and encouragement to take up the brush. More experienced artists will be able to find new ideas to broaden their expertise and enliven their art.

In the first section, ideas are given on choosing a subject and arranging your composition. This is followed by encouragement to make the first mark. A guide to the mesmerising array of artists' materials sorts out what is necessary, what is useful and what you do not need. Finally, the heart of the book demonstrates those techniques which make oil paint such a versatile medium.

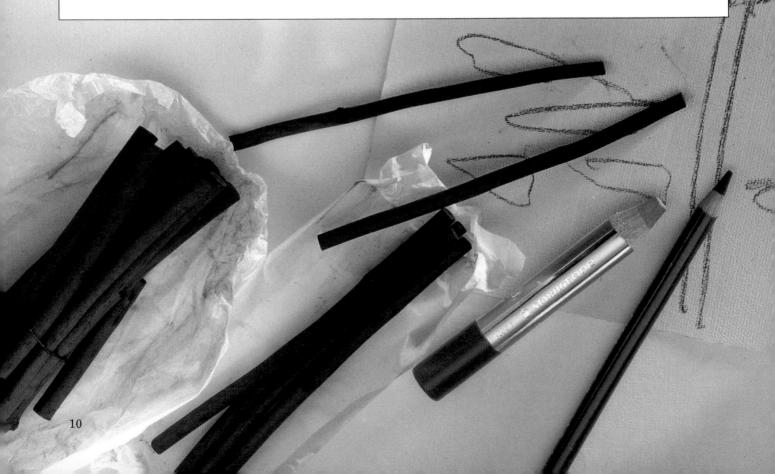

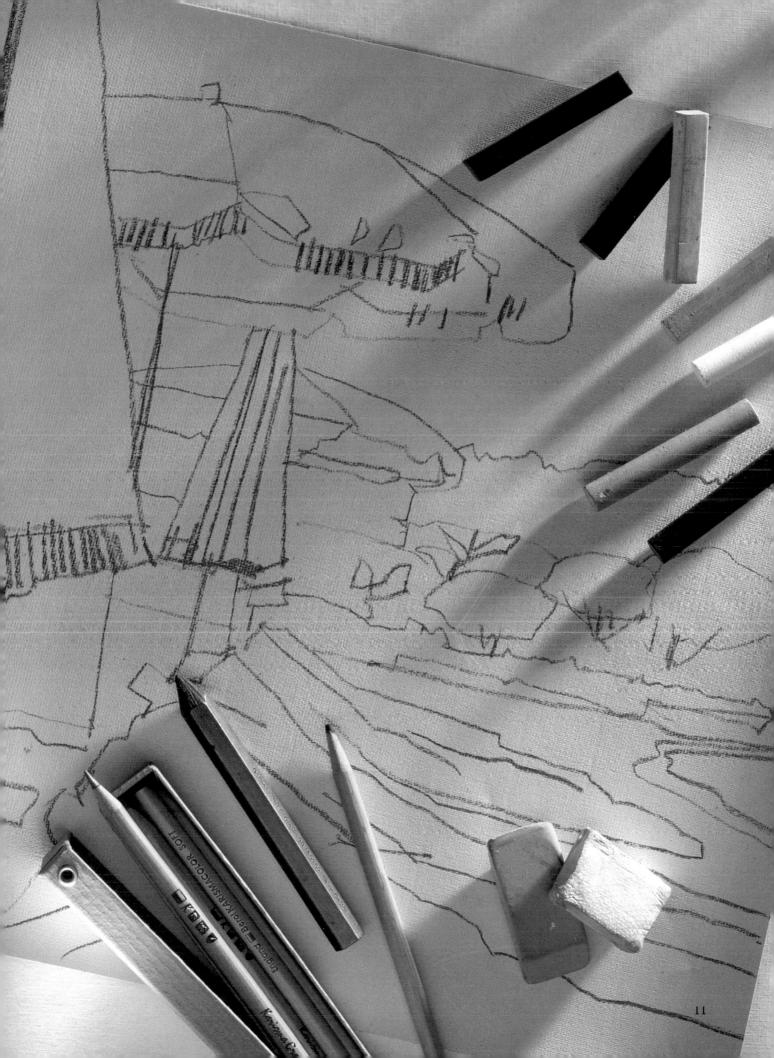

Introduction

THE SUPREME PAINT

Many people have set ideas about the sort of paintings produced with oil paints. They see before them Constable's elaborate vast canvases, or seventeenth-century landscapes — rich browns and greens which are the labours of days, weeks and sometimes years of thought and action. Not surprisingly, their reaction is 'I could not do that'.

But, as the examples on this page

show, oil paints can be used to produce a variety of different styles. They can be applied *alla prima* – in one sitting – to produce a lively surface of brushstrokes. Or, as shown in a demonstration later, they can be diluted to the consistency of watercolour and applied with a cloth merely to stain the canvas. Conversely, the paint can be built up, letting one layer dry before adding another to qualify the first, so

creating a rich surface of colour and texture. They can be thinned down to make translucent glazes and watery washes or built up opaquely in thick impasto relief.

Moreover, as will become clear in the course of the following pages, these techniques are not the exclusive reserve of the trained artist. All that is required is that you take up a brush, squeeze out some paint, and before long

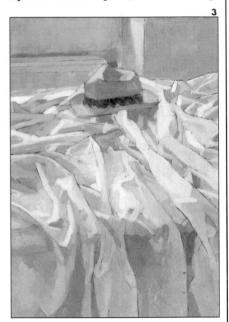

- 1 This atmospheric painting, *Evening Light, Bembridge*, by Derek Mynott, is created by layers of misty scumbles. In the foreground, dabs of broken complementary colours make this area 'sing'.
- 2 With a much freer style, expansive brushwork and a dramatic use of primary colours, *Val d'Entre Congue*, by Frederick Gore, makes compulsive viewing. Again, the overall effect relies on the juxtaposition of complementaries.
- 3 Bold directional brushwork plots the pattern of folds in Eric Luke's *Still Life with Hat*.

INTRODUCTION

you will have a result. It may not be perfect, but take heed from the pages of demonstration later on and you will soon be amazed at what you can do.

Every artist develops his or her own personal style – almost a signature in itself. This is reached through experimentation, observing other artists' methods and approaches and trying them out. It requires a knowledge of what you yourself can do

and what the possibilities are and, of course, what you enjoy. Some artists enjoy a tortuous intellectual style of art which requires much thought and preparation to produce an image. Others simply enjoy the tactile qualities of the paint and the challenge of the medium. The vast range of styles that are considered successful in contemporary art – by which I mean commercially successful – bears

witness to the observation that in art 'anything goes'.

- 4 Reflected Trees, by Susan Hawker, is a fresh painting of abstracted natural forms, created with soft colour blendings.
- 5 A detail from the mysterious *Allegory of the Sea* by Barry Atherton, exemplifies a delicate painterly style.

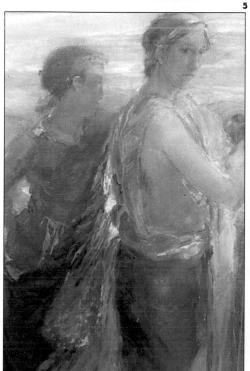

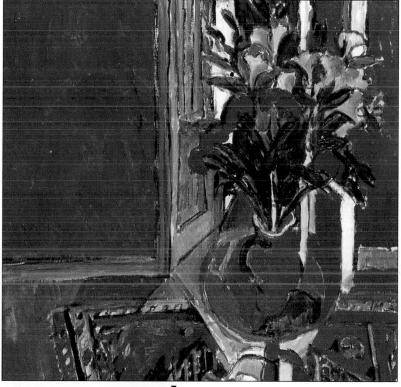

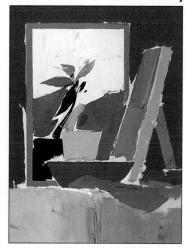

- 6 In sharp contrast, Carnation and Astromer, by John Watson, relies on strong colour and surface pattern and an ambiguous sense of space.
- 7 Still Life with Flowers and Mirror, by Donald Hamilton Fraser, delights in a purity of form well suited to the crispness of knife painting.

CHOOSING A SUBJECT

Even though you might be aching to start painting, when it comes to the point the mind goes obstinately blank and refuses to come up with any ideas. The sight of an empty canvas causes an apparently permanent mental block. Fortunately, there are ways of overcoming this. For a start, try painting what is in front of you - a bowl of fruit, the view from the window or, like Van Gogh, the chair in the corner of your bedroom. Most artists are inspired by their surroundings, and by events in their lives, however trivial they may seem. This applies to writers, poets and musicians as well as painters.

But information and ideas can come from many sources. As you will see in the demonstrations later on, inspiration can come from your photograph album (or more likely from the piles of snaps ready to go in it). In many ways the photograph album is the modern-day sketchbook. In it we record our reactions to situations, places we have visited, people we have met, an odd juxtaposition of shapes created by shadows perhaps, or an interesting viewpoint. And photos include colour notes to jog the memory, even if the purists doubt their usefulness. You may want to recreate a view you have witnessed or just take a tree or a small detail from the photograph to include in your composition.

Traditional style sketchbooks can be fun to keep too. Flipping through old sketchbooks can often give you an idea on a horribly blank day. If you take the trouble to include written notes, the date, etc., they make amusing records of your own personal reactions to what you see around you. Many people find them difficult to maintain, however, and you are more likely to make a sketch on the back of an envelope or whatever piece of paper happens to be to hand at the time. It still serves the same purpose of recording what you see so that you can use the information later on in composing your picture.

Magazines are also a rich source of visual information, particularly advertisements. Use such source material to set off a train of thought. You need not copy such an image slavishly. After all, it is the diversions from the original image that are your own personal contribution to the finished work. Do not feel a cheat in using such material. David Hockney, the British contemporary artist, for example, has always admitted freely that he uses magazine photographs, advertisements and other such visual material to provide information for his painting. By doing so, he has done much to dispel the opinion that such an eclectic approach to art is somehow 'wrong'. Inspiration from abstract ideas is harder work. But artists have traditionally been inspired by poetry and writing of all kinds, expressing their views and ideas through their chosen medium of paint.

COMPOSING YOUR PICTURE

Once you have decided on a subject, the next step is to decide how to organize the composition. Many of the considerations to be taken into account at this stage appear complicated when listed on paper. Yet most of them are natural to us and it is just a case of letting your common sense prevail.

A collection of objects – fruit, tableware, stationery, anything to hand – can make a good subject to start with. Arrange them so that they are pleasing to the eye (if that is your aim). Be aware of size, shape and texture and also of colour. Once you have decided on the arrangement you can start work. There are, however, other considerations which will help you to produce a more interesting image.

The point from which you view your subject matter can affect the way you see it. On this page you will see the same bowl of fruit viewed from different positions — obliquely from one side, from above, below, close up. Each composition attracts attention for a different reason and inspires different emotions in the viewer. Yet the subject matter — a fruitbowl on the kitchen

table – remains the same. Viewed from below, the bowl becomes almost menacing and domineering. Seen obliquely from one side, the eye is lead to the bowl by the edge of the table which leads towards the focal point of the picture. The space on the left of the picture has dramatic impact – it is not boring or wasted and shows that it is not necessary to fill every square centimetre of your canvas with detail.

Such areas can provide an area of calm in a frenzied composition or give emphasis to the main subject matter.

That our eye is directed to the bowl of fruit in this view depends on the fact that in the West we 'read' a painting from left to right as we read a book. Try reversing this composition and you will see that it looks uncomfortable. So, strong compositional lines from the left will guide the eye into the picture.

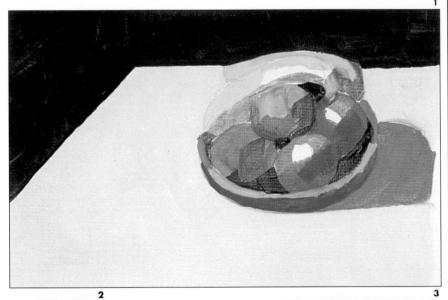

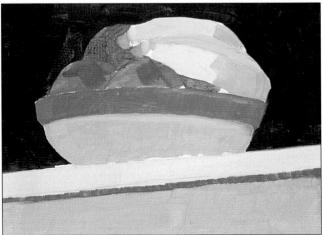

1 In this oil sketch, the artist takes a sidelong view of the bowl. The edge of the table leads the eye into the void on the left and then on to the fruitbowl, thereby animating the various areas of the picture space. As it is viewed from

above, it is the fruit, rather than the bowl, that is the focal point.

2 Viewed from below, our basic bowl of fruit is given status, dominating the image. Painting a figure from this worm's-eye view can make it

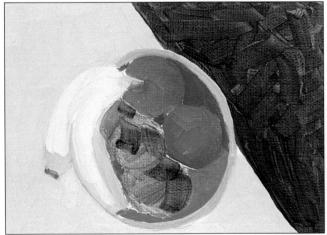

appear powerful and menacing. Note how the side of the table cuts the composition at an angle, fighting symmetry.

3 A bird's-eye view of the fruitbowl reveals new potential. Now the bowl becomes part of a

pattern created on the surface of the painting, even though the ambiguous murky void on the right hints at space beyond it. A sense of tension is thereby introduced, enforced by the cutting of the dramatic diagonal with the edge of the fruitbowl.

INTRODUCTION

Do not be afraid to cut part of your composition with the frame of the picture. This can stop the eye from wandering out of the picture and is also useful in visually nailing an object in the foreground.

Another aspect to take into consideration is the shape of the canvas, board, paper or whatever you are painting on. It is usual to paint on rectangular shaped supports, either

vertical (called portrait) or horizontal (called landscape). Some subjects commend themselves to a particular shape. For a tall vase of flowers with predominant verticals, the portrait shape is the natural choice. The horizontal lines of a line of boats, on the other hand, would suggest the use of a landscape shaped canvas.

The size of the composition is an influential factor too. Imagine the

impact of the fruitbowl seen close up if painted on a large canvas. It changes the way we perceive the subject matter. But supports of all shapes and sizes are used now, including square canvases, which were traditionally regarded as too symmetrical, and specially constructed asymmetrical supports.

Lighting is also an important aspect of composition. Bright, angled light can produce heavy dramatic shadows which stir the emotions; soft, warm lighting will increase the range of tone and give the painting a calmer feeling. Use shadows to link elements in the composition and to provide interesting patterns on the surface.

In a still life or an imaginary composition you are in control. You can move the objects around until they present a pleasing combination of line, shape, texture and colour. But when painting from life the essence of the arrangement is predestined by nature or man. Even so, the same issues prevail.

The point from which the view is painted will alter the effect. An equally testing decision is how much of the scene is included and how the frame will cut the elements. Again light will play an important part and, outside, the effects of the weather can contribute to your composition.

- 4 Zooming in on the fruit in the bowl presents yet another angle of the subject matter. This composition concentrates on the shape, colour and texture of the fruit. The composition is made up from arcs most clearly seen in the edge of the bowl and repeated in the banana, oranges, apples. This gives a sense of unity to the painting. By cutting the banana and oranges with the frame, this has the effect of pushing these fruit back.
- 5 Lighting is an important aspect of composition. Here the light source is behind and to the right of the fruitbowl. It is low down, like the evening sun, and so casts long shadows. Shadows are useful in creating pattern and linking disparate elements. In this composition, the shadow forms a strong angled line which grabs the attention of the viewer, leading the eye to the fruitbowl.

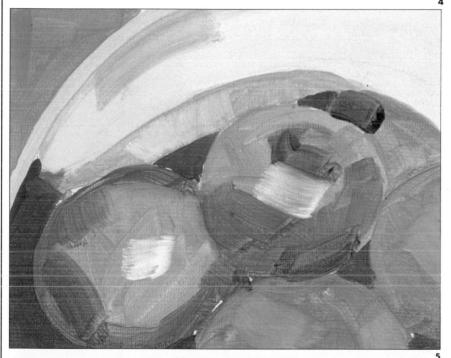

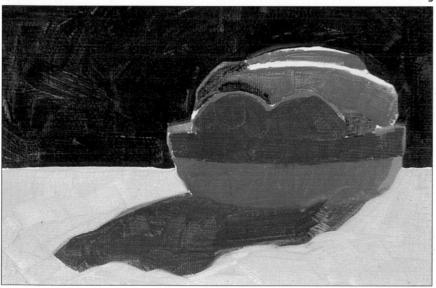

THE FIRST MARK

Now you are ready with a subject you want to paint and some idea of how you want to present it. It is time to start painting. First, however, you need to set up your painting surface so that you can work. An easel is a useful piece of equipment but by no means essential. You can paint flat on a table or by wedging your support at an angle by using whatever ingenious method comes to mind. Plenty of the world's great painters produced their works without an easel - Pierre Bonnard and Paul Klee, for example, and John Constable painted some of his oil studies with his sketchbook wedged in the lid of his open painting box.

Make sure you have all your equipment to hand so that you do not need to break off constantly to fetch something. The light, whether you are working inside or out, should fall on your canvas so that it does not cause reflections in the paint or cause your head to cast a shadow on the paint surface. Northern daylight is traditionally recommended, but artificial alternatives, if suitably placed, will do adequately.

There are many different approaches to starting painting. Some artists meticulously prepare their composition so that nothing is left to chance. Others bravely storm their canvas, applying the paint straight away and developing the composition as they progress. Most artists, however, start by drawing the outline of their composition on to the canvas or chosen surface, copying either a still life or scene in front of

them or whatever visual material they have amassed.

Charcoal or chalk was traditionally used for this underdrawing, but to stop it muddying the first layer of paint it should be fixed with a spray fixative. The ease with which charcoal makes a mark seems to inspire a free line which is often important when copying a scene. The fact that a charcoal stick is so delicate means that it cannot be squeezed. This encourages a relaxed grip which is necessary to produce a flowing line. A soft pencil can be used for this underdrawing, but the mark is fainter and you may have trouble travelling over the weave of the canvas. Graphite pencils or the fatter sticks leave a heavier mark. They are widely used as they are soft and are much

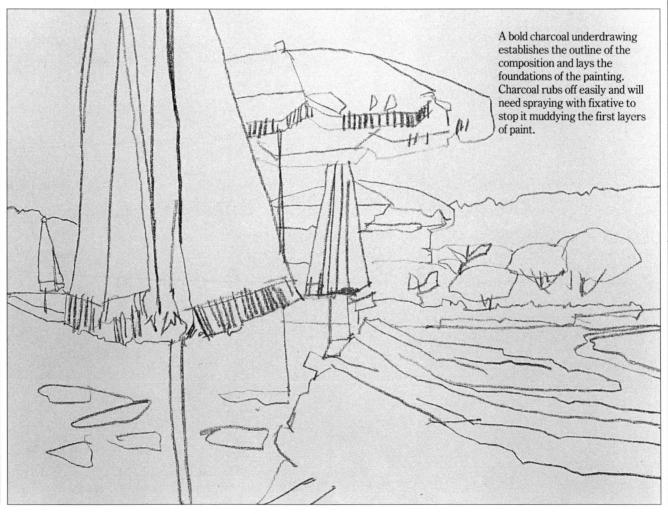

INTRODUCTION

cleaner than charcoal. They can be sharpened into points or wedges with sandpaper.

Some artists, particularly when painting a landscape, like to make an underpainting, outlining the main areas of the composition with a brush and a very dilute neutral mixture of colour. For this underpainting quick-drying paints are chosen, the earth colours such as burnt umber. Acrylic paint,

which dries almost immediately, can be used for such underpainting.

A more spontaneous approach to oil painting can be achieved by sketching in oils in a manner know as *alla prima*. The idea is to lay one brushstroke of paint alongside another so that a single layer of paint is achieved in a fresh, unlaboured manner. The painting is therefore finished in one sitting.

For some the outline drawing is the

most difficult aspect of painting. For the faint hearted, canvases can be bought with an outline already mapped out. But it may help to work out the outlines on some sketching paper first before starting on the chosen surface. Keep your composition simple, editing out extraneous details in an interior scene. for example. If you get the outline as you want it in the right scale on your sketchpad, you can transfer it to the canvas by pricking along the outline with a pin, laying the drawing on the canvas and rubbing charcoal dust along the holes with some cotton wool, or marking through with a sharp pencil. Otherwise, you can transfer and enlarge an image from a sketch, magazine or photograph, using the squaring-up method described on pages 148 53.

There is no doubt that it is worth getting the outline of your composition right at this stage. A certain amount of alteration can and probably will take place at the painting stage, but you will find it much easier if you have confidence in your underdrawing.

Left When painting from life, set up your easel so that you can see your subject without unduly craning your neck. Here the artist wishes to have a bird's eye view of the crabs, so they are set up at a low level. Now he quickly sketches in their outlines with a thin graphite stick, which is less messy than charcoal and makes an easy mark.

Below Left Some artists take the plunge and apply the colour direct without needing an underdrawing. This usually occurs where the forms are simple or where colour dominates the composition. Using dilute turpsy paint, the artist lays in the foundations of the composition. Anything at this stage which appears out of place can be wiped off with a clean cloth dampened with turps or white spirit.

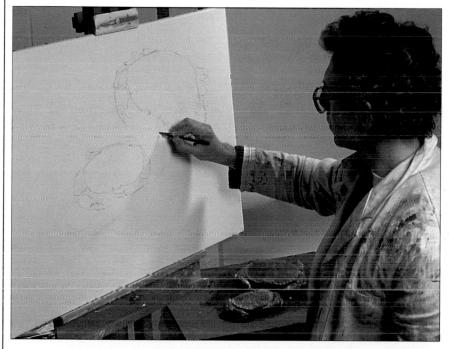

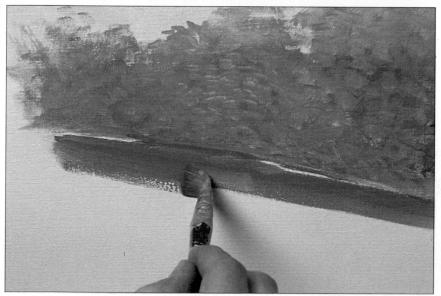

Chapter 2

Equipment

Art stores are bewitching places; they display the enticing tools and materials which promise so much magic. Here you can dream of the masterpiece you are going to paint. The very names of the paints – burnt sienna, yellow ochre, viridian, French ultramarine – seem beguiling.

Such a store can provide many happy hours of browsing, but there comes a point when you need to make decisions. Artists' materials, if you buy everything recommended by the manufacturers, are expensive and it is a pity to buy something you will not need. It is bad enough being faced with racks of different types of oil paints in hundreds of different colours only to find that if you open the tube the paint seems a totally different colour to the strip of colour on the outside packaging. In the following pages, you will be introduced to a restricted family of colours which will be enough to provide adequately for your needs and in due course you will get to know them all

like old friends.

Oil painting need not be an expensive pastime. To start with all you need are a few tubes of paint, three or four brushes and something to paint on. In this chapter you will be given a guided tour of what is available, directed towards what is necessary and advised on what, if you buy it, may end up in the back of a cupboard covered with dust.

Where possible we point out cheap alternatives to what are accepted materials. For example, it is not necessary always to paint on expensive, stretched canvases. Cardboard makes a very good surface to paint on.

It is also worth learning how to look after and resuscitate your materials so that they give you good value. Good oil painting brushes, for example, actually improve with use. Advice and tips based on experience will help you get the best from your materials.

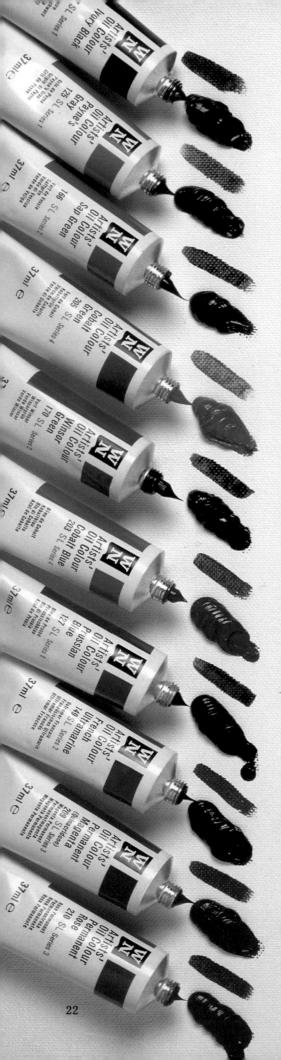

PAINTS

We are fortunate these days in being able to go to our local artists' materials store and buy tubes of oil paint of every hue which are ready to use. No longer do we need to grind the individual pigments and mix them with oil, although there are artists who still prefer to do this. Do not be wooed by the tempting wooden boxed sets of oil paints and other materials which conjure up sepia photographs of the great painters at work. They are certainly useful to keep your gear together when painting on location, but they are not essential. Most of the great painters only used about ten colours and most artists end up by using a suitable bag to keep their paints and other equipment in. Wooden boxes were not designed for artists' paraphernalia – cloths, jars and so on.

Oil colours have wonderfully exotic names which reflect their origins: the mineral colours such as those from the earth – burnt and raw umber, burnt and raw sienna, yellow ochre – and organic colours extracted from plant and animal such as sap green and Prussian blue. Some of these are artificially produced these days and many more have artificial substitutes which are less toxic, more stable or cheaper.

The pigment is ground up and suspended in a binding medium of oil which dries on contact with the air, sealing the colour to the support. Colours vary in their drying times but to a certain extent manufacturers have restricted the variations by adding quick-drying oils to slow-drying pigments.

Choosing your colour can be rather nerve - racking. On page 36 a restricted palette of paints is recommended, with an introduction to the characteristics of those individual paints. Here we will take a general look at what is available, and what to look out for when buying your oil paints.

Just by squeezing oil paint out of the tube on to the palette you can learn a great deal about it. Some pigments are noticeably oilier, others more finely ground and therefore smoother. Applied thinly or diluted, the dark blob can yield some jewel-like hues. Note how these so often differ substantially from the colour shown on the outside of the tube.

Most paint manufacturers offer at least two grades of paint, those usually referred to as artists' oils and those recommended for students which are often sold under a brand name. The latter are usually much cheaper and, therefore, contain inferior substitute pigments and more filler. Some argue that, as a result, they do not go so far and the colours are weaker, making it a false economy to buy them. Needless to say, many professional artists use these students' colours, so buy what you can afford.

EQUIPMENT

Oil paints are usually sold in small tubes of 21ml and larger ones of 37ml. Whites are available in larger tubes of 56ml and 122ml. For muralists or artists working on a grand scale some manufacturers sell large 250ml tins in a limited range. For the beginner, it may be sensible to buy 21ml tubes to start with, together with a large white, replacing them with the larger tubes once you have established your own personal palette.

Colours vary in price too. Manufacturers divide their artists' oil colours into series which differ considerably in price, from the cheap earth colours to the prohibitively expensive vermilion. Students' oil paints, on the other hand, are all priced the same. Few salesmen will point this out to you, so check before you make your final choice. The restricted palette recommended on page 36 does not include any of the expensive paints.

If we still had to grind our colours and mix our paints their qualities and idiosyncracies would soon be known to us. As a beginner, it is a good idea to squeeze out a little of each of your chosen colours and work them individually with your brush on some paper or just on your palette. You will be amazed by the variation in consistency. Some, such as raw umber and yellow ochre, are stiffer than the oilier cadmium colours. You will also see that the colours differ in opacity and strength.

Information about chemical characteristics is supplied by the makers. Oil colours vary in permanence. Some may lose or change their colour and are described as fugitive. This can be caused by contact with sunlight, pollution or through contact with other pigments. The Winsor and Newton range of paints are graded AA extremely permanent, A durable, B moderately durable and C fugitive. The initials SL on the tubes stand for selected list and applies to colours in the AA and A grades of permanence. Rowney and other manufacturers use a similar star system where **** denotes extremely permanent, down to * fugitive.

A few good habits established at the beginning of your painting career can save you a great deal of time and money. Squeeze the tube of paint from the bottom. Every now and then move up the paint from the base of the tube with the top on, by systematically squeezing it with an edge — a steel rule or even with your finger. Clean off the top of the tube after you have squeezed out the paint if it has collected round the nozzle. This can be done with a brush and the paint used; otherwise use a cloth. Then replace the cap tightly so that the air cannot dry up the paint. Paint can be left on the palette for up to twenty-four hours and sometimes longer without it drying up.

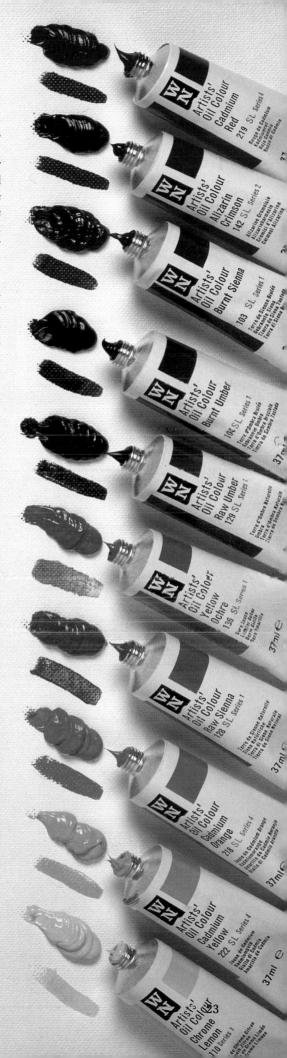

DILUENTS, MEDIUMS AND VARNISHES

Your favourite art store will offer you a blinding range of liquids and gels which promise exciting results when used with your oil paints. Many of these are not strictly necessary. In fact, in the beginning their very existence is merely confusing. Later on you may like to experiment with some of these mediums which encourage certain effects, but you may be pleased to know that most painters get along very happily without them.

Diluents

The paint as it comes out of the tube is sometimes too stiff for direct application on to the canvas. As discussed earlier, the colours vary in consistency – the oilier paints flow more easily. An important rule of oil painting is that when painting in layers (that is, placing one application of paint on top of another) each successive layer should be oilier than the one before. This is the explanation of the saying that you

should paint fat over lean. The reason for this procedure is that the topmost layer, if leaner, will be deprived of its oil content by the layer beneath, starving it so that it cracks, eventually causing the paint surface to disintegrate.

For the beginner (and indeed many artists continue to paint in this way) an easy system can be contrived by adding high dilutions of turpentine or white spirit to the first layers, less in the succeeding layers and pure paint in the final layer. For glazes, perhaps the addition of a little linseed oil will give a good gloss to the paint.

There are problems about using turpentine only as a diluent rather than a mixture of linseed oil and turpentine. As we have discussed, it may cause cracking — probably not in the next ten years, but in the next hundred or so. Turpentine also dulls the colour, removing the glossy appearance which so characterizes oil paint. On the other hand, the addition of linseed oil greatly

retards the drying time between layers.

Using only turpentine to dilute the paint will be easier for the beginner. Later, it will be easier to accommodate the more accepted procedure of diluting the paint with a mixture of linseed oil and other oils available with turpentine or white spirit, gradually increasing the percentage of oil as the painting progresses.

Fresh distilled turpentine is produced for artists so that it does not yellow with age or contain impurities. Keep the bottle sealed and in a dark place, otherwise the liquid will thicken and become useless. Ordinary turps available from DIY stores is cheaper and perfectly usable.

White spirit (or turpentine substitute) is much cheaper than turpentine and freely available in DIY shops. It is a slightly weaker solvent than turpentine but it has the great advantage in that it stores well without deteriorating.

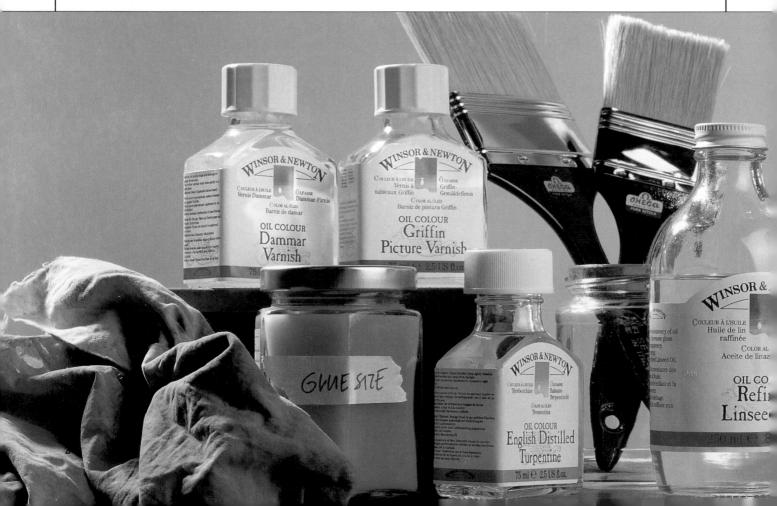

EQUIPMENT

Mediums

Mediums are oils, varnishes or gels which are added to paint to create special effects by altering the consistency or behaviour of the paint. In the tubes of oil paint that you buy, the pigment is already suspended in a medium of oil – usually linseed, but sometimes safflower or the quicker-drying poppy oil.

Linseed oil is the oil most commonly used by the artist, not only to dilute the paint, as mentioned above but also to make colours glossier and more transparent – particularly for use in glazes.

Proprietary alkyd-based oil mediums, which usually come in gel form, can be added to oil paints to affect their performance. They are sold to thin the paint for glazing or for adding to paint to create the right texture for impasto (thick paint which sits in relief on the surface of the painting).

Traditionally varnishes were used as

mediums, with each artist guarding his own particular recipe. Mastic, copal and dammar varnishes are all used as mediums to create certain effects. But there is no doubt that the paint is tricky to use thus diluted and so should be left to the more experienced.

Varnishing a Finished Painting

An oil painting can be protected by a few layers of varnish. It is not absolutely necessary, however, as the paint, when dry, is tough and impermeable. Varnish also has a tendency to yellow with age. But varnishing can prevent the ravages of pollution. It can also recover the gloss associated with oil paints which is sometimes lost with the addition of too much turpentine. If a matt finish is desired then it can be protected with matt varnish.

Some varnishes are applied to protect the paint temporarily, sometimes just while it dries. Such varnish is removable with white spirit.

Permanent varnish must be applied with extra care as it is difficult to remove. Make sure that the room is warm and dust free, without a through draught. Varnishing on a very humid day may cause a white bloom to appear on the surface.

With the painting lying flat on a table or on the floor, check first that the paint is dry – this may take up to a year for thickly applied paint. Dust down the surface with a clean cloth and wipe over gently with a rag dampened with white spirit. When it is quite dry, apply the varnish with a soft, well-worked bristle brush, free from loose hairs and dust. Brush the varnish across the surface in a thin layer, working the patch well out and finishing off with a light stroke to remove the brushmarks. Work systematically across or down the painting in bands, checking against the light that the surface is covered evenly. Apply a second coat when the first has well dried.

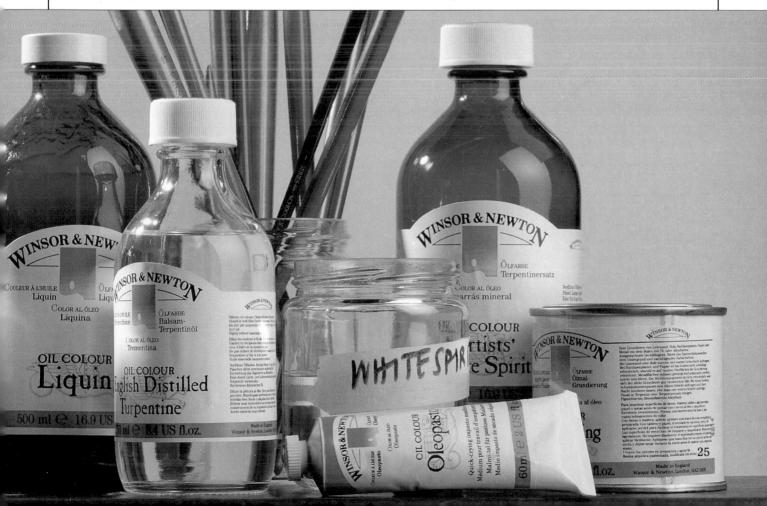

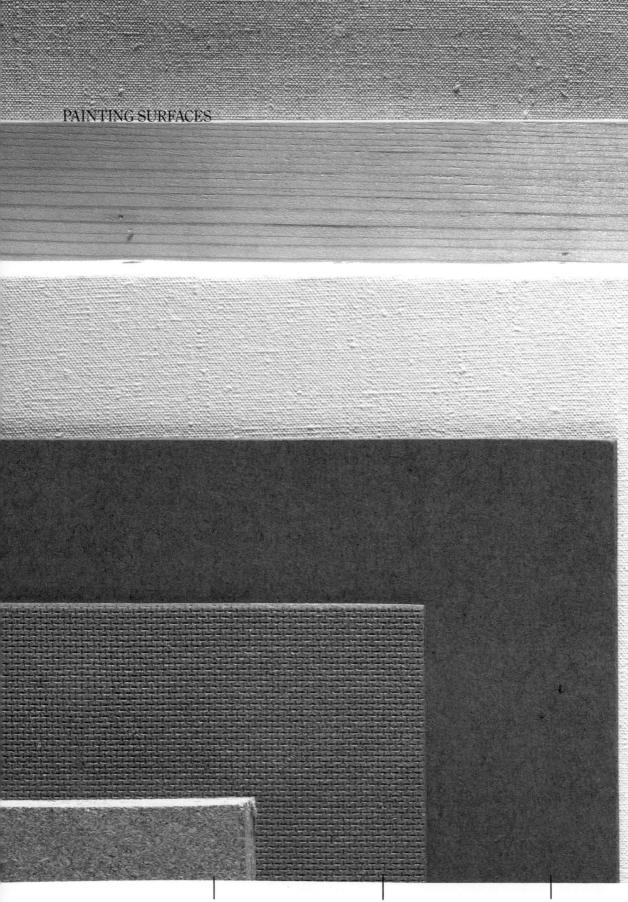

Chipboard is tough and does not warp. But it is heavy and will need well priming.

The rough side of hardboard is a good surface to paint on too. Prepare with size and a ground of oil primer or just with an acrylic primer. Prime both sides to prevent warping. It will need cradling if you intend to hang it.

Cheap and versatile hardboard, shown here with the smooth side up. A light rub with sand paper will give it some tooth and a wipe over with alcohol will prepare it for painting.

A ready-stretched and primed canvas 20 in. x 24 in. (50 cm x 60 cm). All you need to do is paint on it.

Oil paint can be applied to almost any surface if it has been prepared adequately. But it tends to slip and slide on very smooth surfaces without any tooth and some supports; such as canvas, are eventually destroyed by the oil in the paint and so they need to be sealed (primed) before the paint is applied.

Traditionally canvas has been prescribed for use with oils. Certainly the texture of the material and the give it has when stretched make a happy combination. Ready stretched canvases are very convenient but they are expensive to buy even though the price varies tremendously between finest linen and basest cotton. Cotton duck may not be the kindest surface to work on but it is better than many of the alternatives.

Canvas comes in various weights or thicknesses and the weave varies too. A heavy weave, such as that provided by hessian or jute, will give a grainy effect to the final painting. Certain styles call for amoother linens. As mentioned above, canvas needs to be prepared to protect the fibre from the oil in the paint. You can buy ready-primed and stretched canvas or a roll and stretch and prepare it yourself.

Canvas boards are cheaper, but have no give. Alternatively, you can affix canvas or muslin on to cardboard or hardboard with glue size or acrylic primer to make a cheap and highly recommended surface.

Many aspiring artists complain that a bare canvas kills off their inspiration because of the overwhelming "importance" for generations to come. It is pointless to reassure those who suffer from such fears, but perhaps these feelings can be overcome by

recommending that oil paper or cardboard be used to start with. These somehow disposable surfaces tend to defuse the situation.

Beginners tend to buy small canvases or supports, thinking that they will be easier to cover. In fact, on the whole, unless you relish detail and have a miniature subject in mind, then a larger canvas about 24 in. x 36 in. (60 cm x 90 cm) will not be so restricting. This should give you room to move and encourage a looser style so that you are not too bogged down with detail. Make sure you match the canvas with appropriate brushes – that is, not too small.

Wood

Wooden panels are not often used these days. A decent panel needs to be made of mahogany and should be an inch (2.5 cm) thick. It requires seasoning, battening (cradling) on the back to prevent warping and careful preparation. As you can imagine, this sounds like an expensive operation and it would be heavy to hang. Still, if you have a piece of wood to hand, it can be prepared with two coats of glue size and given a ground with at least two layers of oil-based primer. Both of these preparations can be obtained from art stores. Alternatively, it can be primed simply with two or three coats of emulsion glaze (80 per cent household vinyl matt emulsion with 20 per cent water). This will seal the wood as well, so the size is not necessary. Apply with a household brush, leaving the brushmarks to provide a tooth. If the surface is still too smooth, sand lightly before you start painting. Oil paint can be applied on top of oil or acrylic preparations, that is oil paint can be applied over acrylic but not vice versa.

EQUIPMENT

Plywood is more easily available and comes in various thicknesses. Five to seven ply is a good weight for painting. It will need preparing in the same way as a wooden panel. Apply the size or glaze on both sides to prevent warping.

Composite 'woods'

Hardboard and blockboard - are frequently used by students to paint on. Like wood they can be prepared with glue size and an oil-based primer or just with an emulsion glaze. Prime on both sides to avoid warping. Hardboard is surprisingly good to paint on. It has both a smooth and a rough side to choose from. A DIY shop will cut it to whatever size you want but it is easy to saw up yourself. It will need cradling if you want to hang it. The smooth side can be painted on direct if you rub it down first with alcohol. Give it some tooth with sandpaper or by pulling the blade of a saw across the surface.

Chipboard is heavy but will not warp. It is not a kind surface to paint on and needs to be well primed.

Cardboard

Cardboard makes a good, very economic, surface to paint on. It just needs sealing on both sides with glue size. If you want to paint on a white surface, apply some primer when the size is dry. Otherwise use the warm brown of the cardboard like a tint.

Paper

Pads of specially prepared oil paper which have a simulated canvas surface are pleasant to work on and certainly make economic sense. In fact this surface is surprisingly resilient and will last for many years. It is also easy to pin or tape on to a drawing board, so an easel is not necessary.

A piece of ½ in. (6 mm) well-seasoned pine (the bottom panel of a drawer) which would make an excellent surface for painting. For durability, it would need careful priming and cradling.

Raw linen canvas which can be purchased in rolls of various widths and weights, ready for priming and stretching. Sheet from an oil sketching block of 12 sheets. Blocks range in size from 8 in. x 6 in. (203 x) 152 mm) to 20 in. x 16 in. (508 x) 406 mm).

Cotton canvas board, ready for painting – a cheap alternative to a stretched canvas.

BRUSHES

Paint can be applied with a wide variety of instruments but there is no doubt that a good brush will go a long way to helping you achieve what your inspiration dictates. A cheap insensitive brush, though useful for certain techniques, will distract and annoy — more than likely putting you off the whole idea. The brushes, painting knives, etc, on the following pages are

shown with a few of the natural marks they make. Of course, it is not recommended that you should buy this complete selection: you will need only a few to start with and what you buy will depend on your pocket and what it is you decide to paint.

Brushes come in three main shapes – round, flat and filbert – in various sizes from 00 to 14 depending on the range

and with either long or short bristles. A good brush will hold its shape even after it has been wetted. Unfortunately, it is a case of you get what you pay for.

The most useful oil painting brushes are made from bristle — usually hog's hair which has a frayed end to each hair and holds the paint well. In addition, hog's hair is strong and flexible enough to cope with the consistency of the

- 1 No. 12 long flat hog. A large flat such as this holds large quantities of paint well. Excellent for applying paint to large areas or for working loosely. The mark made with a flat brush can be altered by the angle at which it is held to the canvas.
- 2 No. 10 short flat synthetic fibre/sable mix. Softer than the hogs hair, this short flat is useful for applying soft dabs of paint where a strong brushmark is not required.
- 3 No. 2 long flat hog. The long hair is susceptible to pressure, easily varying the width of the mark.
- 4 No. 2 short flat hog. A short flat brush is sometimes known as a bright. Useful for applying thicker mixtures of paint in small brush strokes.
- 5 No. 2 short flat synthetic fibre/sable mix. Suitable for fine, detailed work.
- 6 No. 10 round synthetic, fibre. This size of round brush for oil paint might be more useful in the stiffer hog hair. But even such a brush could be used for underpainting, stippling, soft glazes. Notice the different shape of the stipple mark made by the round brush.

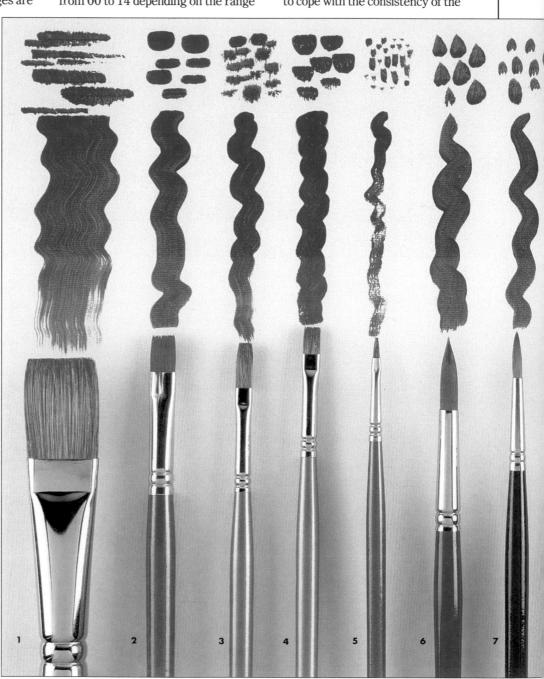

EQUIPMENT

paint. The softer (and very expensive) sable brushes are mainly used in oil painting to add fine details at the end. Needless to say, brushes made of synthetic hair or mixed bristle and synthetic are worth trying. They are softer than hog's hair, more similar to sable but not equal to it. On the plus side, they are certainly cheaper and are easy to clean. Purists will point out,

however, that they are not so sensitive, do not hold paint as well and do not last as long. Oil painting brushes traditionally have long handles so that the artist can paint at a distance from the support.

The size of the brushes you use depends on the size of your painting and your style. It is common practice to start with larger brushes and use

smaller ones as the painting progresses towards more detail. Yet some artists paint almost entirely with one or two brushes. Others will pick and choose sizes and shapes to create particular strokes and marks.

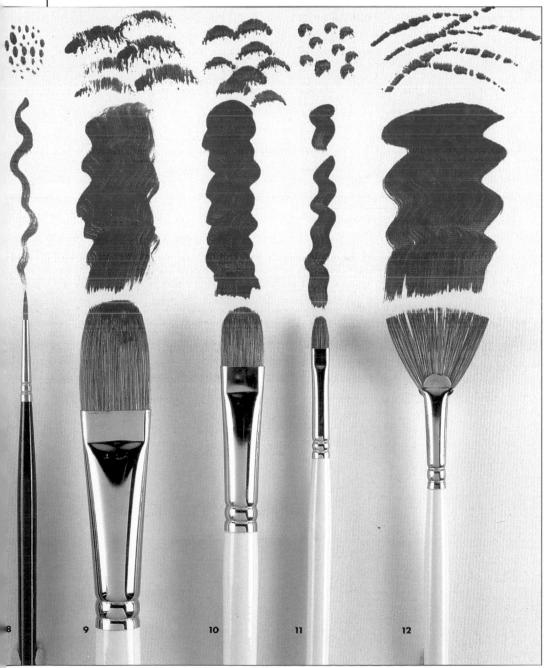

- 7 No. 5 round sable. A cheaper sable brush used mainly for detailed work.
- 8 No. 1 round sable. A very small brush for use in highly detailed work.
- 9 No. 12 short filbert hog. This brush is so called as it is shaped like a hazelnut and, indeed, it has a belly like the nut, making it a cross between round and flat. It holds paint well. Again, the shape of the brush affects the mark.
- 10 No. 8 short filbert hog. A useful general-purpose brush.
- 11 No. 3 short filbert hog. Makes an interesting stippled mark. For detailed work.
- 12 No. 4 fan blender hog. Not an essential brush but can be useful for delicate tonal blending of colours and to smooth out brushmarks where a flat surface is required.

BRUSHES

Care of Brushes

Brushes are well worth looking after; even the synthetic brushes are not cheap. Cleaning brushes can be very relaxing after a hard painting session. Leave time to enjoy it and do it well. When not using brushes, lay them on a flat surface or bristle end up in a jar. Do not leave them to soak resting on their bristles as this does untold damage.

To clean them, use cheaper white spirit rather than turpentine. Pour a little into a jar with a screw top. First, wipe off any excess paint from the brushes on newspaper or kitchen roll and then work them in the white spirit. Rinse in running warm water and then rub on a cake of pure soap (kept for the purpose as it will get messy). Roll the lathered bristle around in the palm of

your hand, rinse and repeat until the lather is clean. Make sure the paint has dissolved at the point where the hairs enter the metal ferrule. Pule them back with your thumb to check. After very careful rinsing, shake out the excess water and coax the brush back into shape. Leave to dry inverted in a jar or tin. Screw up the jar of white spirit as in a day's time the pigment will have sunk

- 1 No. 16 pear shaped painting knife. Painting knives have flexible steel blades and are used mainly for applying thick layers of impasto paint. They are available in various shapes and sizes. The shape of the blade will influence the mark made.
- 2 No. 22 diamond shaped painting knife. The edge can be used for linework. The cranked shaft of these knives allows you to mix and apply the paint without touching the surface.
- 3 4 in. (102 mm) blade palette knife with cranked shaft. Palette knives are mainly used for mixing paints and scraping clean the palette and sometimes the canvas. But they make an interesting mark too.
- 4 Natural sponge. Can be used to stipple, to stain the canvas with colour or to apply flat washes of colour.
- 5 All-purpose cloth. Any rag will do that is clean and lint free. A loose weave will produce a more interesting mark. Wrap round your finger or brush end to get more control (see page 58).

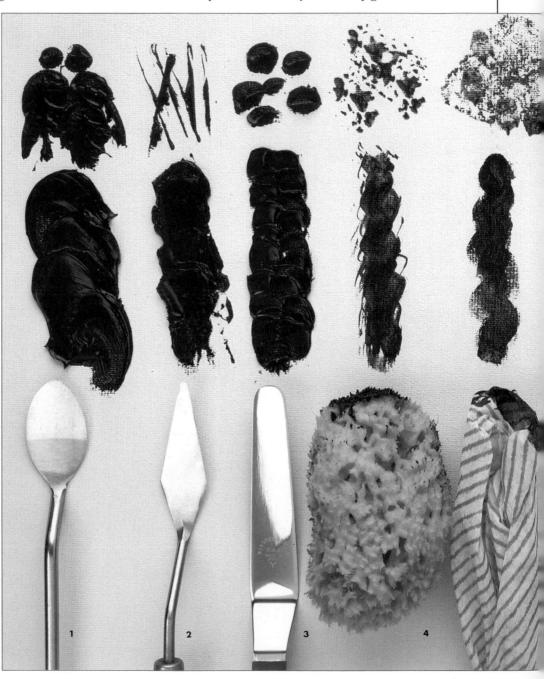

EQUIPMENT

to the bottom, leaving the spirit clear. You can then pour it off into a new jar and use it again.

Sable brushes are considered a delicacy by moths, so for longer periods store in moth-proof boxes, making sure the brushes are clean and dry.

If a brush is left caked in paint until it dries out, it is not lost but it will probably not do it any good. Soak the

brush in paint stripper. Then, wearing rubber gloves, clean off the brush and gently work off the paint. Wash and rinse as above.

Painting Knives

New painting and palette knives are protected with a seal and may need cleaning with white spirit or lemon juice. After use, they are easily cleaned with a rag dipped in white spirit.

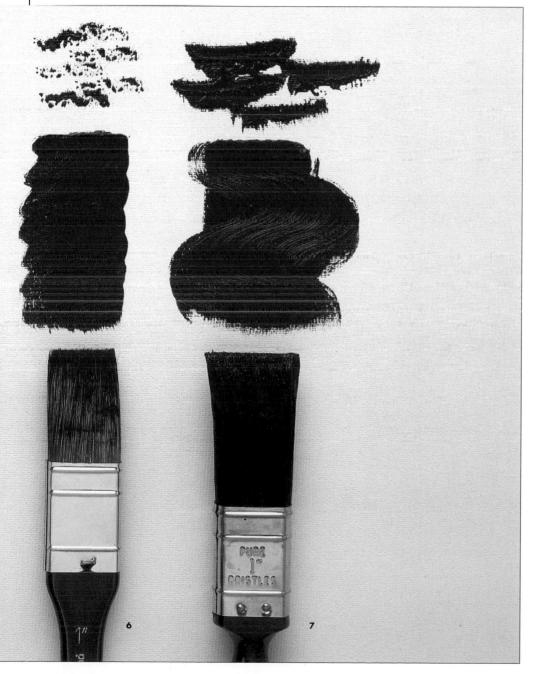

- 6 1 in. (2.5 cm) soft bristle brush. This would make a good varnishing brush. But it would be useful for any large-scale or preliminary painting.
- 7 1 in. (2.5 cm) coarse bristle brush. Available at DIY stores, such a brush is essential for applying large areas of paint as well as priming surfaces etc.

OTHER EQUIPMENT

Palettes

The traditional mahogany palette is a very expensive piece of equipment and it is by no means essential. Many find them too heavy and the wood too dark to clearly assess colour mixes. Of the two demonstrating artists in this book, one uses a piece of white formica veneered board 36 in. x 24 in. (90 cm x 60 cm), placed on portable trestles next to his easel. This provides enough room for the paints and jars, cloths and other equipment needed. It also leaves his hands free to hold the brush and

cleaning rag. The other artist prefers to use a cheap disposable tin foil dish. This is very light to hold, does not distort the colour and means there is no palette to clean; it is just thrown away. This particular artist paints in white overalls on which he cleans his brush, leaving his hand free to hold the palette.

Dippers

Oil painters traditionally use dippers for holding diluents – turpentine and linseed oil. They are two small combined dishes with non-spill rims which fit to the side of a traditional palette. Small jars on a table next to the easel work well; small ceramic dishes are less easy to knock over.

Easels

An easel is probably the most expensive piece of equipment necessary for oil painting and it is certainly not essential. It is better to establish yourself as a keen painter before embarking on such an expense. By that time you will have a clearer idea of what exactly you require. In the meantime, with a canvas, either

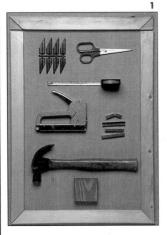

1 No unusual equipment is needed to make up a canvas, which is genuinely easier than it looks and much cheaper than

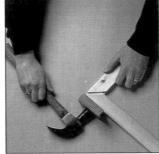

buying it ready-made. Seen here from top left: corner wedges, scissors, tape measure, staple gun, staples, hammer, block of wood.

2 It is cheaper to buy stretchers as you require them and buy a roll of canvas,

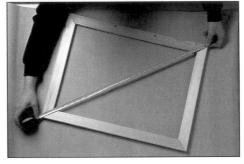

otherwise buy a kit with all you need for one canvas. First join the stretcher by tapping the corners together. The block will cushion the effect.

3 If you have four right angled corners, the diagonals should be equal. Check with a tape

measure or a piece of string. Now, cut the canvas to size with a 1 3/4 in. (4 cm) overlap all round, lay it on a clean table with the stretcher on top.

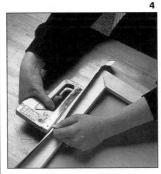

4 Fold the canvas over down one side and staple in the middle. Then pull it taught across to the opposite side and repeat. Continue with the third and fourth sides and then follow with staples in the outer edges always matched with their opposites.

5 Having inserted staples at about 3 in. (8 cm) intervals, now pull a corner of the canvas diagonally down to form the corner.

6 Fold neatly and as tightly as possible and then staple down firmly with two staples. Repeat for the other corners.

7 Now, finally, fix the small wooden wedges into the spaces provided in the corners of the stretcher to make the canvas extra taut. These wedges can also be used to adjust the angles slightly if they are not quite true.

paint flat on a table or prop up the top of the canvas with a book, holding the base steady with your non-brush hand. The paints can be mixed on on a palette on the table next to you. Oil-primed paper can be pinned to a board balanced on your lap against a wall or chair. There are many ingenious ways to work without an easel.

Having decided to go ahead and buy an easel, it is worth getting one that

works. This means one that is easy to assemble and to alter. It must be secure enough to withstand jabbing strokes without the fear that it is going to collapse. The best are made of solid wood. They are, however, very heavy so if outdoor work is your preference then a light portable aluminium-tube sketching easel is the answer. If you prefer sitting at a table then a desk easel will suit your needs.

Studio paraphernalia

Now we have looked at the main pieces of equipment necessary to start painting. There are other items you will find you require but most of these will be easily available — plenty of clean lint-free rags or all-purpose kitchen cloths, kitchen paper, jars, scissors, drawing pins, pencils, erasers, masking tape, rulers. The list could go on for ever.

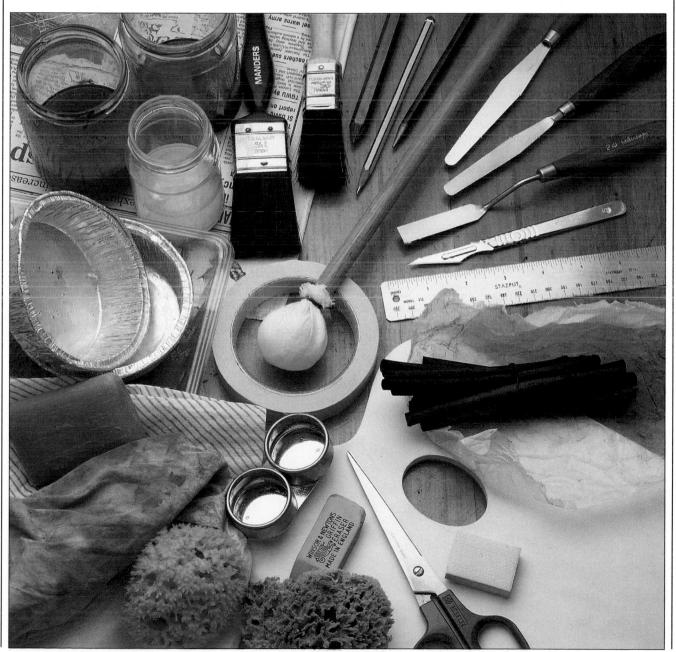

Chapter 3

Making the Most of Your Paints

The art of mixing and using colour is one which any artist will be aiming to develop and improve. Yet this is an art which is often taken for granted. There is no doubt that colour mixing and interpretation becomes easier with experience, but a little time spent experimenting with theory will greatly improve your early attempts. Needless to say, every time you use oil paints, even when you are an old hand, you will make exciting new discoveries about how the colours interact — not only when mixed together, but when applied next to each other, when laid in thin glazes one colour on another, when diluted or built up in thick impasto.

Knowing how to mix certain colours is partly intuitive and partly knowing the properties of the pigments you are using. We can learn that blue and yellow make green, but is only by experimenting with these two colours that it is possible to mix when required the infinite shades of yellowy, blue browny greens possible. The results will depend on the proportions of the primaries and on whether the original blue leans more towards violet or green or the yellow towards

orange or green. Learning to use these subtle differences in colour will enrich your painting.

Colour is an important part of composition. Knowing how to use colour in this way gives the artist another tool with which to work. A strong colour, for example, can help pick out an important figure or element in the composition. It is also through the artful application of colour that the viewer of your work can 'read' the picture as you planned. The eye so prompted will involuntarily leap from one patch of strong colour to the next, taking in the full extent of the composition on the way.

It has long been recognized that colour affects us emotionally and that generalizations can be made about our reactions to particular colours. So it is that colour can help promote a particular mood in a painting. Pale, warm, rosy colours are meant to be relaxing and undemanding; cool atmospheric blues, the colour of the surreal; bright strident primaries hit you between the eyes and demand extreme reactions.

RECOMMENDED BASIC PALETTE

It is difficult to know which of the tempting range of colours to buy when starting to paint. The restricted palette of eighteen hues shown on this page will give you a basic range of paints from which it will be possible to mix what you want without too much hard work.

It is not suggested that you will use all these colours every time you paint. In fact, you will probably find that in due course your personal preferences will edit out a few of these colours and possibly add a few more. For example, if you use a lot of cadmium orange, even though it can be mixed from cadmium red and cadmium yellow, it would be sensible to buy it ready mixed in a tube.

It is surprising to find that most colours can be mixed with a five-colour palette of titanium white, yellow ochre, cadmium red, cobalt blue and ivory black and it is a good exercise to try this out. You may find to start with that such a restricted palette is easier to control in keeping the colours in harmony. But with a slightly more extended palette, the mixing of colours will be a lot easier.

General advice on buying and looking after oil paints is given on page 22. But remember that colours even with the same name vary between makes. Also, some pigments are poisonous although those that have been discovered to be dangerous have now been replaced with harmless alternatives. Even so, the cadmium colours, lemon yellow and others are designated harmful so take care to wash your hands and clean your nails after painting.

The pigments are usually arranged on the palette with the warm colours together and the cools likewise. How exactly the colours are arranged is very much a matter of choice. Try and keep to your own formula so that you can find the colour you are looking for without thinking.

French ultramarine

Deep, intense, semi-transparent, violet blue used a great deal to tint other colours, but mixes with alizarin crimson to make rich violets or with yellows for good vegetation greens. A chemical replacement for the priceless lapis lazuli based original. A slow drier.

Prussian blue (Phalocyanine blue, Winsor blue or Monestial blue)

A strong, cold, green blue with tinting power. The original Prussian blue was unstable and so to a great extent has been replaced by the chemical phalocyanine, Winsor or Monestial blue.

Cobalt blue

Bright, rich blue which makes a good clear sky blue. Also very useful in creating flesh tones.

Cerulean

A highly opaque sky blue leaning towards green rather than violet. A quick drier.

Sap green

A good ready-mixed, semi-transparent yellow green.

Viridian

A bright, rich, transparent blue green which is of the most permanent of colours.

Cadmium red light

Bright, opaque red, developed to replace the very expensive vermilion. Mixes with cadmium yellow to make a rich orange or with blue to make dull browns. A finely ground soft paint, cadmium red is durable but a slow drier.

Alizarin crimson

Truly luscious deep red crimson. Makes a rich transparent glaze though only moderately durable in very thin washes. High oil content, slow drier.

Cadmium yellow

A strong, powerful yellow which has replaced others, such as chrome yellow, because it is permanent. Soft consistency, it is a slow drier.

Lemon yellow

A deceptive colour, looking rather washed out when first squeezed out. It is a bright, cool, useful yellow, making a range of dazzling greens when mixed with cobalt or French ultramarine blue. Slowish drier.

Yellow ochre

An opaque dull yellow which is a generally useful mixer – for example, with blues to produce subtle landscape greens.

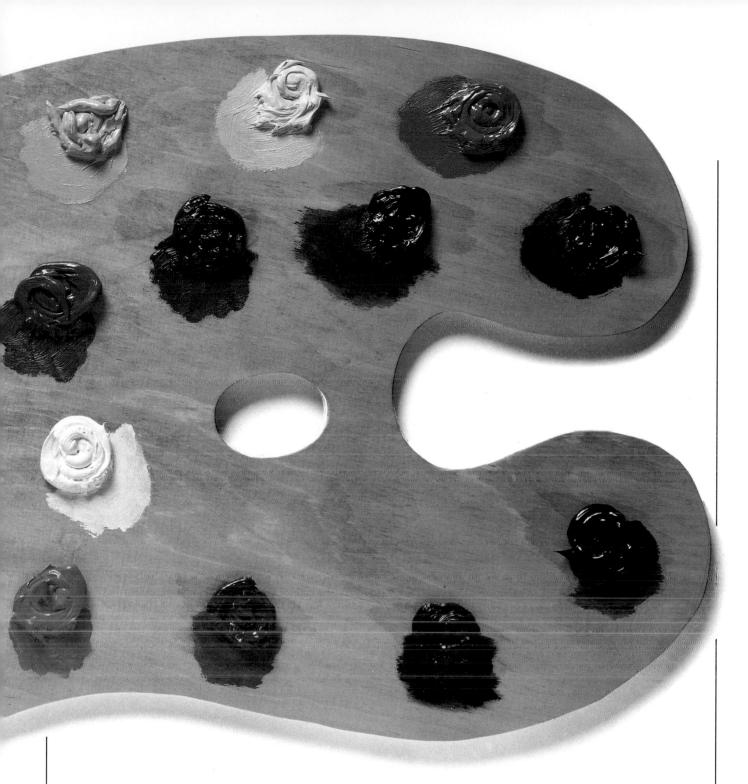

Burnt umber

Looks most unexciting when squeezed out, this is an essentially strong, dark, warm, permanent earth colour. Often used in underpainting as quick drying.

Raw umber

Another quick drying, permanent earth colour which is a yellow brown. Almost transparent, it is useful for underpainting. A very good mixer.

Burnt sienna

A transparent, reddish warm earth colour with many uses for mixing warm tints and broken colours. Quick drier.

Raw sienna

A yellow brown made from natural clay containing iron oxide. Quick drier

Paynes grey

A mixture of two blacks, ultramarine and synthetic iron oxide, this is a useful cool grey for modifying and tinting colours.

Ivory black

A semi-transparent, warm browny black which produces some surprises when mixed with other colours. Excellent green when mixed with cadmium yellow.

Titanium white

A relatively new, whiter-than-white white made to replace the poisonous flake white which is based on lead. Dries more quickly than the old whites and is more opaque. Ground in safflower oil so should not be used extensively in underpainting.

COLOUR BEHAVIOUR

Armed with your recommended palette of colours (see page 36), some glorious hues are ready at your command. Colour mixing depends a great deal on getting to know the individual paints and how they react with each other, but intuition and a palatable slice of colour theory also play their part.

In our first introduction to paints, we learn about primary colours - red, blue and yellow - and we learn the catalogue of colours achieved when these are mixed together to produce secondary colours – violet, green and orange. As you can see in this colour wheel (or flower), by mixing a secondary colour with its primary neighbour a tertiary colour is formed. In our palette, cobalt blue is the only near approximation of a primary colour. Primary yellow can be mixed from lemon and cadmium yellows and primary red from cadmium red and alizarin crimson.

Warm and Cool Colours

This wheel is useful to explain certain characteristics of colours. Round one side there are the so-called warm colours of fire and round the other the cool colours more associated with snow. These can be chosen and mixed to affect the mood of a painting. Even so, evaluating colours in such a way is purely subjective and different people will have different reactions. All colours have their warm and cool sides. You can see that ultramarine is a warm violet blue, while Prussian blue is a colder green blue.

Warm colours mixed with white, even when used in an abstract painting, will

A colour wheel, or flower, is made up centrally of the three primary colours, red, blue and vellow. When mixed in equal parts with their neighbours, secondary colours are produced - orange, violet and green. Furthermore, when these secondaries are mixed with their neighbouring primaries, they

make tertiary colours. In this example, the warm colours are basically in the left half and the cool in the right, although, as you will see, there are cold yellows and warm blues. This flower too demonstrates complementary colours which appear opposite each other, for

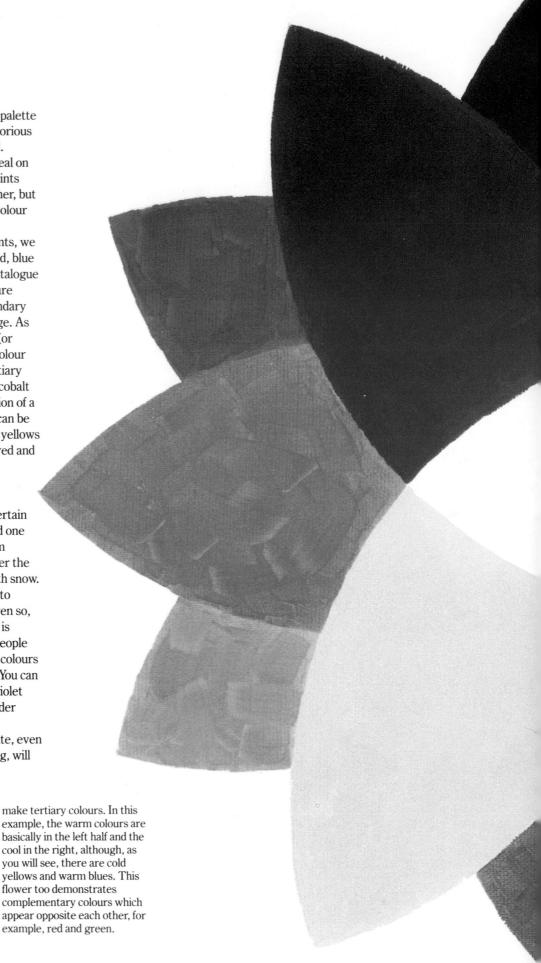

not violently arouse the emotions. If anything, they will promote a feeling of well-being and contentment.

The primary and secondary red, yellow and oranges can be used in an alarming manner. But as the commercial artist knows, they are usually associated with enjoyment and the sun.

The cool colours, on the other hand, can give an ethereal, eerie, atmospheric tone to a painting, as demonstrated by René Magritte in his surreal paintings of skyscapes and bowler-hatted men.

Complementary Colours

Complementary colours are those which face each other on the colour wheel - red/green, yellow/violet, blue/orange. These combinations of colours are very important to the artist. Laid next to each other on a canvas, they can draw the attention of the viewer to a certain area, qualifying each other to appear brighter and more intense. The French Impressionists, who were much concerned with colour theory, applied these colours alongside each other in small dabs much desaturated with white. They found that this gave the paint surface a quiet brilliance.

Mixed together, complementary colours make a greyish neutral colour. Yet, a little of a complementary will dull its partner and can be used to mix shadow tones with the addition of blue. To simplify, the shaded side of a red ball can be mixed by adding some green to the red and a little blue.

MIXING COLOURS

Knowing your colours and how they behave is the secret of colour mixing, but even so colour mixing is to a great extent intuitive and rather hit and miss. As has already been said, it is only by physically mixing colours yourself that you will find out about them.

Artists usually lay out the colours on the palette in a particular order, with the warm colours together and then those referred to as the cool colours. If you always follow the same pattern you will instinctively go for a colour when mixing.

True primaries and any mix of two of them will produce pure colours, but once a third is introduced the result is darker and muddier. To keep colours fresh and vibrant, therefore, mixing should be kept to a minimum. The more you work the paint round and round on your palette, invariably the duller it becomes. Sometimes you will just have to abandon a mix and start again.

There are so many different ways for an artist to mix colours apart from the obvious method of on the palette. The French Impressionists felt that colour was kept fresher by mixing the colour optically on the canvas. This is achieved by laying colours side by side in small areas or patches. At a distance the colours merge, so patches of red and yellow will make orange. A form of this optical mixing is achieved by artists who invariably only loosely mix their colours on their palette. The resulting brushstroke contains the constituent colours visible to the eye. The paint surface is thus made more interesting

when viewed close up and yet the effect from a distance is the same.

A certain amount of mixing is carried out on the paint surface itself. It is not advisable to use the canvas like a palette as this invariably leads to muddy colours but certainly an artist will work wet on wet and blend neighbouring colours into one another on the canvas itself, thereby causing them to qualify each other.

Another technique of oil painting, glazing, enables the artist to build up barely definable hues and tints with thin layers of transparent paint each qualifying the previous layers.

Tinting and Shading

A colour or hue is described as being fully saturated when it is strongest.

- 1 White can be added to a colour to lighten or tint it. Here, titanium white is added increasingly to blue, showing a gentle gradation of tone.
- 2 Colours are rarely darkened or shaded with black. The addition of black only muddies a hue. To darken the cadmium red, here on the left, first alizarin crimson is added and then, for the darker tones, small amounts of cobalt blue.
- 3 Mixing two colours together little by little can produce some surprising results. These hues will harmonize in close proximity in a painting. In this example, cadmium red has been gradually added to cobalt blue, finding hues ranging from deep violet to grey black, to deep brown.
- 4 Here cadmium red is added to chrome yellow to produce some good corn yellows and burning oranges.
- 5 Now Winsor green is added to chrome yellow, producing some cool shaded yellows and some useful clear greens. The hue can be affected by the smallest addition of pigment.

MAKING THE MOST OF YOUR PAINTS

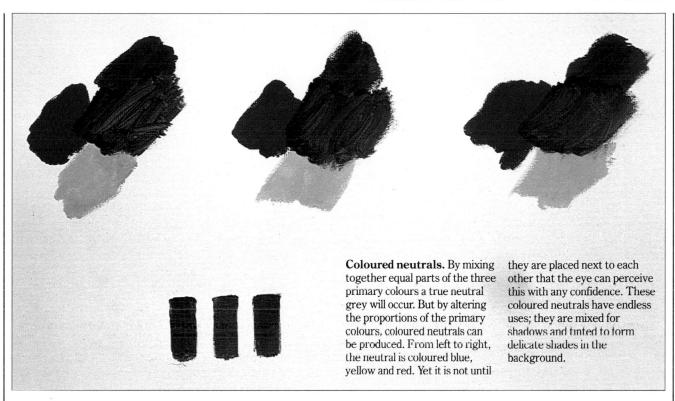

This does not mean darkest, but when the colour is most pure. A colour can be desaturated by tinting it, that is, adding white, or by shading it by adding a darker colour.

In these examples you will see how by adding progressively more white to pure blue, the colour becomes progressively desaturated. Artists tend to use a great deal of white, if only in tiny amounts. Colours are rarely used full strength unless for a special reason.

The examples showing the shading of colours demonstrate a very important point – colours will only become dull and lifeless if black is used to darken them. Many artists ban black from their palettes, but that is extreme as black has its uses. Learning which colours will darken others will come with experience. The most obvious examples are shading bright cool lemon yellow with warm cadmium yellow, then maybe adding a touch of red and then a touch of burnt sienna. Often it is a case of scanning your palette to look for a suitable shading agent which may

indeed be among the ready-mixed colours.

Two-colour Mixing

Having experimented with tinting and shading colours, thereby providing an overwhelming range of tones to play with, now let us try mixing two colours together to increase the range of hues. Choosing a yellow and a blue or red (not a primary, but yellow ochre and cerulean or alizarin crimson) gradually add the darker colour by degree to the lighter colour. The result often contains a few surprises even to the experienced. The range of colours produced will harmonize with each other and can safely be used alongside each other on the canvas. This mixing of two colours is rarely so explicitly laid out by the artist: the different tints are more usually visible around the central mixing area between two colours. They are, therefore, picked out with the brush or progressively mixed.

Coloured Neutrals and Greys

If you mix a number of colours together they eventually form a dull greyish colour. The reason for this is that if you mix all three primaries together you will arrive at what is called a neutral. If all three primary colours are mixed in equal strengths a true grey — not leaning towards any of the primaries — will be formed. But if one colour dominates then a coloured neutral will appear. Coloured neutrals and greys can also be contrived by mixing a colour with its complementary — blue with orange, yellow with violet etc.

Neutrals play an important part in painting, often forming the receding colours of the background. Using a coloured neutral that tones with the foreground hues will ensure colour harmony. But an unsaturated colour will look stronger if placed against a background of its complementary neutral. Corot, the eighteenth-century French painter, used this ploy in his painting by drawing the eye to a dash of red set in a neutral green.

INTERPRETING COLOUR

We tend to be brainwashed about what we claim we see. A person will swear that the trunk of a tree is brown and the leaves green even if golden evening sunlight is turning the reflecting leaves yellow and casting patches of violet-coloured shadow on the trunk. An artist, to make his painting interesting, must look at what he is painting, making an effort to isolate the different hues which make up the mosaic of colour of

any object. This is now accepted procedure. But when the French Impressionists recorded the truth about colour there were howls of disapproval – always encouraging to the artist. What is perceived and recorded then in paint, finally must be checked by an objective appraisal by the eye. To this end many artists look at their work through a mirror to give them a truly objective view of their work.

Yet an artist does not necessarily always want to paint exactly what he sees. He will use colour as a means of expression, interpreting what he sees before him. This interpretation of colour has been likened to music. A chord of music is made up of a number of single notes — sometimes harmonious, sometimes discordant. An observant person can distinguish the individual notes in such a chord. Just as

- 1 Colour is an important part of composition. Some colours, such as red and yellow, are described as advancing they appear to be in front of receding colours, such as greens, blues. This is demonstrated here where a line of red dots across a mixed background of green and blue stand out so much that the eye is destined to follow it from the bottom left corner to the top right. In the West we 'read'
- paintings from left to right like a book and the artist makes use of this fact, manipulating the way the composition is viewed.
- 2 The same principle of advancing colours is used here with this line of fruit. The apples and orange are all roughly the same size and in a disordered line, yet attention is focused on the orange which appears nearest to the viewer, and it even appears larger. But this is an optical illusion caused by the advancing nature of the flaming orange in contrast with the green.
- 3 A modern interpretation of an ancient formula to denote distance using colour, the foreground is painted brown, middleground yellow green and the background tinged with pale blue. Thus a sense of space into the picture can be created with colour alone.

MAKING THE MOST OF YOUR PAINTS

the composer uses such notes to express him or herself, an artist uses colour.

Composing with Colour

Colour is an important part of composition. You will find that some colours dominate a picture and attract attention and that others naturally sink into the background. Those that come forward are called advancing colours

and are primarily the warm colours of the colour circle. The cool colours are described as receding colours. The extent to which this applies depends on the saturation of juxtaposing colours. A pure cold blue, for instance, will appear to lurk behind a neighbouring pure warm red but will leap forward out of a sea of neutrals.

It is through the artful application of colour that the viewer of your work can

be guided round the picture space.

As an example, Pieter Bruegel the Elder leads us in a zigzag course through his crowded scenes of village life with carefully conceived patches of red – a hat here, an apron there. The eye involuntarily leaps from one to the next, taking in the full extent of the composition on the way. What appears, therefore, to be an amorphous mass is thereby given some structure.

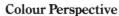

It is by knowing the effects of colour on the viewer that the artist is able to create a sense of distance in a painting. A knowledge of seemingly complicated mathematical systems is not strictly necessary. It is simply a case of painting what you see - parallel lines receding to a single point on the horizon, the overlapping of objects and the fact that when objects are viewed from a distance the earth's atmosphere bleeds them of their colour, desaturating them and giving them a bluish tinge. Colours in the foreground are strong and vibrant and objects well defined. In the background the same objects are paler, bluer and ill defined.

Seventeenth-century painters employed a well-worn formula for landscape painting: the foreground was painted in brown, middleground in green/yellow and the background in blue.

Mind you, as in most aspects of painting, your natural intuition will guide you in such respects. If you paint a person wearing a bright red coat in the background of a painting, you will have difficulty in keeping that area in the background – this strong colour will bring it forward. This will become immediately obvious so, to overcome the problem, there is a choice of toning down the colour or changing it to a naturally receding desaturated blue. On the other hand, if you are trying to create an ambiguous picture space and confuse the viewer, you will leave it as it is.

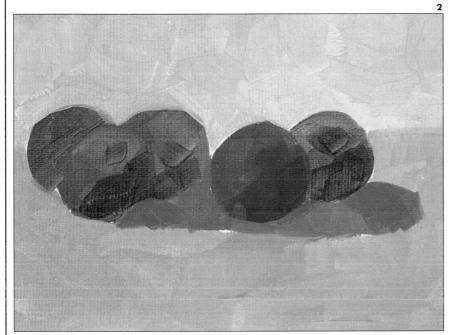

Chapter 4

Basic Techniques

At last, it is time to take up the brush. In the following pages we will see how this can be done, starting with the basic skills of painting in oils and progressing in easy steps to more complicated techniques. The aim is to give you the confidence to try your hand. Once you have, there is little doubt that you will be hooked.

Every section starts with a demonstration of useful techniques. These are photographed in the studio away from the hurly-burly of the composition itself. By doing so, it makes it possible to fully understand and practise these techniques before embarking on the great masterpiece itself.

You will need plenty of cheap paper to practise on. Wallpaper, lining paper or even newspaper will do – although the latter will tend to dirty your paint with newsprint. At this point it will not matter unduly. The aim is to become familiar with your materials – experiment with brushstrokes, use the paint, and simply sort out and get used to the place where you intend to paint. Once you feel confident about the techniques and are ready to use them in the context of a painting, turn to

the project pages which follow and witness these techniques put into practice.

The two artists whose brushwork we observe in detail in the course of the following pages, have been chosen for their individual styles – styles which demonstrate different aspects of oil painting. These projects can provide the basic information for a similar painting of your own. Your work of art will not be exactly the same as that demonstrated. It should not be so: your interpretation of the subject will undoubtedly include your own observations. Alternatively, the projects may spark off your imagination and give you guidance in how it can be practically translated into paint.

Naturally it is not possible to include coverage of every brushstroke made in the course of these projects — it would make monotonous viewing. In each demonstration, therefore, a particular approach or technique is observed in detail, making it possible to consider the problems and to see the results in context. So now it is a case of harnessing your courage and taking the plunge. I can assure you it will be worth it.

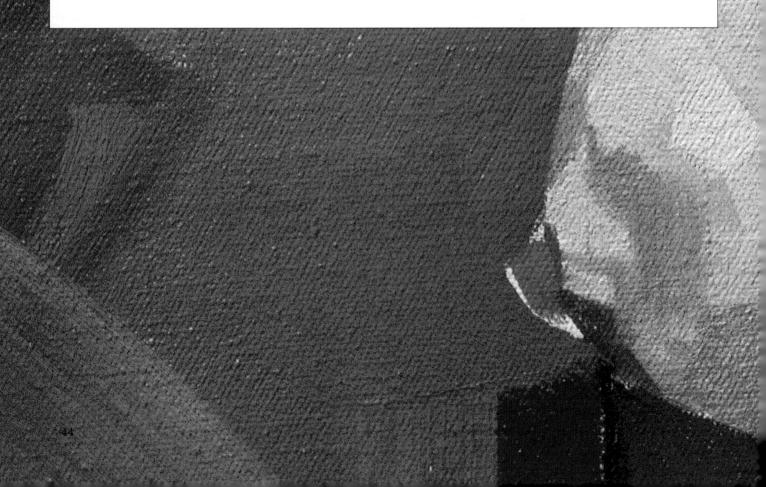

Basic Techniques

GETTING READY TO PAINT

By now you will have equipped your workplace and bought your paints as suggested in Chapters 2 and 3. You will need plenty of rags, a selection of brushes and two containers of turpentine or white spirit: one, which should remain clean, to dilute the paint and the other to clean the brush in, which will soon become very dirty. At the end of the day, leave the dirty jar covered and by the next day the

pigment will have sunk to the bottom and the clear spirit can be poured off to use again. If you use white spirit you can afford to be more generous with the size of your containers (jam jars are excellent) as it does not deteriorate. Turpentine should only be poured out in small quantities as it will thicken and grow yellow in contact with the air. The small metal containers, called dippers, which clip on to the side of a palette are

perfect for turps.

It was mentioned in the section on diluents that, to start with, it may be easier to use just turpentine or the cheaper white spirit to dilute your paint. In the following projects both white spirit and turpentine are used, but oil rarely. This simplifies things dramatically for the beginner.

Now to squeeze out the paints. This artist uses a plank veneered with white

1 Squeeze out the paints on to the palette, pressing the tube from the end. If you get paint round the nozzle of the tube, clean it off before replacing the cap. It will be easier to remove next time. Most artists place the warm colours together on the palette and then the cool colours.

2 Mixing colours is an art in itself, but the only way to master it is to give it a try. To keep the colours spontaneous try not to overwork the paint. Beware, too, of the overloaded brush which will soak up into the metal ferrule and give you an unpleasant cleaning job.

TECHNIQUES

Formica to mix his paints on. This can be simply supported on a table or with a couple of portable trestles. The warm colours are squeezed out on one end and the cool colours on the other. If you haven't already been lured into trying your hand at mixing paints by the previous chapter on colour, now is the time to have a go. Take a touch of turps to wet the palette, then neatly pick your colours, working them together in a

circle on the palette. Try not to overwork the colours or they lose their freshness. Take care, too, not to overload the brush so that the paint seeps up into the metal ferrule where it will dry and cake. If it does, press the excess out on the palette and wipe the brush clean with a cloth and start again.

In between different mixes of colour, clean off your brush. First, work out as much paint as possible on the palette (or

in practice on the canvas), then clean the brush out in the cleaning jar, pressing out the excess liquid on the rim, and finish by drying off the brush on a cloth.

As you can see, the artist links his colours by tinting and shading them with other mixes already on the palette. It is not necessary to revert to the tube paints all the time.

3 Using the tube colours to mix with will keep the colours bright and pure, but an artist is constantly tinting and shading his colours. A certain harmony of colour will be ensured if you tint and shade from the colours already mixed on the palette.

4 Before moving on to the next colour mix, the brush is cleaned off in the white spirit. The excess is squeezed off on the rim of the jar, and now the brush is dried off on a rag, splaying out the bristles to reach up to the ferrule.

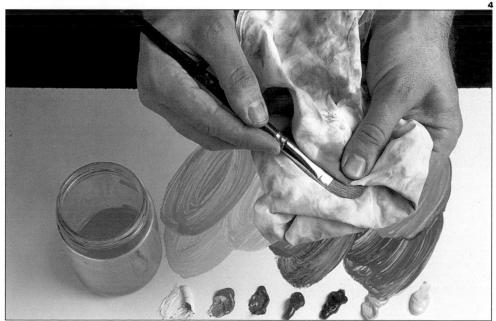

Techniques

APPLYING THE PAINT

Brushwork

One of the aims of the oil painter is to keep the surface of the painting lively and interesting. This effect is achieved in part through the brushwork.

The paint as it comes from the tube is of a consistency that will keep its shape on the support. This means that if painted on with a bristle brush the brushmark will remain in the paint, catching the light and so making the surface more vibrant. In the early stages of a painting this is not particularly encouraged as these marks will be covered with later layers, and the paint is usually diluted so that the brushmark is not retained. In the later stages this aspect of the painting becomes important.

In these first demonstrations, we suggest ways of applying areas of flat paint to achieve different effects.

- 1 Here the brush is loaded with pure, bright cerulean blue from the palette. Enough is taken to work on at one time without swamping the brush. The first dab is worked into the weave of the canvas, ekeing it out as far as it will go. Then another brushload is worked over the top, leaving a rich surface of brushmarks.
- 2 Sometimes a flat, washlike surface is required. Unlike other paints, however, with oils the paint remains fresh and workable so a flat surface can be more easily achieved. If you are covering a large area, mix up enough paint to cover it. The scenery painter's brush used here has soft long hairs which help to spread out the paint and leave a smooth surface. The result, as intended, is flat, opaque and consistent in colour.
- 3 Using the same brush and consistency of paint, a flat layer of chrome yellow is applied. Then the surface is worked with the brush from every direction to leave an interesting meshwork of strokes.

TECHNIQUES

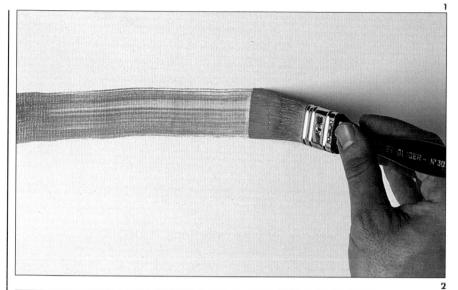

Brush control

Brushmarks are affected by the individual brushes and the way they are handled. The angle of the brush and the pressure exerted on it is important and also the consistency of the paint. For general painting hold the brush like a pen but away from the bristles, consciously relaxing your hand. Λ stiffly held brush produces contrived marks.

- 1 First try dragging the brush along in a straight line. By altering the pressure, the line can be varied. The dilution of the pigment will affect the result too. Make sure that the brush is held in a relaxed grip or the brushmark will appear laboured.
- 2 A more precise line can be painted with the help of a ruler or straightedge. Hold the ruler up off the surface at an angle so that the metal ferrule of the brush can run along the edge to guide the brush.
- 3 Here, with a ¼ in (6 mm) flat brush the artist paints a line, not by dragging the bristles along but by touching down with the tip lifting off and touching down again alongside
- 4 Using the same method an arc is described. For more precise work the brush is held closer to the bristles on the metal ferrule.

Misty Mountains

BASIC TECHNIQUES

This first, simple project gives you an opportunity to put into practice the mixing and brushwork skills suggested in the previous pages. It also demonstrates how easily a feeling of distance can be introduced into your painting. What we are painting is the effect of the atmosphere on colour when viewed from a distance. The effect of seeing the far-off range of mountains through this misty pink morning light is to bleed them of colour. This is known as aerial or atmospheric perspective. By gradually adding more white to the mixture as each succeeding range is painted (although this was not the only addition), the mountains appear to recede into the picture.

The colour mixing involved in this project poses an interesting task. The painting appears at first glance to be monochrome – that is, without colour, in tonal mixes of black and white. But the wonderful ethereal attraction of this scene is created by the colouring of these greys, making them coloured neutrals.

The artist chose to start at the bottom of the painting in the foreground and work up the canvas board to the background because it was easier to cut the lighter paint round the outline of the darker band. This means that you will need to keep your hand clear of the wet paint of the previous band.

1 The source for this painting is an atmospheric photograph of mountains in China. The artist does not in any way copy this slavishly; in the final result the colours are simplified and the shapes more regular. The photographic image simply sparks off his imagination.

Materials: canvas board 20 in x 15 in (50 cm x 37.5 cm); brushes $- \frac{1}{4}$ in (6 mm) and $\frac{1}{2}$ in (12 mm) nylon flat; white formica-veneered board palette; graphite pencil; two jars of white spirit; rags.

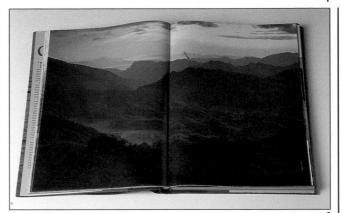

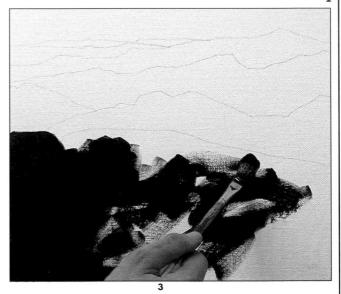

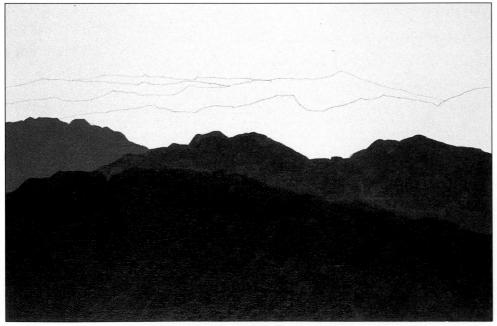

- 2 To act as a rough guide, the artist has already mapped out the ridges of the mountain ranges with a graphite pencil. Now he starts on the foreground, using a mix of Payne's grey, with a touch of sap green and cadmium red and a little white to give it opacity. The paint is diluted with white spirit to ease mixing but applied thickly to the canvas. Here it is almost scrubbed into the weave of the canvas, painting it out more delicately with a recharged brush over the top.
- 3 With the foreground painted in, it is time to stand back and appraise the situation. Note how the artist has purposefully kept the paintwork lively, preventing it from appearing too flat.

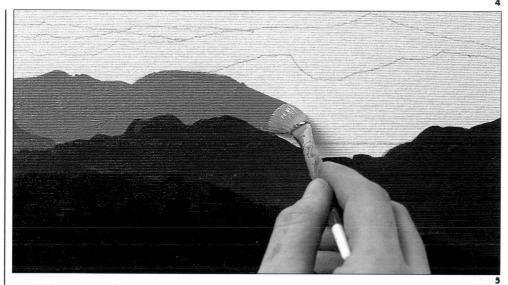

Now the receding mountain ridges are added. These ranges are mixed by adding progressively more white and modifying it with touches of sap green, cobalt blue and cadmium red. Here you can see how the soft nylon brush is carefully controlled along the undulating ridge. The brush needs to be well charged with paint, but too much will drip down on to the darker band below. Just wipe it off with a cloth if this happens, clean off the brush and patch it up. If you need confidence you might like to practise such brush control on a piece of paper first.

Take care to keep your hand well away from the picture surface as you are working over wet paint.

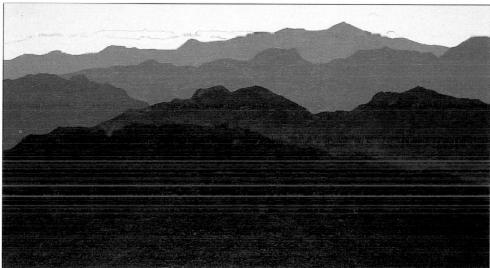

5 At the half-way stage, there is already a strong sense of recession in the picture. The artist makes no attempt to blend the paint between the bands. It is carefully laid on the canvas, joining with the darker band below but not merging with it.

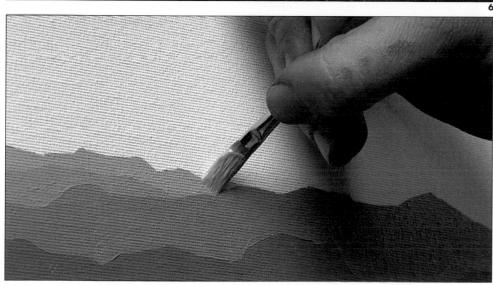

6 The artist uses various ways to apply the paint to the canvas. Here the brush is cutting in from above, using the corner tip of the flat brush to follow the ridge line. The bands have become narrower, so the smaller ¼ in (6 mm) flat brush is used. The artist is concentrating on this delicate work and for more precise control the fingers are gripping the brush nearer the bristles.

BASIC TECHNIQUES/MISTY MOUNTAINS

7 In a more relaxed manner, the paint is applied along the final ridge. Note the build up of paint along the ridges, particularly in the earlier bands where the paint is thicker. These ridges catch the light and thereby help to define the shapes of the composition.

8 The artist's palette is now beginning to look suitably messy. The different colour bands, it can be seen, grew from one another with only touches of tube colour added to modify the base mix. The sky blend is mixed by adding a touch of lemon yellow (perhaps

suggested by the original photograph).

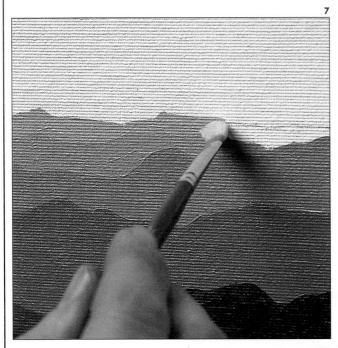

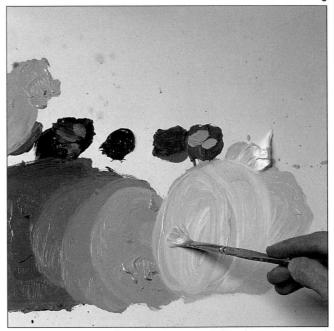

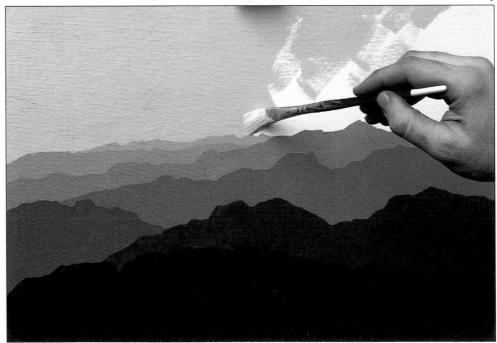

9 The sky is applied thickly using the larger ½ in (12 mm) brush again, working the paint from every side to cover the canvas weave well but keeping the surface from looking flat.

10 The finished painting has a certain luminosity which is a result of the subtle use of colour. These coloured neutrals are complementary too – greener in the foreground, redder in the background. The brushwork in this painting is not complicated but even so the receding planes of hills are not painted in flat colour – the surface is kept lively by applying the paint in dabs and working it from different directions. But towards

the background the paint is more dilute and the paint applied more smoothly. This formula – thick paint and lively brushwork in the foreground progressing to thinner, smoother paint in the background – helps to create a feeling of distance. You may have found this exercise harder than it at first appeared. But having mastered the techniques demonstrated in this project, you will be ready to build on this knowledge.

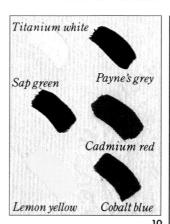

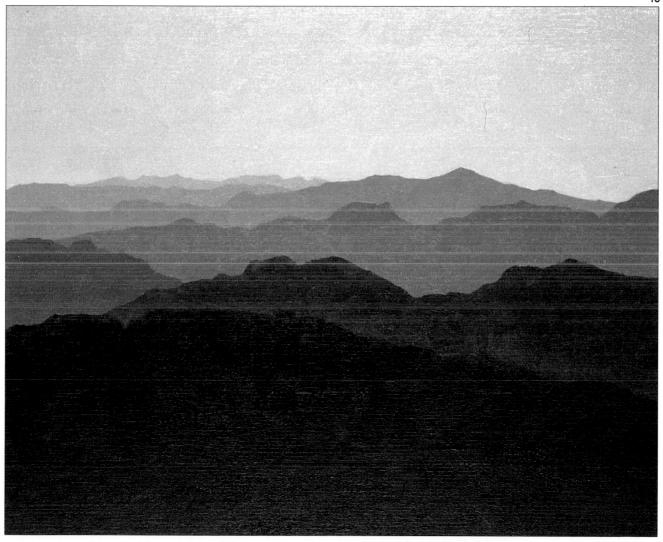

Yellow Tulips

BASIC TECHNIQUES

This vase of spring-like yellow tulips makes an inviting display for the aspiring artist. Flower painting is an art in itself – the colours must be kept fresh and pure and the forms distilled down to basic shapes. But tulips are a good choice to start with – their simple and graceful petal and leaf shapes inspire confidence and invite artists of all capabilities to try and capture their graphic simplicity.

The artist has placed a strong artificial light overhead, trying to give an impression of bright sunlight. This casts interesting shadows on the white background which become an important part of the composition. This bright light also has the effect of bleaching out the subtle mid-tones, reducing the tonal areas to light and dark with not many tones in between. Although this may not appear to some to be so interesting, it makes a dramatic composition and it is certainly, at this stage, more simple.

The arrangement of the tulips and the way the artist chooses to represent them on the canvas demonstrate how we should not be slaves to rules. He decides to place the vase of flowers symmetrically in the centre of the canvas, thereby spurning traditional advice. He even measures out a central axis to guide him (primarily in the drawing of the vase). But there is plenty of asymmetry, coming principally from the tulips themselves which are left in a natural state of disarray and also from the shadows cast on the background. The artist also shuns what would seem the obvious portrait (vertical) shape for this composition, sensing that the area of empty white enhances the appearance of the flowers. In this painting, first the main shapes are roughly blocked in using mid-tone, much diluted, colours and then the forms are built up in several layers. But the artist keeps the brushwork loose, resisting the temptation to get bogged down in too much detail.

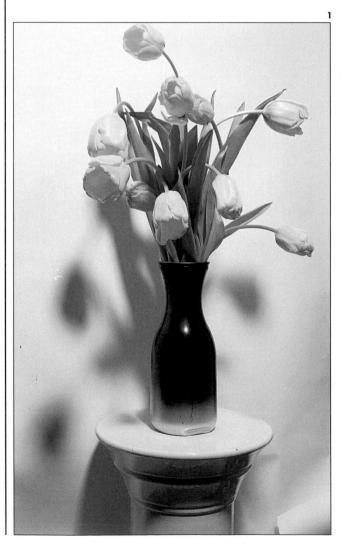

1 The yellow tulips were purposefully left unarranged to break away from the natural symmetry of the composition. The shadows cast on the white background emphasize this asymmetry and add a further dimension to the composition by locating the position of the tulips in the picture. Otherwise the tulips would appear to be suspended in space.

Materials: Coarse canvas prepared with acrylic primer 20 in x 25 in (50 cm x 62.5 cm); brushes – No.5 round and flat, No.2 round; graphite pencil; soft eraser; square wooden palette; metal clip-on dippers; turpentine; jar of white spirit to clean brushes in; cloth.

- 2 The paints have been squeezed out in an arc ready for the artist to mix the mid-tone yellow for the tulips cadmium and lemon yellows and white, diluted well with turpentine.
- 3 The artist has mapped out roughly the main shapes in the composition. The ellipse, formed by the circular top of the plinth seen in perspective, could be a problem. It was arrived at by drawing loosely round and round in an ellipse shape until the correct ellipse was found.

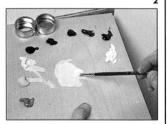

The artist then removed all but the correct outline with a soft eraser.

Now the tulips are blocked in with the dilute paint using a No.5 round brush. The graphite slightly muddies the yellow paint but as this is just an underpainting it does not matter.

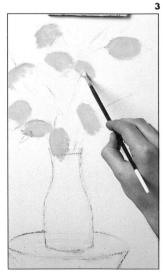

- 4 To block in the leaves, the same sized flat brush is used with a much diluted mixture of sap green, lemon yellow and a touch of white. As can be seen, at this stage the paint is applied quickly and roughly, simply to confirm the shapes and colours of the composition.
- 5 Already at this stage the artist can get an idea as to how the composition is going. He has placed his easel so that he can

see the tulips without having to crane his neck or peep out from behind the canvas. The same overhead light provides good lighting on the canvas, not reflecting off the paint nor casting unhappy shadows. This artist likes to sit down to paint. His chair can be raised or lowered to suit his point of view. He uses his overalls to dry his brushes on, leaving his non-painting hand free to hold the palette.

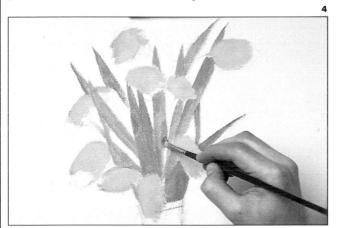

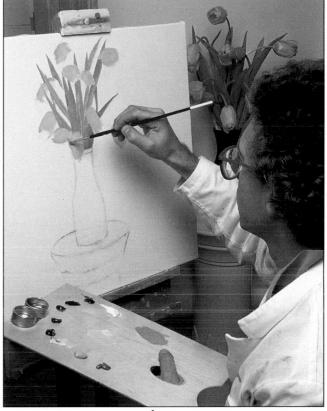

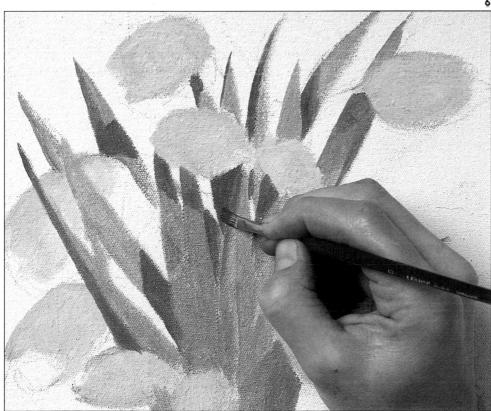

6 Now the artist adds the darker tones to the painting, starting with the leaves, by adding the merest touch of Prussian blue, which has strong tinting power, to the green mix. He is using the real tulips as a point of reference but not to copy exactly. The first layer of underpainting was so dilute, it is almost touch dry. Still the paint is diluted with turpentine.

BASIC TECHNIQUES/YELLOW TULIPS

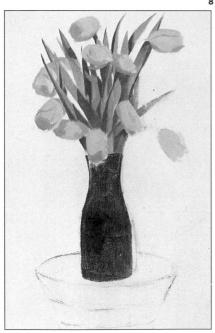

7 The same darker tones are added to the tulips – the original mixture plus yellow ochre and cadmium yellow. The artist looks carefully to locate these areas of colour and tone and applies them boldly. The aim is to keep the brushwork loose. It is possible here to see the heavy weave of the canvas. Such a weave ensures that the early brushstrokes are bold and the paint dilute, otherwise it is hard to get the paint into the weave and you end up wanting to scrub it in. After a few layers of oil paint, finer details are possible on the built-up smoother surface.

8 Standing back to look at the painting, at this point the subject does appear isolated in the centre of the canvas. But there is much more to come. Even with only two tones of colour the flowers are beginning to develop some three-dimensional form. The vase has now been blocked in with a very dilute combination of Payne's grey and a touch of Prussian blue. Note how the artist paints the vase well within the drawing guidelines, closer to the actual object.

9 The artist now chooses to bring on the vase and the base. First, a layer of stronger Payne's grey and Prussian blue is applied into the wet underpaint of the vase. Then, a much desaturated mixture is worked into this for the white base of the vase. The plinth is painted with various combinations of the vase mixture added to white with a touch of lemon yellow.

- 10 Here the highlight is being added white broken with a touch of the vase colour. The paint is undiluted and must be applied with one sure stroke as the vase paint is still wet. If you dab the paint on it will blend with the darker paint and lose its strength.
- 11 Further highlights are added to the rim of the pedestal and to the bottom of the vase with a small No 2 round bristle brush. This highlight paint is applied undiluted so that it forms a slight impasto ridge which catches the eye.

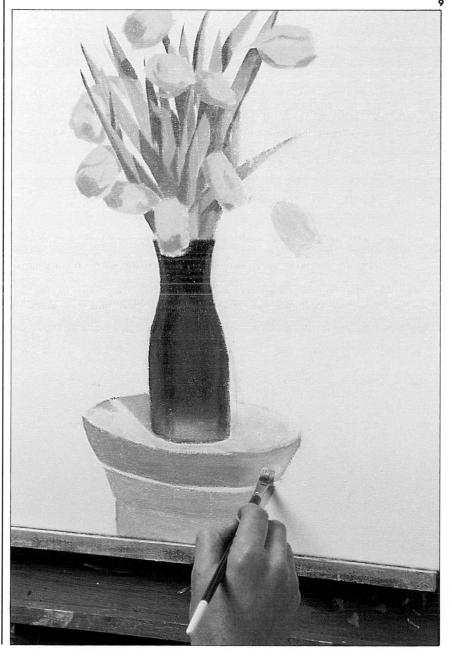

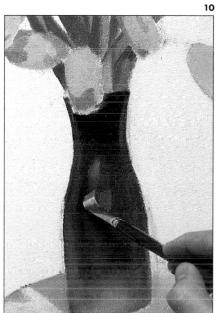

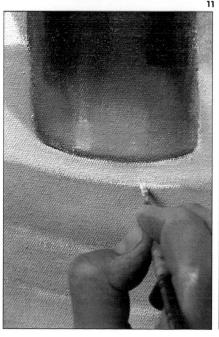

BASIC TECHNIQUES/YELLOW TULIPS

- 12 The next task is to add the shadows of the tulips and the pedestal against the background. Diluted Payne's grey and cobalt blue added to white is painted on with a bristle brush. Avoid overworking this, aiming to achieve indistinct outlines. The edges of the shadows are further blurred with an all-purpose cloth wrapped round the finger.
- 13 A glance at the palette at this stage will show you how the colours have been mixed. For example, in the centre of the palette, highlight leaf green has been made by adding the shadow green to the highlight tulip yellow.

14 Lighter green tones are added to the leaves so that little of the original underpainting shows. A brighter yellow – a mixture of cadmium and lemon yellows – is added to the tulips to enliven their colouring. And now, finally, the flower stalks are added in a single confident stroke with a well-charged No.2 round brush.

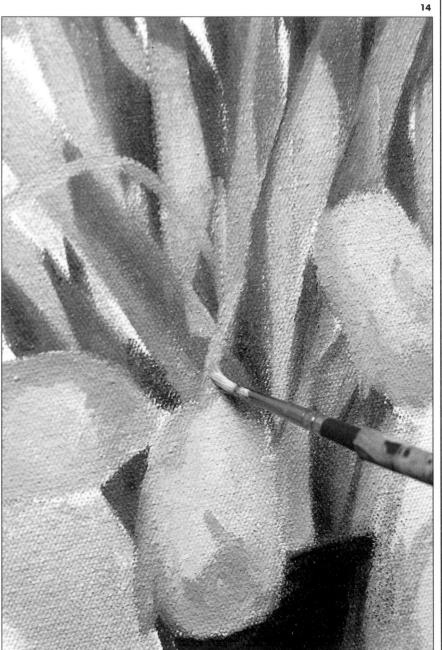

15 The artist adds the finishing touches to his painting, checking it against the still life arrangement alongside. Note how he holds the brush at the end, allowing him to paint while 'standing back'.

16 The final painting has certainly captured the freshness and natural beauty of the tulips. Part of the vibrancy of the painting is due to the high contrast produced by the bright lighting of the subject matter discussed earlier. It can be seen now that this produces a somewhat stark image. But this suits these waxy flowers - soft roses would not benefit so much from such treatment. Note how the artist has emphasized the twining stalks of the tulips, undermining the stark severity of the vertical leaves and the vase.

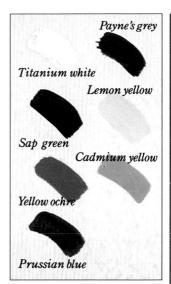

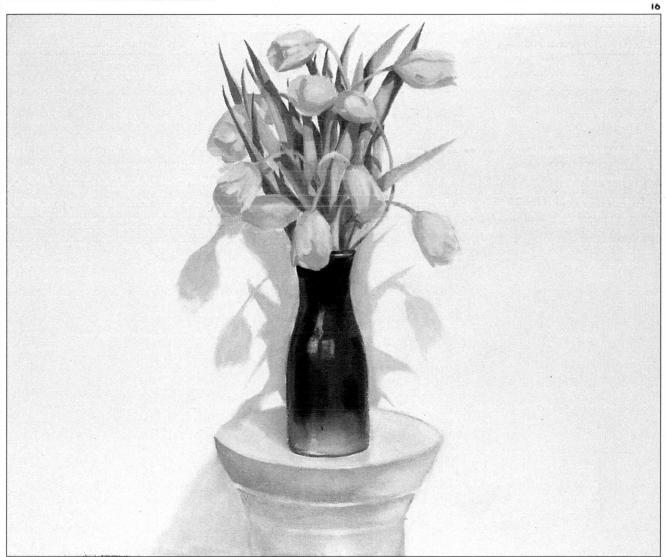

Peppers and lemons

BASIC TECHNIQUES

The artist picked these peppers and lemons for their simple shapes and primary colours. Then, by placing them on a red cloth and cutting this with another of primary blue, he arrived at a dramatic composition. This arrangement was in no way hurried. The artist tried out various combinations until the demands of his 'eye' were satisfied. But he continued to adjust the objects even after he had started drawing.

Even though the composition was arrived at in this pragmatic manner, it nevertheless satisfies some of the traditions of still-life arrangement – rules that can be learnt but which are also natural to us; rules which once assimilated are made to be defied.

The group of peppers are linked to each other by the fact that they overlap. The yellow pepper behind the other two has been set on end to give it some height (and the artist slightly exaggerates this in his drawing to make the point). The lemons are isolated in another group which is cleverly linked to the peppers by the dramatic angled line down the length of the composition where the two coloured cloths meet. Both the red pepper and the left-hand lemon cut this line and thus visually the eye passes from one group to the other. An arrow pointing from one group to the other could hardly do the job better.

The drawing is beautifully executed by the artist. But you might like to transfer the image to your painting surface in another way. There are suggestions on page 19. For example, you might like to take a polaroid photograph of the

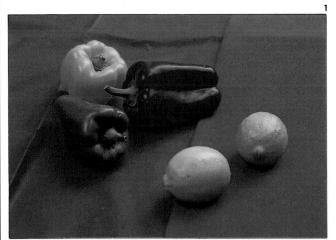

1 The objects for this still life were chosen for their simple shapes and primary colours, with the aim of practising colour mixing. The arrangement of the peppers and the lemons took some time to perfect. The artist tried several variations before reaching this successful configuration. For a more simple exercise, the two lemons in the bottom corner might be singled out and painted on their own.

Materials: self-stretched fine canvas 20 in x 24 in (50 cm x 60 cm), primed with acrylic primer; brushes – No.5 flat bristle, ½ in (6 mm) flat nylon, 1½ in (38 cm) flat soft bristle; white formica-veneered board palette; graphite pencils; soft eraser; white spirit in two jam jars; cloth.

arrangement and square it up to transfer the image to the canvas, as shown in the project on page 148.

The artist has tackled the subject in a bold manner, isolating the planes of colour and tone and applying them with assurance. This involves close scrutiny of your selected objects. You will probably observe details you have not consciously noticed before – such as the coloured reflections on the skins of the peppers here. Tom Phillips, the British painter, recently aptly described this voyage of discovery. 'In painting, say a still life from nature,' he relates, 'there is a moment when one suddenly becomes a tiny figure wandering among the huge apples, climbing up cliff-faces of drapery; the items on the table become an explorable world.'

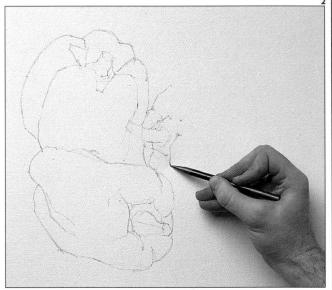

2 The first task is to draw the outline of the still life. This will confirm the composition for the artist and, of course, act as a guide for the first layers of paint. For this, the artist uses a soft graphite pencil which is not as messy as charcoal, nor as hard as even a soft pencil. Even so it is sometimes hard to draw on

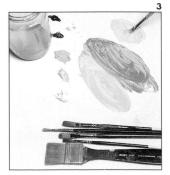

3 Using a No.5 flat bristle brush, the first paint is mixed for the yellow pepper – various shades of cadmium red and yellow, with a little cobalt blue added later for shadows. The paint is kept pure and of the same consistency throughout – that is, diluted with enough white spirit to make the paint manageable but no more.

4 Throughout this painting the brushwork is kept bold with as little blending as possible. The planes of colour are laid side by side — occasionally overlapping or almost covering a previous patch. Locate an area of colour, mix the paint to match it and then carefully apply it. Having completed an area, stand back and assess your progress, modifying any distortions.

As a rule this artist works in

the mid-tones from dark to light and then adds highlights and shadows. Here, the neighbouring red pepper and the background cloth cause red reflections on the yellow pepper. These are located and slightly exaggerated by the artist.

Before cleaning out the brush see if you can use up the paint anywhere else in the composition. This will help to unify the painting.

- 5 Now for the lemons a mix of lemon yellow with a touch of cadmium. The strokes are applied at different angles depending on the shape required. This means the light catches the brushstrokes and adds to the interest.
- 6 The shadows are added with a red shadow from the cloth on the left and a blue shadow from the cloth below.
- 7 Now stand back and appraise the work and modify anything which looks awkward. You will notice that some of the lemon yellow has been used for the lighter tones on the yellow pepper and the green lemon shadow becomes the lighter tone of the green pepper.

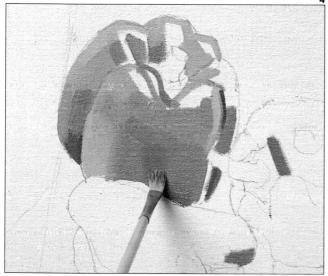

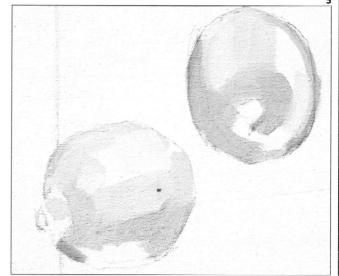

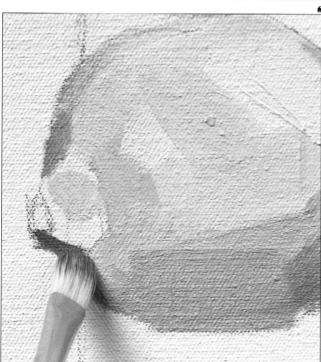

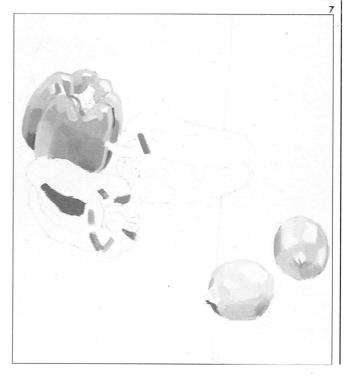

BASIC TECHNIQUES/PEPPERS AND LEMONS

- 8 Working from dark, the red pepper is built up in the same way. A mixture of cadmium red and alizarin crimson was too strong so the yellow pepper mix is added to deaden the hue. The bold yellow highlight added earlier has been modified by the darker paint but it is still visible and plays a part.
- 9 The contours of the green pepper are boldly mapped out with a flat brush. Some more cobalt blue is added to the pale lemon mix for the darker mid-tones of the green pepper, with a little of the red mix for the shadow. Instead of returning to the tube colours to modify the colours, the artist uses the paints already mixed. The bright tones of the red pepper are pure cadmium red and the shadows
- mixed with a touch of ultramarine blue.
- 10 Standing back, the artist now feels a need to place the peppers and lemons more in context. The folds of the red cloth are therefore sketched in and patches of shadow added to put the objects in relief. The stalks of the peppers have been built up too. But still the artist resists too much detail and keeps the colours clear and direct.

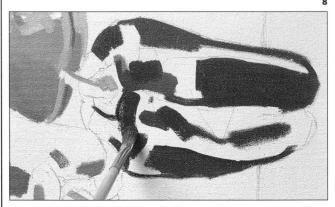

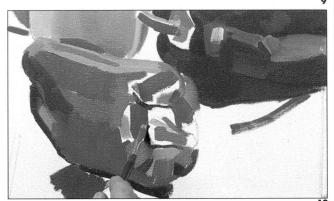

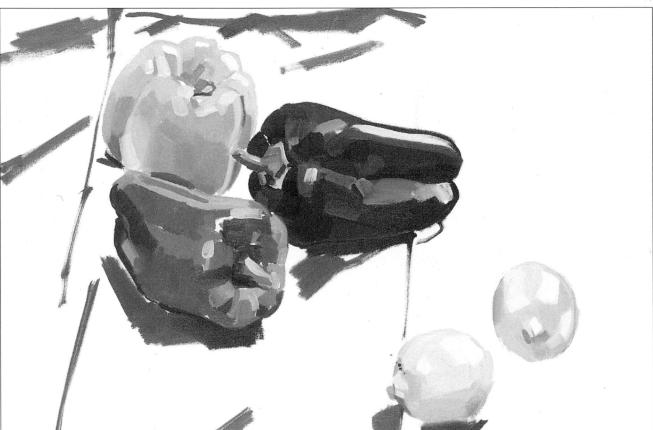

11 At this stage the palette looks like this, showing how the subtle shades of colour developed from one another. You can see too how the different colour blocks – yellow, red and green – merge into each other creating a unity of colour.

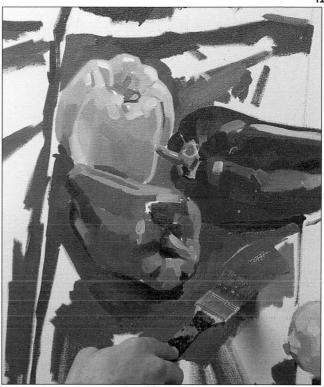

12 After adding the shadows, the artist filled in the lighter areas of the table-cloth. Now, with a large 1 1/2 in (38 cm) soft bristle brush he paints in the mid-tone. Be sure that you mix enough paint and apply it in the same way as the rest of the painting — in bold strokes, working it into and around the shadows and highlights. The large strokes made with this decorator's brush help to distinguish the background from the foreground and fix the objects in the picture space. Here the paint is almost pure cadmium broken with a little white.

13 The cadmium is found to overpower the painting so it is toned down by working in another layer of the same with a little white and a touch of ultramarine. Lighter highlights are worked down the folds.

BASIC TECHNIQUES/PEPPERS AND LEMONS

14 The blue table-cloth is treated in the same way as the red cloth on the previous page. First the shadows are applied with a smaller brush – cobalt and ultramarine blue and white with a touch of ivory black to deaden the colour. The brushstroke cuts clearly round the outline, painting over any stray marks.

15 Again the flat area is completed with the larger brush. Some more white is added to the blue shadow mixture. It is important that it is the same tone as the red to keep it in the same plane. The contours of the lemons and peppers are emphasized by taking the brush round their outlines.

16 Finally, highlights are added to the peppers to give them a truly shiny appearance. Pure white is used but it is brushed into the still-wet paint beneath, so that it does not appear too bright in contrast with the shadows. The artist is still using the same No 5 flat brush which does not permit any fine detailing.

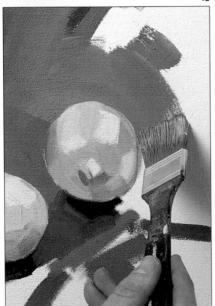

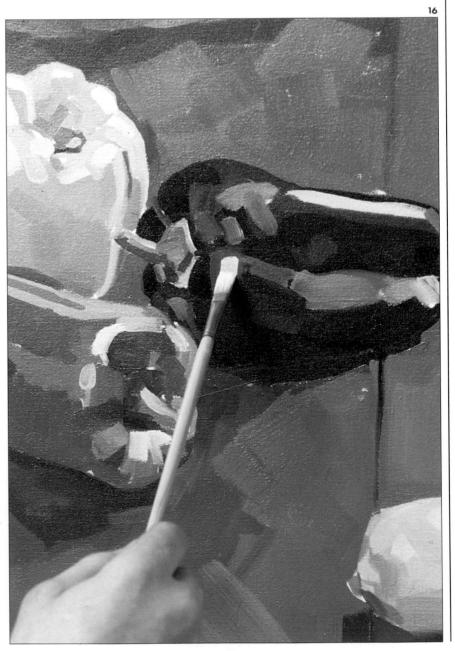

17 The finished painting is bold and colourful. The primary colours of the cloths have been reduced in tone so that they do not overpower the objects. Consequently, the peppers and lemons stand out well. Note, too, the different treatments of the textures – the shiny peppers with their bright highlights and dark shadows compared with the less reflective lemons and the soft

linen cloths where the variation in tone is much less extreme.

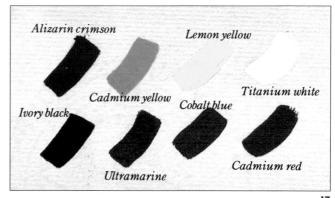

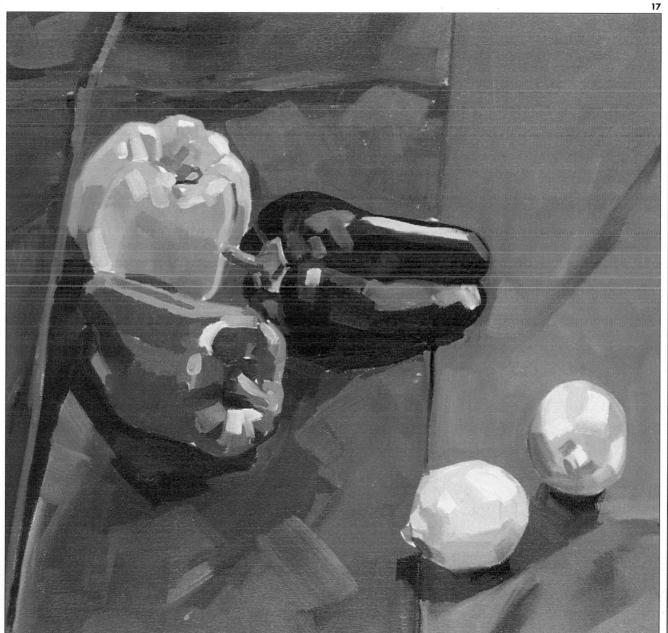

Chapter 5

Light and Shade

Light for the artist is an elusive element. In fact an artist who has a talent for depicting light achieves a timeless quality in his work. It is for this reason that Turner's work has remained in the public eye ever since it was first painted. His ability to capture the atmospheric effects of light, often combined with water, is guaranteed to delight anyone who sees his paintings in the original.

Depicting light, however, is a case of depicting light and shade. This may seem like an obvious statement, but sometimes the obvious is overlooked. A patch of bright sunlight will only appear bright if shown up by a patch of shadow that is tonally as dark. But light is fickle and matters are not quite so simple. Most of us find it difficult to visualize colours as tones. It is a good idea to study black and white photographs to get an idea of the distribution of light and shade over familiar objects. Tonal drawings in charcoal or pencil are good practice too. Otherwise, establish the tonal make-up of your composition with a monochrome underpainting, as demonstrated on pages 70-3. Then the paint overlaid can be matched tonally.

The type of light (natural or artificial, bright or dull, clear or misty and so on) and its position (from above or low down)

affects every aspect of your painting — the tonal value, colouring, mood, composition. The Impressionists recorded the changing effects on a scene of the passing hours of daylight and changes in weather. Claude Monet's numerous paintings of Waterloo Bridge produced in the early 1900s have titles such as Waterloo Bridge, misty morning 1901; Waterloo Bridge sun in fog 1903; Waterloo Bridge, grey weather 1903; Waterloo Bridge, effect of sunlight with smoke 1903; and there are many more. Each study presents the subject afresh. Sometimes the subject itself, the bridge, all but disappears in a swirl of fog.

Some artists delight in the effects of light on what they see around them. Their art thrives on the gentle gradations of tone produced by, say, soft evening sunlight. Equally, the dramatic extremes of light and shade produced by bright light can provide inviting contrasts. They seek to represent the three-dimensionality of an object. For them shadows and highlights, and the vast range of tones between these two extremes, are what painting is about. Others are more interested in other aspects of art — pattern, colour, mood. More often than not, however, all these aspects of art are brought together in a painting.

Techniques

BLENDING TECHNIQUES

Blending is the mixing together of two colours or tones so that they merge one into the other to form a third. There are many ways of doing this as the techniques on the following pages will demonstrate. The nature of oil paint means, however, that the degree to which two colours are blended can be carefully controlled. If required, the paint can be applied precisely without any merging of the two colours at all.

On the other hand, working wet in wet by brushing one colour or tone into an underlying wet layer causes a spontaneous blending of colours. This technique produces a freshness in the painting, more often associated with *alla prima* painting. The two colours retain their own identity; they do not blend together completely, but qualify each other. In such a case the eye completes the blending for you.

Some artists, however, strive to produce softly blended gradations of tone for which oil paint is uniquely suited. It remains workable for a number of hours, sometimes days, so subtle variations in tone can be laid side by side and then gently blended with a fan brush or soft bristle brush. Rubens (1577-1640), in the flesh tones of his buxom nudes, shows how this should be done.

Blending

Colours can be laid down next to each other so that they retain their individuality, or the edges where they meet can be blended together so that a soft gradation of colour or tone leads you from one into the next.

- 1 In this exercise, the artist starts by laying down strips of colour, starting with chrome yellow and adding to it, little by little, cerulean blue until a strip of the pure blue is reached.
- 2 Taking a soft bristle fan brush, the oil paint is gently worked strip into strip, back and forth, stroking it from side to side, sometimes in a figure of eight pattern.

3 Such blending forms a gentle gradation of colour ranging from yellow to blue. Fan brushes are not commonly used but for a smooth gradation of tone they are unbeatable.

TECHNIQUES

- 4 A similar effect is achieved by laying down the same strips as in example 1 but blending them into each other as the paint is applied. A soft nylon brush is used which will leave a smooth finish.
- 5 The result is similar to that produced with the fan brush, if not quite so smooth. But this is the more common way of blending in the course of painting as it can be done with the brush in hand.
- 6 Artists have traditionally used their fingers where they achieve the right effect. Here the forefinger is found useful for blending, producing a very flat surface. Rub backwards and forwards with the flat of the finger until the colours have blended evenly across the centre.
- 7 The blending is not so smooth, but the effect is interesting. Finger blending is resorted to by all artists sometimes just to deaden a bright highlight or soften a sharp edge.

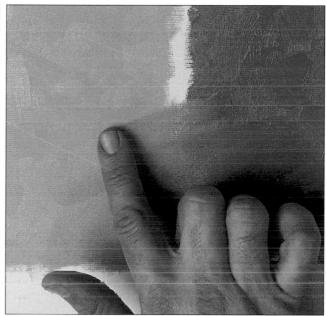

WET IN WET

Wet in wet

Spontaneous blending occurs when paint is applied on top of another layer of wet paint. But the original colours retain their own identity, giving the resulting hue a depth and freshness.

- 1 A layer of chrome yellow is worked into with bold brushstrokes of cadmium red. The
- stroke is made with some pressure, making the bristles splay out and so merging the two colours.
- 2 In the midst of this burning orange, streaks of the original two colours can be seen. The freshness of *alla prima* painting, which is completed in one sitting, derives partly from this technique.
- 3 Now dabs of alizarin crimson are added in the same way adding a further dimension to the burning orange
- 4 The result is a rich, lively area of colour which appears to glow. Even with two colours superimposed the original yellow layer shines through in places, giving a three-dimensional depth to the colour.

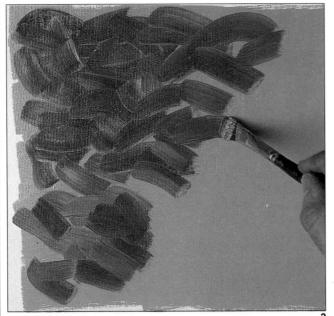

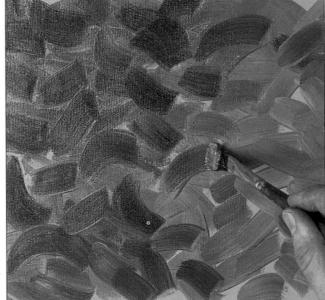

TECHNIQUES

Optical blending

Patches, dabs or spots of pure colour laid side by side on the canvas will be blended optically when viewed from a distance.

- 1 Using the same colours as the wet-in-wet demonstration, and still applying one wet brushstroke into another, quite another effect is achieved. First the 'layer' of yellow is applied in a bold irregular pattern.
- 2 Adding the cadmium red, the paint is applied briskly with assurance, yet with little pressure so the pigments do not blend together too much on the canvas. The paint is drier and so covers the paint beneath more efficiently.
- 3 The addition of a series of darker alizarin red dabs creates a richer optical blend of colours.
- 4 From a distance, or viewed with the eyes half-closed, the colours will blend to form a flat area of burning orange similar to that on the opposite page.

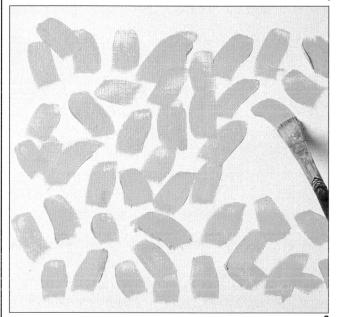

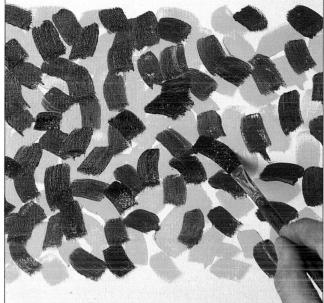

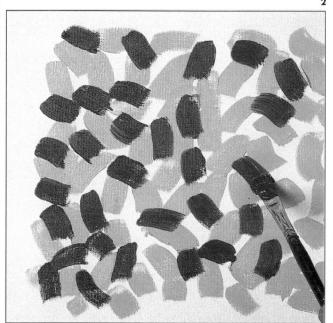

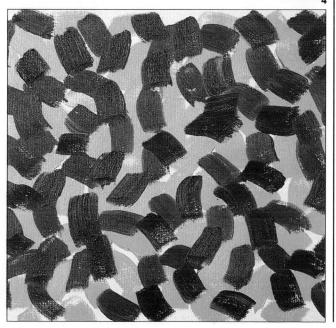

Kettle

LIGHT AND SHADE

The old masters would invariably start painting by laying down a monochrome underpainting in dilute washes of burnt umber — a fast-drying earth colour suitable for the job. This underpainting acted as a guide to the tonal values of the painting, mapping out the areas of dark and light and thereby helping in the mixing of colours as the painting proceeded.

Such tonal exploration can also be made in a charcoal or pencil sketch. In fact, it is a useful exercise to carry out a tonal drawing before embarking on the painting itself. A photograph of your subject – particularly in black and white – will help you and certainly a Polaroid camera which will produce the photograph on the spot is useful in this respect. A photograph tends to reduce the gradations of tone and takes no account of changing light, so the situation is simplified for you. Some artists find this simplification debasing and therefore spurn the photograph as a useful aid.

In this project, the tonal exploration of the copper kettle is made in a monochrome underpainting. Then, the black and white representation is glazed over with a dilute wash of paint to transform it into a copper kettle. But the artist is not satisfied with such magic and demonstrates how to add life to the painted subject.

The artist could have followed the masters in choosing an earth colour for his underpainting, leaving the canvas bare for the areas of highlight. But he decides to spend a little time working up a three-dimensional monochrome image of the kettle. The reflective nature of the copper, as well as the beaten surface and the many dents collected over the years, combine to make a testing exercise.

1 This splendid round-bellied copper kettle has an interesting beaten surface which is best observed in the highlights. In addition, the bright shiny copper bears the scars of many knocks it has received during its long life. Not only is the light

reflected in its belly but other objects in the room, forming unexplained areas of dark and light.

- 2 The outline of the kettle has been sketched in with a graphite pencil. Canvas board is hard and almost slippery both to draw and paint on. But it is cheap and freely available and so provides an acceptable alternative to canvas.
- 3 Mixing up a dilution of Payne's grey and titanium white, the mid-tones of the kettle are located and painted in with a

No.8 nylon flat brush. This is not a laborious process but completed roughly and quickly.

Feeling his way, the artist adds white highlights to the mid-tones, dabbing them on to imitate the beaten surface with a smaller No.2 brush. Note that the paint is still very dilute. The gradations of tone, describing the dents, are blended together at the edges.

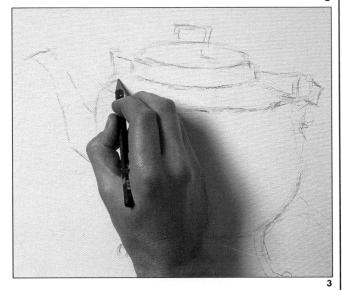

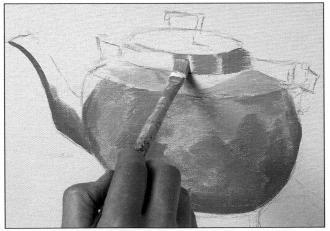

Materials: Canvas board 20 in x 15 in (50cm x 37.5 cm); graphite pencil; soft eraser; brushes – Nos.2, 5, 8, 14, flat nylon, No.2 round sable; tin foil palette; white spirit; all-purpose cloth.

4 In order to bring out the contrasts, the dark shadows are added. These will counterbalance the highlights also seen here, which have been dabbed on with a smaller No.2 brush to imitate the beaten surface.

5 The artist adds the shadow cast be the kettle on the backcloth with a broader No.8 flat brush. This helps to fix the kettle in space and creates an interesting background pattern with the folds in the backcloth.

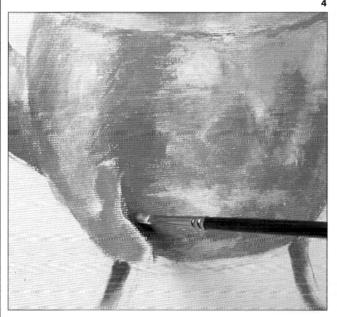

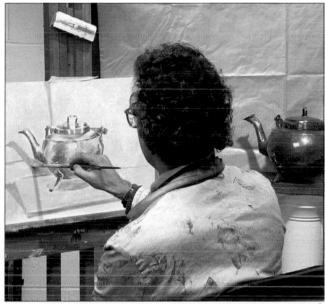

6 To complete the underpainting, details of the wooden board on which the kettle stands and the background cloth are broadly blocked in. The dilute wash of grey over the background puts the kettle in context tonally. At this stage, the painting is left to dry before further layers of paint are applied.

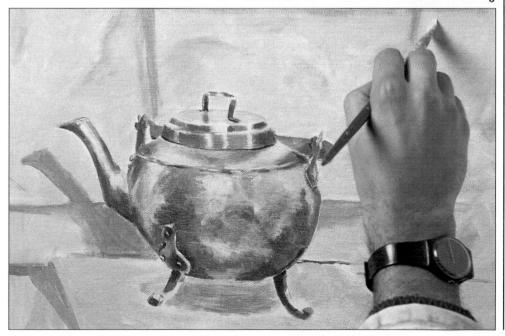

LIGHT AND SHADE/KETTLE

- 7 Now for the magic. The kettle is glazed with a mixture of burnt and raw sienna and chrome yellow well diluted. For this larger area a No.14 flat brush is used. Glazes in the final stages of a painting are usually diluted with a high percentage of linseed oil, which gives a rich gloss to the painting.
- 8 The wooden board is given the same treatment and the painting starts coming to life. But note how the kettle appears dull. It has lost its highlights and yet retained the dark shadows, making the tone uneven. Also it takes no account of the reds and golds and other colours visible in the copper.
- 9 The backcloth is glazed with diluted cobalt blue. While cutting in with the brush around the lid of the kettle, an undiluted particle of paint causes a bold splash on the board. It just needs redistributing with the brush. Oil paint is easily lifted off with a clean brush or cloth if it is not given time to stain the canvas.
- 10 To bring back the reflective quality of the copper the highlights are replaced. The white paint is applied wet in wet allowing the copper glaze to temper the brightness. Again, the paint is dabbed on to imitate the beaten surface of the kettle.

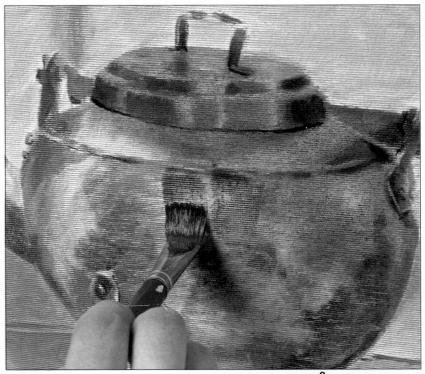

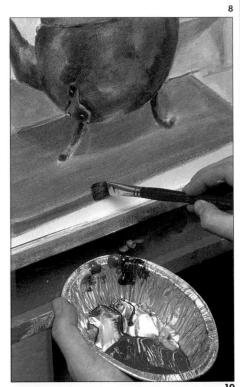

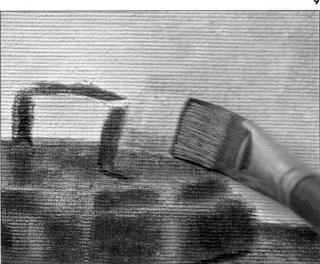

and what might have seemed a daunting prospect has been carried out with the minimum of fuss. Different subjects require equally different approaches. It is only with experience that the correct course can be visualized from the start. Even experienced artists find their best-laid plans undone by unexpected circumstances. All that is required is a flexible mind that enjoys the challenge of such unforeseen developments.

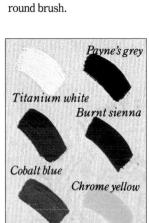

Raw sienna

11 The artist has been

working on the kettle, building

kettle is added with a small No.2

up the areas of colour. The highlight on the spout of the

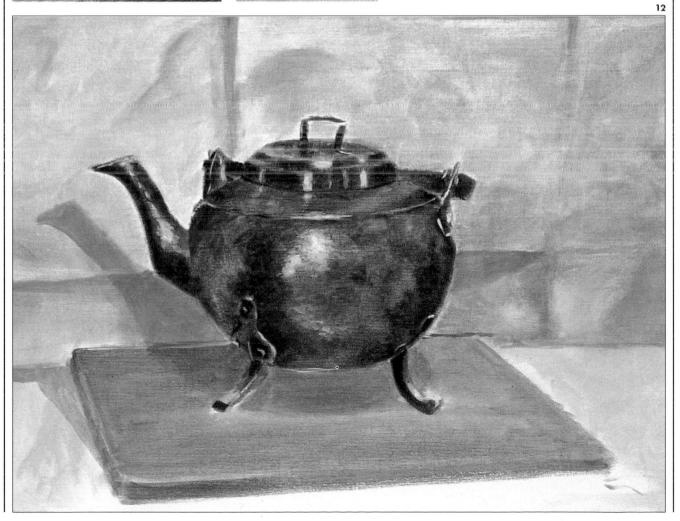

Hat and Denim Jacket

LIGHT AND SHADE

An artist has at his disposal various means of describing an object. First, the outline is important and will give the observer a good idea of the shape of the object. If it is a well-known shape – the jacket and hat demonstrated here, for example – the mind will instinctively fill in the details, suggesting texture and colour, even if it is a simple line drawing.

Second, information about the scale of the object and its function is supplied by the context in which the object is presented. So we could have learnt more about the coat and hat if they had been represented hanging on a hat stand, maybe next to a bag full of beach toys. These other objects would have confirmed the scale and introduced the idea that what we are looking at is summer gear.

Third, by observing the fall of light on the object and mapping out the areas of light and shade, the artist can give more precise information about the form of the object, its three-dimensional shape and texture, and also its position in the picture space. So, by observing gradations of tone from dark shadow to bright highlights, we find out that the hat is soft, cotton perhaps. And the jacket? The blue gives it away as denim, but we can see it is made of a thick, smooth material. It is the addition of the final shadow that fixes the coat and hat in space and shows us that they are hanging flat against a wall.

The artist of this exercise simplifies the tonal range of the coat and hat, so that there are not so many gradations of tone between light and shade. The eye fills in the missing steps and sees the painted copy as identical to the original. Only, close examination shows that this is not the case.

1 Once the coat and hat were arranged to the satisfaction of the artist, the light overhead was altered to cast the required shadows on the wall. To get the proportions right, the artist plotted the main points of the still life on the surface of the board with a graphite pencil, joining them when satisfied. The areas of shadow on the wall are broadly hatched in so that they are not mistaken as part of the jacket.

Materials: For the support, a sheet of hardboard (24 in x 34 in, 60 cm x 85 cm) was lightly sanded on the smooth side and then very loosely primed with two or three coats of emulsion glaze (vinyl matt emulsion diluted with 30 per cent water). Graphite stick; soft eraser; brushes – No.4 and 5 long flat bristle, $\frac{1}{4}$ in (6 mm) and $\frac{1}{2}$ in (12 mm) long flat nylon, 2 in (5 cm) decorator's bristle brush; rags.

Another technique has been employed in this exercise to help describe the form of the coat and hat, and that is directional brushwork. The folds are clearly indicated in the preliminary drawing, then patches of tone are laid side by side along these folds. The undulations in the jacket, therefore, are emphasized by the mark of the brush in the paint. The different tones are not intentionally blended except in larger areas of more subtle tone as on the crown of the hat. A close up of the finished painting reveals a mosaic of easily visible brushwork which gives the painting a rich textural surface.

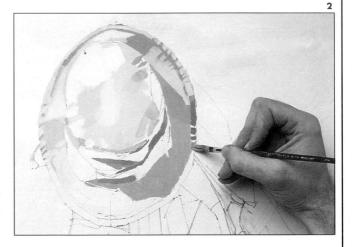

2 First the artist tackles the hat. The main mix is white with raw umber and yellow ochre, modified with touches of cobalt blue, cadmium orange and raw sienna for the shadow tones. The darks are mixed at one end of the palette and the lights at the other. In this method of painting, patches of light and shade are painted alongside each other, forming a patchwork of tone from which the three-dimensional form emerges.

3 Viewing the hat from close to, it is possible to see this mosaic of light and shadow. Note that the paint layer is thin (the drawing sometimes shows through) and the patches of colour are only cursorily blended at the edges as they are applied. The highlight tones are added deftly wet in wet.

4 Now to proceed with the jacket. The mid-denim mix is made from cobalt blue, Payne's grey, yellow ochre and titanium white. First concentrate on a small area, locating the areas of mid-tone. The form of the denim is described with this line of abrupt brushstrokes placed side by side along the fold to the right of the top pocket. The brush is charged, then the paint applied using one side of the

brush. When there is no more paint, the brush is flipped over and the other side used.

5 Standing back, the line of straight-edged brushmarks can be seen in the context of the whole jacket. See how the artist is picking out areas of the same mid-tone. From this view point the hat does look convincingly three-dimensional. A broader brush was used to soften the edges of the pre-placed colour on the crown of the hat where the creases are shallow and the gradations in tone subtle.

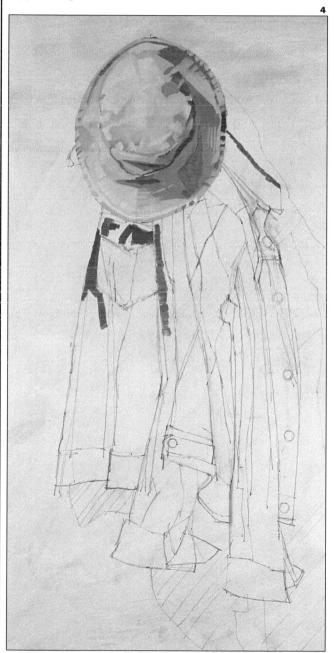

LIGHT AND SHADE/DENIM JACKET AND HAT

- 6 Lighter tone is worked in and around the mid-tone and now the artist adds the darkest shadow cast by the hat on the jacket.
- 7 The jacket progresses patch by patch, gradually building up the whole. The paint remains workable so it can be modified at will. If the direction of a brushstroke does not appear right, just brush it the other way.
- 8 Now to add the final details to the jacket. With pure cadmium orange, a line of stitching is added to the bottom of the sleeve. This is a detail that is hardly visible with the naked eye, but the artist exaggerates its importance. The same colour is used to add the name label to the pocket and, modified with the denim mix, for the brass buttons.

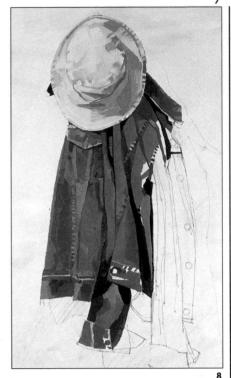

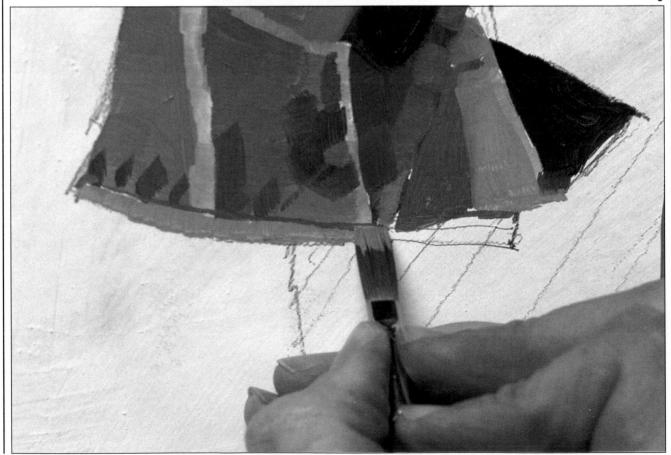

9 With the hat and jacket finished, all that remains is the shadow of the jacket cast on the wall and the background wall itself. The shadow has already been blocked in with a mixture of Payne's grey, cobalt blue, alizarin crimson and titanium white. There is quite an area to cover so a larger ½ in (12 mm) long flat brush is used to apply the broad irregular strokes.

Here, finally, the background is added in with the same ½ in (12 mm) long flat brush. The irregular brushstrokes from all directions ensure that the background does not appear too flat. This background colour is white broken with a little of the shadow colour.

10 The finished exercise is truly remarkable in its depiction of three-dimensional form. Yet, we have seen how the artist simplified the image he had before him, keeping the brushstrokes broad and even and detail down to a minimum. The eye certainly provides the missing information, filling out the clues offered by the artist.

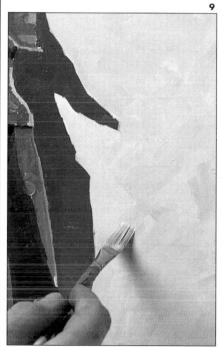

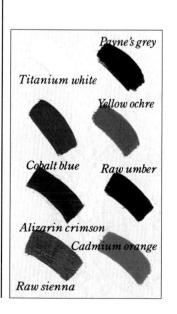

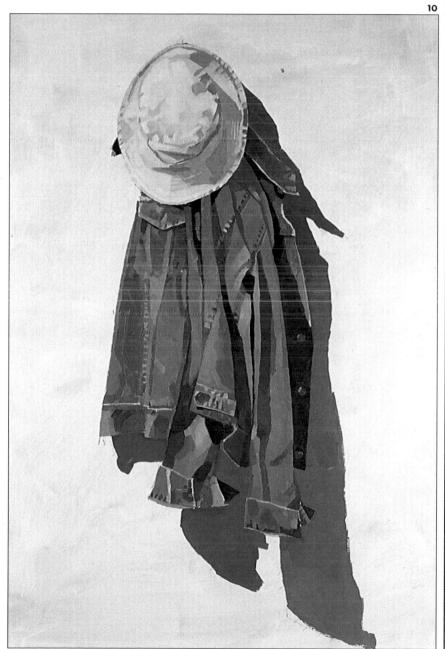

Pool House

LIGHT AND SHADE

The artist chose this photograph (an advertisement in a magazine) because he liked the arrangement of geometric shapes made by the openings in the façade of the house and the contribution made to the composition by the shadows and reflections. Bright sunlight creates strong contrasts – here in dark shadows on the white walls and dappled sunlight on the terrace. The cool blue pool in the foreground repeats the geometric shapes of the house in a separate abstract composition of reflections. So, in effect, this painting is not about creating space in the picture but about the patterns created on the surface of the painting.

The other important aspect of this painting is that the paint has been built up in layers, starting very dilute and working up to thicker paint in the final layers. But the paint is worked wet in wet, not waiting for it to be touch dry before proceeding with the next layer. The shadow areas receive most attention in this respect. Indeed, we can see how, through the application of several thin layers of paint, the shadows achieve a depth of tone which could not have been achieved with one single thick layer of paint. Even so the paint layer is not thick and the canvas is left exposed for the white walls of the house.

Note how the artist chooses to simplify some areas of the original scene. The shutters, for example, are just a single stroke of dry paint. On the other hand, he spends time on the reflections in the pool and on such details as the wicker chairs on the terrace. It is not necessary to maintain a high degree of detail over the whole composition. In fact, if the artist had done so here, it would have become monotonous.

1 This photograph, reminiscent of summer holidays, was discovered in a magazine advertisement. The way it is cropped reduces it to a composition of geometric shapes and the surface pattern becomes the important unifying force. At first glance, the configuration of the house is not

obvious. It is only on further inspection that certain details come to one's notice, such as the view of the sky and vegetation to the left of the house and the recessed right-hand side of the façade. It should be possible to explore paintings in this way, and so sustain the interest beyond the initial glance.

2 Very sketchily, with a soft pencil, the artist has roughed out the main shapes of the composition. Now the main areas of colour are boldly blocked in with dilute paint. This is executed quickly only to give a general idea of the layout of the composition.

3 Now the artist chooses to concentrate on the pool. First, he applies the areas of shadow into the still-wet paint. These are applied directly without working them into the underlying paint so that the first layer can be seen to qualify the second.

Materials: Stretched canvas 20 in x 16 in (50 cm x 40 cm); brushes – No.10 flat nylon, Nos.2 and 5 sable round; HB pencil; soft eraser; tin foil palette; cloths.

- 4 The tone of the steps needs to be lighter so a little white is added and blended with the first layer of blue.
- 5 With the addition of more limpid mid-blue tones and white reflected highlights, the study in blue is completed.

6 Now the artist returns to the facade of the house. This is a moment when he would look again at the source material. Note how he has pinned the magazine page to his easel for easy reference. He glances up at it every now and then, but does not slavishly copy every detail.

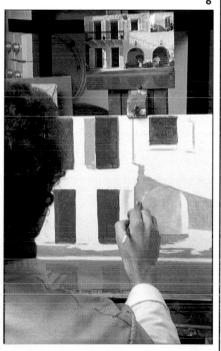

LIGHT AND SHADE/POOL HOUSE

- 7 The shadows on the house take up our attention next. Over an underlayer of burnt umber and white, a further layer of cobalt blue, burnt umber and white is added. Now the second layer is blended into the first and teased along the window frame to capture the dappled shadows. Keep the brushwork lively; shadows are rarely flat and hard. They consist of subtle variations in tone and colour
- which can be hinted at in the brushwork.
- 8 Next, the cantilevered balcony is visually condensed down to deep shadow with highlighted corbels. To clarify the areas of tone, it may help to look at the area with half-closed eyes. Here, with a No.5 round brush, the white highlight is applied.

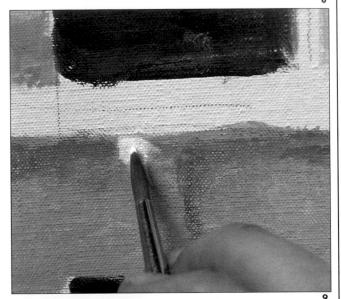

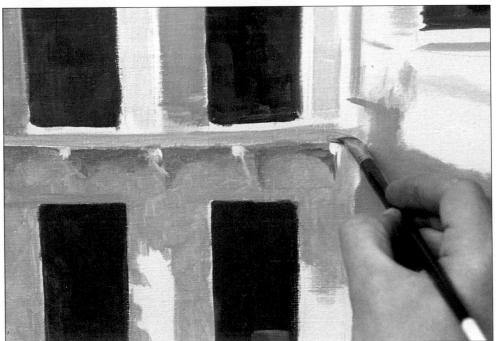

9 A neat horizontal line forms the platform of the balcony, which is now ready for the wrought-iron railings. But that comes later.

- 10 The stark blue of the underpainting which outlined the heavy areas of shadow has been qualified with a further layer of the shadow mixture. The interesting, angled shadow cast across the right-hand side of the façade is brushed across. The brush is kept dryish so that the edges of the shadow are undefined, blending into the white of the wall.
- 11 Work starts, too, on the smaller details such as the arrangement of wicker chairs on the terrace. First, the main shape of the chair is blocked in.
- 12 At this mid-way stage, the house facade is beginning to fill out. The blind black window openings have been worked on, wet in wet, with Prussian blue and white, hinting at space and furniture inside the rooms. Other details have been added, such as the terracotta pots.
- 13 The shutters are described very simply with a single stroke from a flat brush charged frugally with a dry mixture of burnt sienna and white. This stroke of uneven colour is drawn across the shadow to give the impression of the slats.

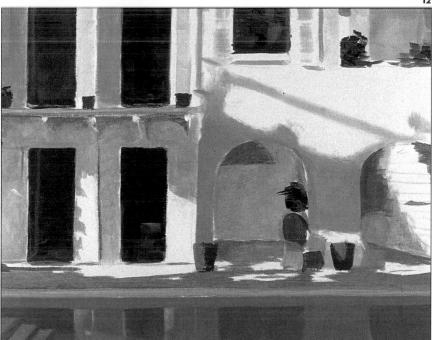

LIGHT AND SHADE/POOL HOUSE

14 Now to work up the vegetation. Into the initial layer of Prussian blue and lemon yellow, the artist has dabbed white, wet in wet, so that the two pigments merge. Now he re-establishes the darker tones by stippling with a small round brush. Note, the contents of the terracotta pot get the same treatment.

15 Finally, again with the same small round brush, a further irregular scattering of lemon yellow dabs is worked in to the wet layers beneath. The effect of these successive layers of small dabs is convincingly three-dimensional.

16 When this area is touch dry, the balcony railings are added deftly with a small round brush and some dilute ivory black. This needs to be executed with assurance and some speed, so practise on some paper before you take the plunge.

19 The painting has been given its finishing touches with the addition of the lanterns above the arches. The gradual building up of the various layers in the areas of shadow has played an important part in the painting process. As a result, the artist has managed to capture the feeling of bright sunlight in this painting.

17 Attention now turns to the terrace area. The chairs and the view through the two arches are worked up. Now the artist returns to the shadows on the facade to which he adds a final

18 To give the dappled shadows on the terrace further depth and warmth, a glaze of raw sienna is brushed over the dry underlayer.

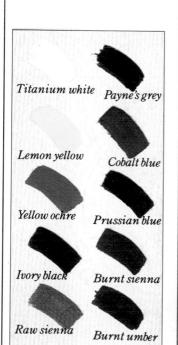

layer of burnt umber and white.

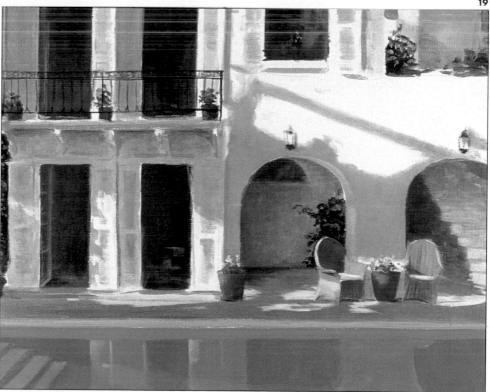

Chapter 6

Broken Paint

By this stage you will be beginning to understand why oil paint is described as versatile. It is possible to manipulate it in so many exciting ways. This means that, by learning to use the many different techniques described, the artist will be able to translate into paint exactly what is visualized in the mind or seen with the eyes.

Of course the artist is not only concerned with precise representation, but in the various ways – or, you could say, the most stimulating way – an object or an idea can be presented. Consequently, it is worth trying out as many different techniques as possible so that this battery of skills is allowed to grow, thereby providing for a certain freedom of invention.

The techniques covered in this chapter, with evocative names such as scumbling and stippling, involve areas of broken paint brushed over an underlying layer so that patches of the paint beneath shine through. Such brushwork results in fascinating atmospheric and three-dimensional effects and deep rich areas of tone and colour.

These techniques are most effective if the underlying paint is allowed to dry. And this is where the oil painter's great virtue of patience comes into its own. Or his ingenuity – after all, breaks to allow time for the paint to dry can be timed to coincide with life's essential needs such as eating or sleeping. Fortunately, the early applications of paint are usually dilute and so take a shorter time to dry and the drying time can be speeded up with the addition of an alkyd-based drying agent. But, you will find that the thicker the paint and the more oil added, the longer it will take to dry. Some artists avoid long delays by having two or even three paintings on the go at the same time. However, hopping from one subject to another may be merely confusing for others.

But there are many ways of achieving the same result. The preliminary layers can be carried out in fast-drying media such as acrylics or pure egg tempera. Oil paint can then be taken up for the later stages of the painting. But, beware — oil paint can be applied on top of these paints but not vice versa.

SCUMBLING

Scumbling is an expressive technique whereby opaque or semi-opaque paint is applied unevenly over the top of another layer of dry paint in order to modify it. The paint can be applied in a number of ways, but in order for the paint beneath to show through, it must be applied either in a hazy veil or irregularly, in a broken layer of brushstrokes.

Scumbling creates rich textures and colours that are impossible with direct colour. Flat colour can be given the appearance of soft animal fur, wool or hair with a layer of scumble. It is also a useful technique for giving zest to what appears to be a dead area of colour. A scumble can be used to gently modify a colour as the superimposed colour will mix optically with that beneath without killing it. If your colours are too bright in the background so that they come forward, for example, a light scumble will have the effect of toning them down. As can be seen from the examples below, scumbling also lends itself to representing intangible, atmospheric masses – clouds, fog, smoke.

DRY BRUSH

Dry brush is another technique where the paint is applied with a broken uneven brushstroke so that the underlying paint is allowed to show through. Dry brush is much as it sounds: the pre-dried brush is loaded with thick undiluted paint and applied lightly on a dry surface. The bristles splay out leaving streaks of the surface below visible. Strokes of dry brush need to be quick and assured so that the paint does not have the opportunity to blend. Again, the weave of the canvas helps to break up the paint, making the surface more vibrant. The splaying of the brush can be encouraged, without having to apply too much pressure, by holding the brush down by the ferrule and pressing the thumb down on the bristles.

- 1 Scumbling on a hazy veil of Payne's grey, the brush is rotated, working the paint into the canvas.
- 2 Over the grey, a layer of alizarin crimson is scumbled, creating an atmospheric effect.
- 1 With the dry brush technique, the bristles are splayed with the fingers.
- 2 This produces a delicate mesh of blurred strokes, with an interesting texture when viewed from a distance.

STIPPLING

Stippling is a technique of many parts. It can involve a tiny area and be painstakingly precise or cover an expansive background, requiring healthy jabbing with a decorator's brush.

An area of stippling is made up of tiny dots of paint applied with the tip of the brush held vertically, creating areas of vibrant tone or colour. The marks made by the stippling technique can vary hugely depending on the brush used. Dots of paint can be carefully applied with a small round brush, slowly building up an area of colour or texture – such as in the crab project on page 90. Larger areas, such as backgrounds, can be quickly stippled with a large round bristle brush or decorator's brush to provide a lively surface. Nail brushes and sponges make interesting stipple marks too.

Layers of stippling can be superimposed to create a pulsating depth of colour or texture. Starting with a dark ground and working to light gives an optical illusion of the three dimensional.

The density and the size of the dots affect the tonal value. The closer together the dots, the denser the tone. So by varying the density, gentle gradations of tone can be achieved.

- 1 Stippling with a large round decorator's stippling brush creates a coarse mark.
- 2 The depth of colour can be regulated by altering the pressure on the brush and also the dilution of the paint.
- 3 Here a natural sponge creates a dense but regular stipple mark.
- 4 The result is a delicate textural area of paint with many possible useful applications.

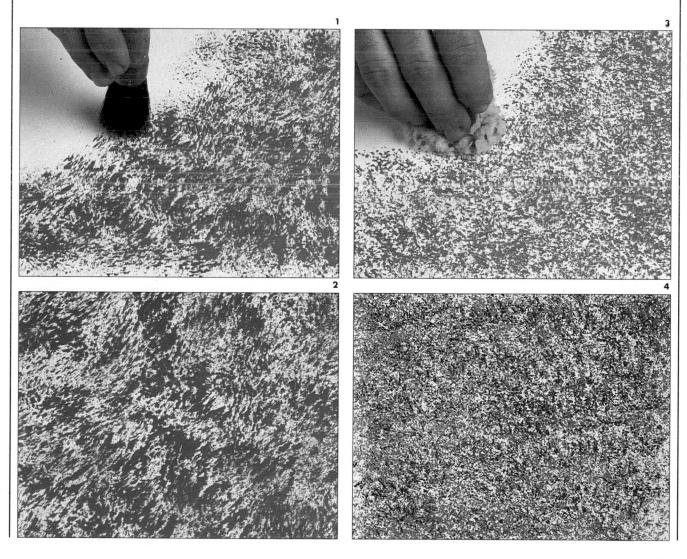

Crabs

BROKEN PAINT

These two crabs make perfect subjects to demonstrate the art of successive layers of uneven colour. They appear to have been scumbled by nature herself. And this is certainly where their attraction lies for the artist. Their shells have a fascinating texture and colour which prompt an invitation to paint. There are neither delicate gradations of tone in the shadows nor complex compositional arrangements: the artist relies on the crab itself which is simply a masterpiece of design.

The first stage of painting was completed in very dilute paint which dried fairly quickly. Even so, an alkyd-based drying agent could have been added to speed up the drying process. Or, indeed, quick-drying paints such as acrylics, alkyds or pure egg tempera would have speeded up the early stages. The later stages could still have been completed in oils so that by the end the surface would have been covered with the characteristic richness of these paints.

The colours discovered by the artist in this crab remind us to be bold when trying faithfully to reproduce what we see. Some artists delight in colour, while others are more interested in other aspects. When this artist looks at the crabs he sees the hint of a colour – the pale magenta on the claw, for example – and exaggerates it. But note, the colour does not remain there as a flagrant patch of magenta, but it can be seen burning through the successive scumbles of red. So take courage where colour is concerned. After all, if it does not work you can always cover it, qualify it, temper it. But it will rarely need removing and, more than likely, it will energize your painting.

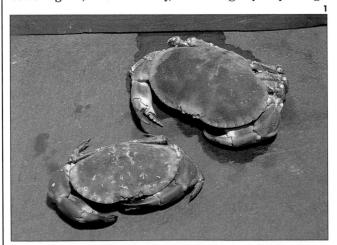

1 The beauty of these crabs lies in their colouring and their designer armour plating. They are well shown off on this heavy slab of slate – suitably funereal, considering their cooked state.

Materials: Fine grained flax canvas 30 in x 24 in (75 cm × 60 cm); brushes – Nos. 5. 8 and 14 flat nylon, No.2 round sable; graphite pencil; tin foil palette; fine grade sandpaper.

2 For the underpainting, the artist lays down suggestions of colours observed in the crab. Finding these colours, he claims, is largely intuitive. But it is clear that you need to be brave. After all, if the colour you choose is not right, it can always be covered over, modified, or lifted off with a cloth. The striking magenta on the claws forms the basis of the shadow but it would be hard to identify, without

looking for it, in the final painting. The background was literally scrubbed into the canvas in an attempt to represent the texture of the slate. This, too, will receive further treatment.

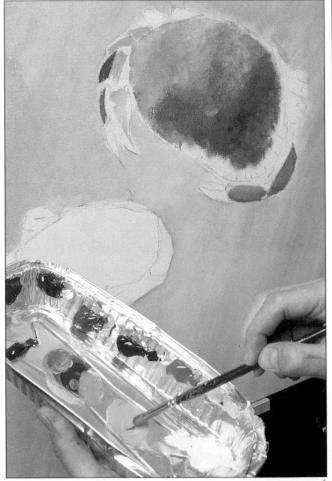

3 Working wet in wet, the pale foundations for the large crab's left claw are laid with a No. 5 flat brush. Note how the graphite pencil has muddied the paint. Fixing the underdrawing would have prevented this, but it is not a problem as the subsequent layers will cover it up.

4 Once the lower crab has received the same treatment, then the painting is allowed to dry. The colours have been merged together on the canvas to give a gradated flat area of colour. But note that, already, the wild magenta has been modified a little.

5 The artist adds the shadows cast by the crabs on to the slate. These follow the contours of the crabs, emphasizing their three-dimensional form and throwing them into relief. It also has the effect of tidying up the outline. This delicate task is performed with a No. 2 round sable brush.

6 Now, to build up the background and give it some depth, another layer is worked over the first one. Using a large flat brush, the paint is roughly stippled over the top. These two layers of uneven colour make the surface live.

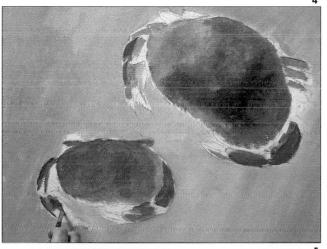

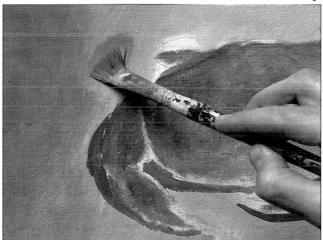

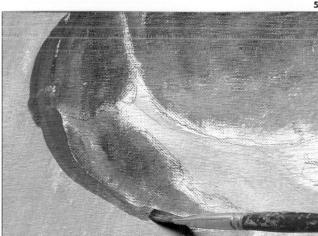

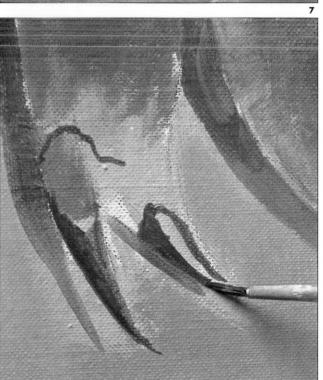

7 Back to the upper crab to work on its right-hand claw. With dilute ivory black and a No. 2 fine round brush, the delicate black tips of the claws are painted in. Also the shadows along the joints of the claw are carefully observed and added. These details are important as they constitute the essence of the crab. Note, too, how the

claw has been filled out with a further layer of orange/red laid over the top of the dry underpainting.

BROKEN PAINT/CRABS

- 8 Again, the paint needs to be dry before this next layer of paint. Still working on the top crab, a final layer of colour is scumbled over the top. The dry paint is scrubbed quickly backwards and forwards, round and round over the surface. It is important that only a very little of the paint is applied at a time. The uneven scumble creates a soft area of uneven colour through which the underlying
- colours can be seen. The grain of the canvas also helps to separate the colours and produce the undefinable depth of texture.
- 9 The crab's right claw is scumbled with the same colour and blue highlights are added to the claw tips. Note the grain of the canvas showing through the scumble on the shell.
- 10 Moving to the left claw, the dull sheen of the crab is perfectly captured in the lilac highlights. The paint is applied with a small brush and then smeared with the finger to flatten and deaden it. The indentations round the edge of the shell are delicately picked out with the same pale mixture.
- 11 The hind claws are the last to receive attention. Still using the small round brush, the artist stipples two layers of colour, hinting at the stubby bristles. This small area breaks from the formula of the rest of the crab. It is an interesting small area of paint which delights the eye.

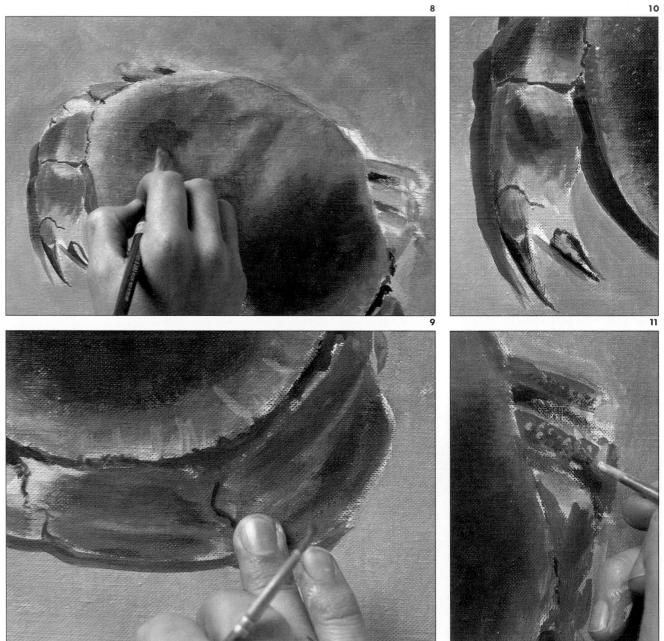

12 Now for the final touches on the lower crab which has been brought up to the standard of its larger neighbour. The chalkiness on its shell is added as some white paint is dry brushed on. Make sure the brush is quite dry by wiping it on a cloth. Take up a tip of the full-strength paint and brush it on.

13 The very final detail – the delicate feeling hairs – are added with the same No. 2 round brush.

14 To build up the texture of the background still more, the surface has been gently rubbed with fine sandpaper. To do this the paint needs to be quite dry; also take care not to rub down through the priming coats to the canvas. Even so, fine specks of white and the pattern of the canvas weave now show through the grey adding to the lively texture.

Building up layers of colour wet on dry, as has been done in this project, is well worth the time and effort. It creates a remarkable depth of colour and sense of the three-dimensional.

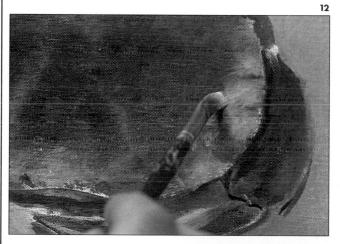

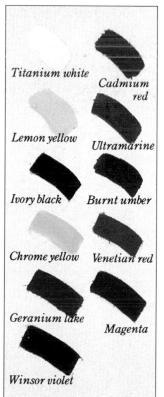

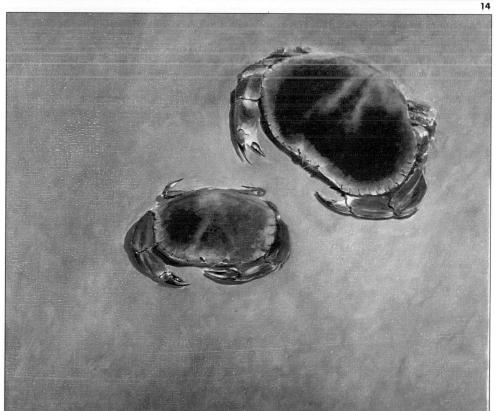

Constable

BROKEN PAINT

Flatford Mill stream, with Willy Lott's cottage in the background, was the subject of one of John Constable's most famous paintings, *The Haywain*. It is a typical English country scene with a bank of mixed trees coming down to a sluggish river bordered with rich flora and a white cottage in the background.

Armed with a photograph of the scene today, it is a challenge to try and paint the same subject again. But not quite in the same style: the original took Constable five months to complete and, indeed, his friends paid tribute to the speed with which he completed the project. If this information makes it seem like a daunting prospect, watch how the artist simplifies the scene. He has avoided making this a detailed study of the nature at Flatford Mill. It is the atmosphere of the place that he is trying to capture.

Looking at the finished painting, the eye takes in the trees of different shapes, colours and sizes and sees among them a fir, hawthorn and maybe rowan, but precise species would be difficult to identify. It is the same with the river bank. The different plants are simplified down to a few basic leaf shapes, but flag irises, balsam and other waterside plants are assumed to be there.

After the initial blocking in of the main shapes, the artist concentrates on the foliage and riverside plants, building them up with superimposed dabs, dots and areas of stippling, so that the surface of the painting is a lively flurry of strokes broken by

2 First, the foundations for the painting are laid down. Even at this stage, the paint surface is lively and broken, applied in dabs of dilute paint and worked out at the edges in a hazy scumble. Notice how this bank of trees is already made up into clumps of foliage, hinting at the individual trees. These neutral greens are mixed from variations of yellow ochre, cadmium yellow, cobalt blue and

white. The artist is working without an underdrawing, painting straight on to the canvas and feeling his way as he goes. The area of deep shadow where the trees meet the water is put in place with a dark flat line of dilute green. This immediately draws attention to the contrasting texture of the trees and the flat water.

the flat, still area of water between them. The artist works quickly, mixing and then dabbing on the paint, hopping from one side of the bank to the other. In contrast the sky and the water are built up with layers of soft scumbles. By leaving these two areas until last to complete, the dilute layers of underpaint have a chance to dry.

Materials: Canvas 22 in × 16 in (55 cm × 40 cm); brushes – Nos. 5, 6, 10 flat, No. 5 round; tin foil palette; white spirit.

1 This view has come to epitomize the English countryside, thanks to the painting by John Constable, completed in 1821, known as *The Haywain*. Today the scene survives intact. Still protected by a bank of trees, the slow-moving River Stour oozes past Willy Lott's cottage. It is a challenge for any artist.

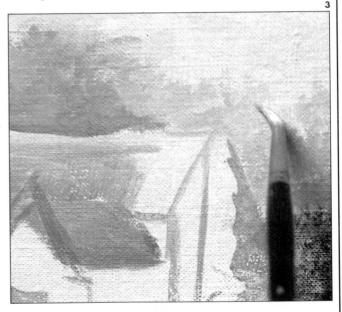

3 The artist starts working up the background and then comes forwards. Here, the glimpse of the distant horizon is scumbled on with a round brush and a mixture of Payne's grey, ultramarine blue and white, so that the white of the priming coat shines through. Willy Lott's cottage has a more defined structure so the outline has been economically brushed in with very dilute paint. At this

stage the artist is still very much feeling his way. The pinkish colouring of the cottage roof, for example, helps the artist to visualize the composition; it is not necessarily useful as a colour base.

- 4 Now, the artist begins to work up the individual trees. This fir shaped tree has dabs of lighter and darker green (ivory black, cadmium yellow, cobalt blue and white for the lighter tones) worked into the underlying scumble with a stippling motion, using the tip of the flat No. 10 brush. The paint is reasonably liquid so the foliage appears dense.
- 5 Beneath the fir tree, a small tree with lighter foliage is delicately formed with the same brush, using just the very tip.

 Make sure the brush is dry before adding a touch of paint some lemon yellow worked into the green colour. Then, with minimal pressure, bring down the brush vertically on to the surface of the painting and quickly off again.

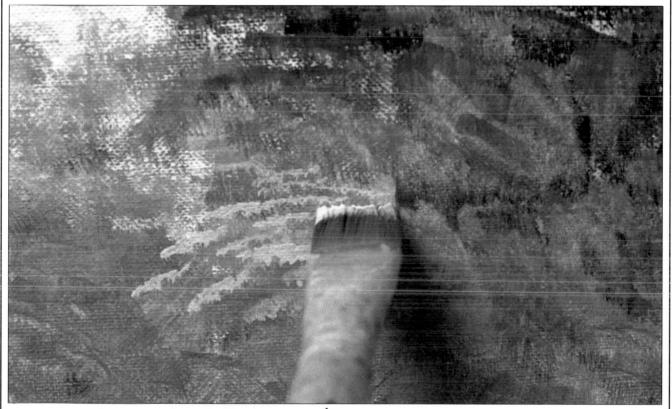

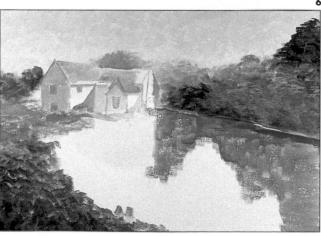

6 Taking stock and standing back, you can see that the surface is now almost covered with a lively layer of paint — more in some places. A base layer of Payne's grey, ultramarine and white has been applied to the sky area with irregular strokes. Also the reflection in the river (yellow ochre, cobalt blue and white) has been worked into the dark shadow under the trees. At this stage the painting is allowed to dry.

BROKEN PAINT/CONSTABLE

7 The same sky mixture, tempered with a little of the green, is worked into the river area. Water reflects the sky. So if it is flat and calm, as it is here, you will get a long stretch. In moving water, only small patches of sky colour will be glimpsed. The same mixture with a bit more green is worked over the tree reflections very gently so that the original broken layer of paint is not blended completely. Now there is a hint of the limpid depths below the reflected surface.

Willy Lott's cottage is reflected in the water, too, with just a few dabs of dry brush.

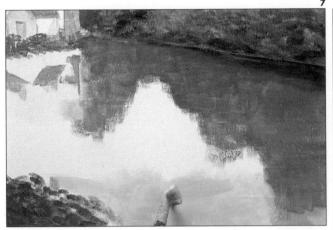

8 Now the cottage itself is given some attention. As it is part of the background, it must not become too laboured with detail. The paint is kept thin and the brushwork loose. The shadow areas of the walls have been built up with pale scumbles of Payne's grey, ultramarine blue and white. On the roof, a couple of strokes of dry brush over the pinkish foundation paint is punctuated with the rows of broken lines, conveying an impression of tiles.

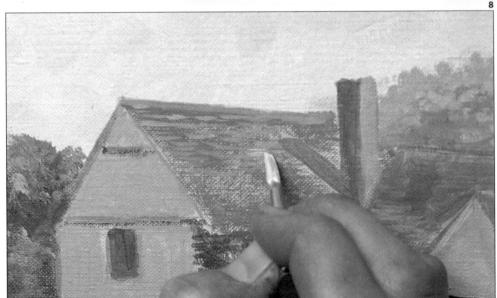

9 Further stipples of light paint are added with a small round brush to the trees by the cottage. These pale stipple marks seem to float above the murky neutral greens beneath, enforcing the three-dimensionality of the trees. The further away, the smaller the stipple.

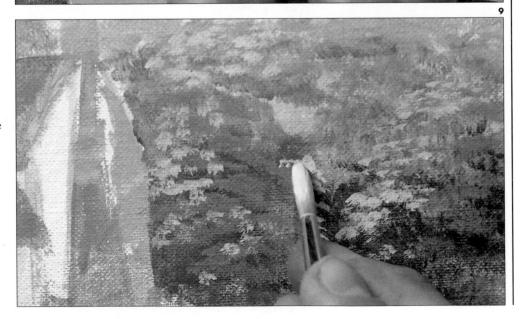

10 The artist works some darker tone into the point where the river disappears round the side of the cottage. By now, everything is beginning to fall into place and the painting is filling out. Note how the artist has used up the paint on his brush at times to build up the tone of the left bank.

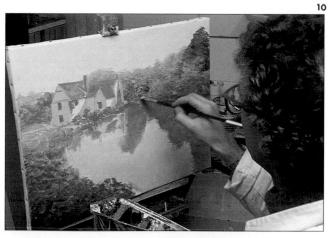

11 Now it is time to concentrate on the left bank of the river. As the artist works, he is forming the simplified shapes of, first, the clumps of plants (as in a border of flowers) and, second, the shapes of the leaves themselves. Over the top of the multishaded scumbles, the artist stipples with tiny blurred strokes.

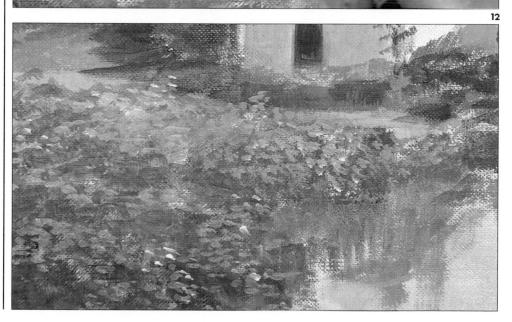

12 These pale green stipple marks are superimposed with delicate flurries of colour – more saturated in the foreground, bleached in the background. Finally, tiny specks of pure white are placed at random with the very tip of a round brush.

BROKEN PAINT/CONSTABLE

13 Now the foreground bank of rushes and flags are painted in, using a large flat brush with the bristle ends held vertically. Held like this the brush almost paints these leaf shapes for you. First, a random crop of mid-tone green leaves and then a few in the highlight green. The paint here in the foreground is thicker, adding to the sense of recession.

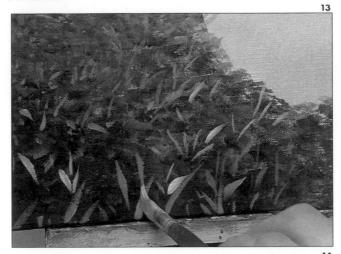

15 For the final touches on the right bank, suggestions of the trunks and branches of the trees are made with careful strokes with the tip of a dry brush in two tones of brown. It is necessary to isolate these strokes to see just how economical they are.

14 Clumps of rushes break the rather harsh line between the bank and river. Notice the slightly different colours and saturation of these leaf shapes. Still the primed canvas can be seen shining through to form glistening highlights.

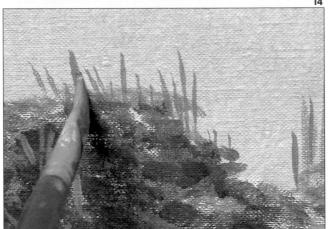

15

16 The rich mixture of foliage further along the bank is punctuated with vertical trunks. These are less defined as they appear further in the background.

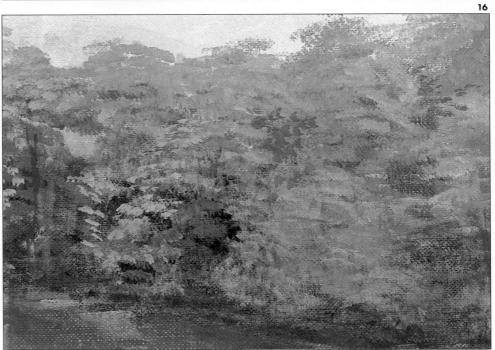

17 Finally, the artist works on the sky – soft white clouds in a blue sky. Over a layer of white, ultramarine and Payne's grey, a dab of pure white is applied neat and then worked over the surrounding area. This white paint is scumbled round and round, forming an atmospheric mist of cloud.

18 The superimposed layers of uneven paint give the finished painting a living surface which contrasts with the stillness of the scene itself. There are contrasts, too, within the painting, with the busy areas of foliage separated by the oily calm of the water. The eye naturally focuses on Willy Lott's cottage but it strives to go beyond, following the murky depths of the river. It is a peaceful scene but, as we have seen, it is made up of small areas of inspired painting that will sustain the attention of the viewer.

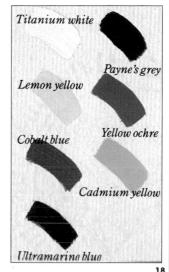

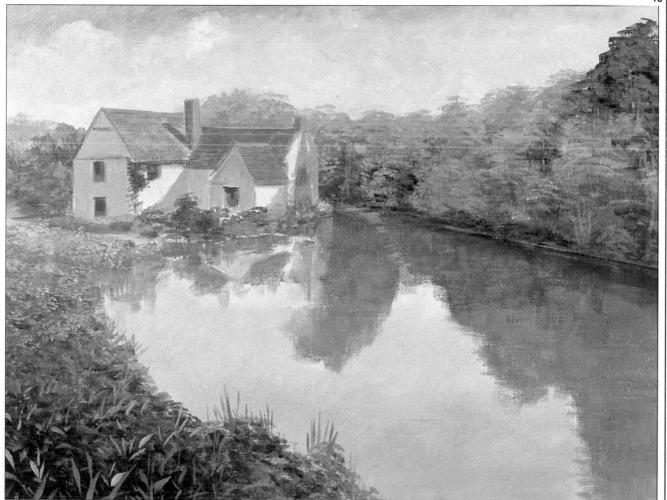

Chapter 7

Texture

By now we have a useful set of techniques at our disposal with which an enviable number of effects can be achieved. But, until now, the paint surface itself has remained reasonably flat. The textures depicted in the paintings have been achieved visually through deft brushwork. Yet one of the joys of oil paint is the texture of the paint itself – thick globs and smears of paint which break the two-dimensional quality of the surface.

Oil paint will maintain its form exactly as it is placed on the surface if it is used undiluted. And there is something spontaneous about a dash of thick impasto paint with the brushmarks still visible in it. At a distance it makes up part of the image, but, close to, it forms a direct link between the viewer and the artist.

In this chapter we look at some of the techniques used to apply paint in such a way. In knife painting this is taken to its extreme. The paint is applied like soft butter and teased into ridges and peaks. Such thick applications of paint cast their own shadows on the surface and glisten in the light, adding a further dimension to the painting.

A textured surface can be achieved by scratching into the surface or adding a granular substance such as sand to the paint. Francis Bacon, the British contemporary painter, has been known to fling vacuumed house-dust at certain parts of his paintings to give the surface a fuzzy appearance. There are really no limits to invention.

Although some artists specialize in these extremes of textural painting, most artists dabble at one time or another and perhaps add a few strokes of impasto paint in the final layer of their painting. But, by trying your hand at this type of painting, you will find it is fun to do and it will help you to learn to be bolder with your paint. With knife painting, for example, you cannot afford to get bogged down in detail, or your image will blur and get muddy.

So, take courage, and have a go.

KNIFE PAINTING

Painting with a knife is like a feast. It could almost be described as a delicious occupation. The luscious paint is applied thickly with a small, highly flexible steel knife-blade over which you have a surprising amount of control. These sensitive knives come in various shapes and sizes, each capable of their own individual marks.

As with a brush, pressure, angle and use of the different parts of the instrument affect the result. The paint can be smeared on with the flat of the blade to produce an area of thick creamy paint. Slight regulation of pressure will produce ridges that catch the light. Or the tip can be used to place precise dots and dabs of paint or dragged along to make thick juicy strokes. On the other hand, the edge of the knife can produce crisp irregular lines.

The paint will hold its impasto best if used straight from the tube, but you will find some paints are much oilier and less able to keep a true impasto. You can leave the paint to dry out a bit, or extract some of the oil by squeezing out the paint on to some blotting paper. Wait until it is the right consistency and then use it.

It is easy to get over-excited with knife painting and apply the paint too thickly. General areas should remain about 3 mm thick, with ridges and points about 5 mm. This will ensure that your masterpiece will dry – eventually. It may take a year before your knife painting is really dry and ready for varnishing.

- 1 The different parts of the painting knife can be used to great effect. With the edge of the painting knife it is easy to make the imprint of crisp straight lines. Place the knife edge on the canvas, lifting off cleanly to leave the ridge of impasto paint.
- 2 By rotating the flat of the knife with the wrist, an arc of smooth paint is formed, edged with a ridge of paint which catches the light.
- 3 Here a 'scumble' of white paint is applied with a painting knife. Each application is applied at random encouraging the broken surface of the pigment so that the underlayer of blue shows through.

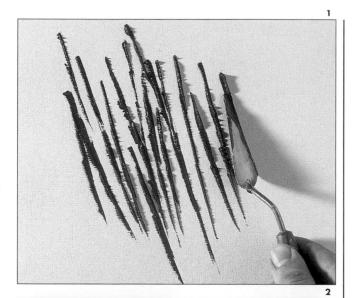

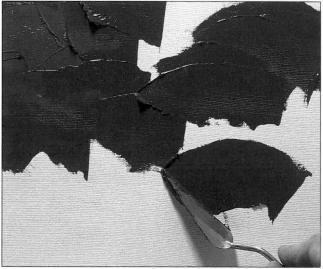

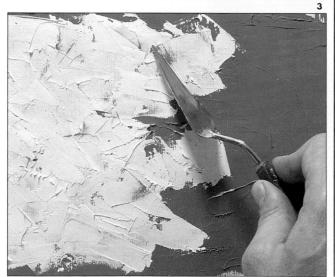

TECHNIQUES

- 1 Glazing with a painting knife is possible too. Here a transparent layer of alizarin crimson is carefully scraped over a layer of cadmium orange.
- 2 The resulting area of colour smoulders with the underlying orange qualifying the deep red. The impasto ridges add to the liveliness of the paint surface produced by this technique.
- 3 Here the knife is used to stipple, using the very tip to dab on the paint. Scrape up sufficient paint on the underside of the knife, press down and lift off cleanly.
- 4 Smearing these dots with the flat of a clean knife produces an interesting blending of the colours.

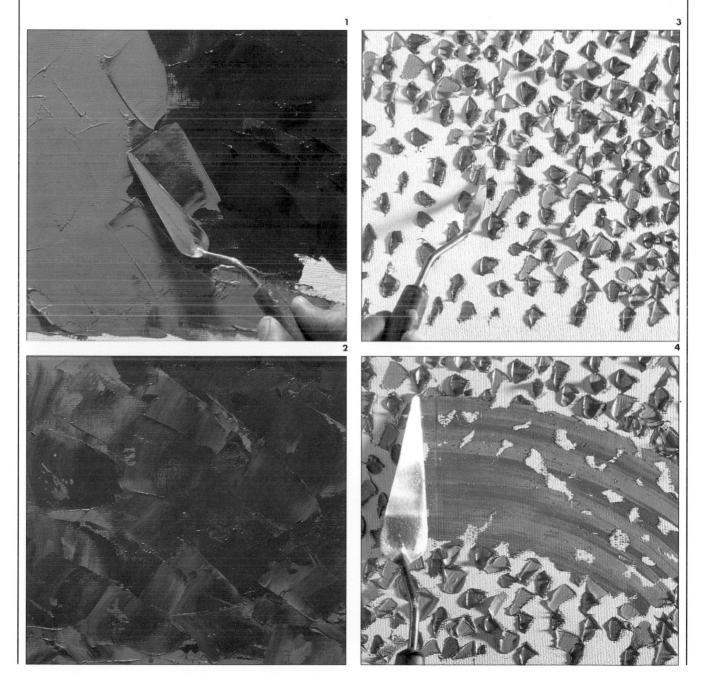

SGRAFFITO, SPATTERING AND TONKING

Spattering

Spattering is when a shower of tiny dots of paint is flicked from a brush to cover an area with a spray of minute droplets of paint. Spattering can produce the same effects as stippling, but the appearance is more mechanical and it should be used with care. The spots on the back of the trout on page 114 are perfectly captured with this technique.

You will find that the size of the spatter can be controlled by altering the distance between brush and support, and also by the choice of brush and the consistency of the paint. A toothbrush is a useful spattering tool. Hold the brush 3-6 in (7.5-10 cm) away from the surface, load the brush with paint and then pull the thumb across the bristles (see picture 1). If you want to spatter a specific area then mask it off with newspaper as shown on page 114. A decorator's brush loaded with dilute paint and simply flicked on to the surface will create a large sized spatter (see picture 2). Either pull the thumb across the bristles or bring down the handle of the brush on to your other hand so that the paint sprays forwards. You may find this easier if you place the painting horizontally on the floor and knock the spray of paint downwards.

- 1 For a fine spatter, the bristles of a toothbrush are pulled back with the thumb.
- 2 A decorator's brush, loaded with dilute paint, is brought down sharply onto the other hand so that droplets of paint fall on the surface of the painting.
- 3 To demonstrate sgraffito, the tip of the paint knife scratches into the paint surface to reveal the yellow underlayer.
- 4 For tonking, a sheet of newspaper is pressed over a still wet layer of paint.
- 5 Once the paint has been absorbed, gently lift off the paper to reveal an unusual textural effect.

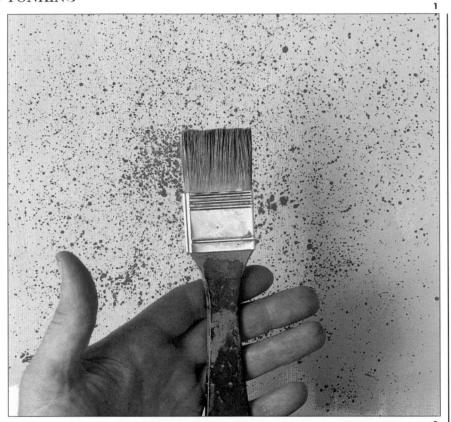

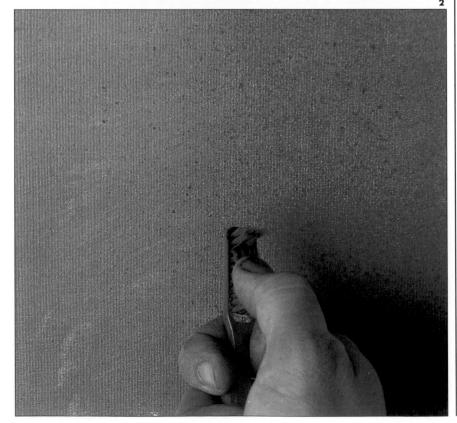

TECHNIQUES

Sgraffito

Sgraffito is a method of creating linear marks on a canvas, by scratching through the top layers of paint to reveal the white priming or a stained underpainting beneath. It was a technique much popularized by the French artist Jean Dubuffet (born 1901) whose sgraffito was sometimes scratched into a dense covering of oil paint, sand and coal dust, exposing a crimson layer beneath.

Any sort of pointed instrument can

be used to etch with, but the end of a brush handle or tip of a painting knife (see picture 3) does the job well. To obtain a textured effect, the top layer of paint needs to be thickly applied. Sgraffito is best performed when the paint is still fresh.

Tonking

Tonking is a process named after the artist and teacher Sir Henry Tonks whereby an area of dense paint is sopped up and partially removed by a

sheet of absorbent paper. This technique can be used to produce an interesting textural effect, or, if carefully performed on an overworked area of paint (maybe more than once), it will remove the top layers of paint.

Place a sheet of newspaper over the wet paint, gently flattening it with the palm of the hand (see picture 4).
Allow the paint to be absorbed and then carefully lift the paper away (see picture 5).

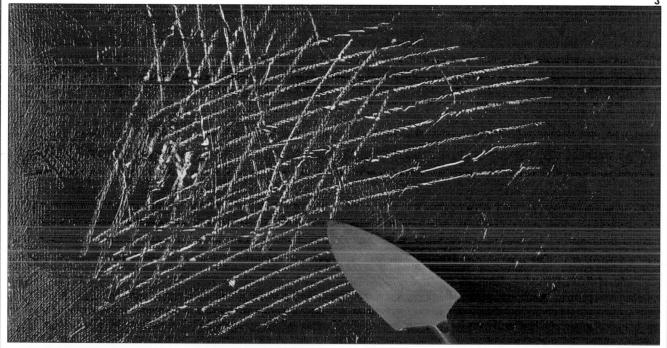

Melon and Pomegranates

TEXTURE

Having discussed the glories of knife painting earlier, we now have a chance to see the knife, or rather knives, in action. The artist has chosen a still-life arrangement where the texture of the paint can best be used to express the texture of the subject: the seeded centres of these fruit are most aptly translated into similarly juicy paint.

At first you may find the painting knife rather clumsy and restricting after the sensitivity of the brush. This style of painting requires absolute assurance on the part of the artist and you have to know where to place your colours otherwise the result will be messy. Consequently, knife painting is a good exercise in forethought and control.

If you are not used to knife painting, choose a very simple subject to start with, but make sure it is suitably textured and the colours are clear. (The melon was chosen just for these reasons.) It may help then to complete a studied drawing of the subject as by drawing it you will get to know every detail. The drawing will also help you to distil the image in your mind as the nature of the knife does not allow for delicate detailing.

But, even so, you will find that a wide range of effects can be achieved with the different knives. In this painting you can see in the richly textured seeds of the fruit the full glory of glistening impasto; yet, in contrast, the leathery pomegranate skin grows out of several superimposed glaze-like layers of paint, smeared on with the knife. As in all painting, the thickest

layers of paint should be reserved for objects in the foreground. It can be seen that, on the melon, the artist tapers off the paint layer towards the back, eventually leaving the stained canvas exposed.

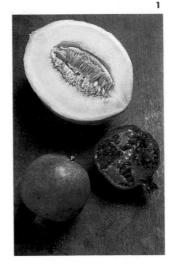

1 To show off the full capabilities of knife painting, the artist chose this melon and the two pomegranates, knowing their centres would reveal these glistening textured seeds. To keep these fresh looking during the painting session, they were occasionally sprayed with water.

Materials: Self-stretched, 10 oz. (285g) cotton duck canvas 20 in × 15 in (50 cm × 35 cm) prepared with acrylic primer; 1 in (2.5 cm) soft bristle brush; No. 13 (small), No. 18 (large) trowel shaped painting knives; graphite pencil; turpentine; cloth.

2 For his composition, the artist takes a high viewpoint and breaks up the regularity of the shapes by cutting the melon with the frame. First, the rough shapes of the fruit are loosely blocked in with dilute turpsy paint. It is so dilute it runs down the canvas, but this happy accident is encouraged. These delicate stainings, in the course of the painting, are allowed to show through the thick impasto paint, forming an important part of the composition.

3 While this staining layer of turpsy paint is allowed to dry (it is very dilute so will not take long), the next layer of thick paint is mixed on the palette. The paint is used straight from the tube and mixed with the underside of the knife, scraping it up and pressing it down repeatedly to get an even mix. However, you will notice that the paint is left only loosely mixed on most occasions so that the individual colours are clearly visible when applied.

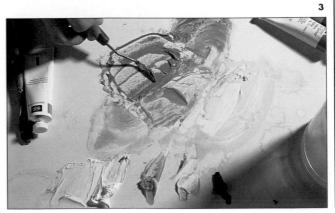

- 4 The first exercise with the smallest painting knife is to plot the outline of the melon skin with successive applications of paint made with the edge of the knife. This line, as you will see in the final picture, forms the pale green layer of flesh between the skin and the ripe yellow flesh. To guide the artist with this line, the rough outlines of the still life have been pencilled in over the dried paint with a graphite stick.
- 5 Now to tackle the deeply ridge skin of the melon. A generous helping of sap green paint is taken up with the underside of the knife and smeared on, lifting the edge up to create a ridge. On top of that yellow ochre is applied in the same way, lifting up to form ridges and scraping off to reveal the darker green and form the indentations. If it does not look quite right, scrape off the

paint with the underside of the knife and reapply it.

6 The light cast on this impasto glistens to form highlights on the ridges and cast shadows in the grooves, describing well the texture of the skin. But already the thickly applied paint is beginning to bring some order to the composition.

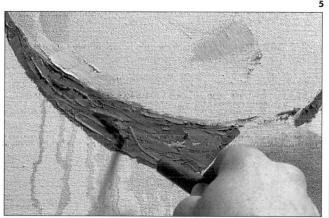

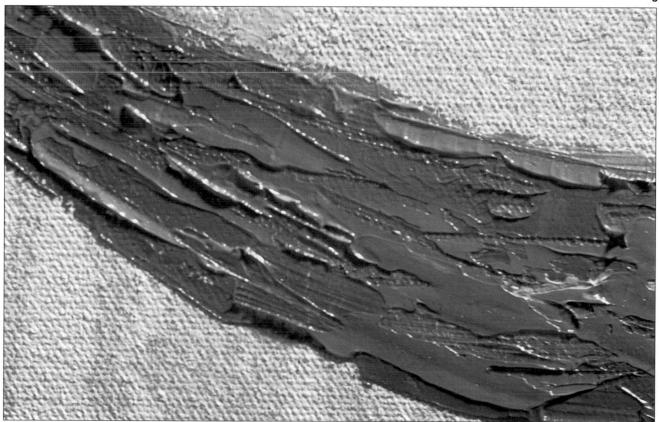

TEXTURE/MELON AND POMEGRANATES

7 The golden yellow flesh of the melon has been applied with the flat belly of the knife, mixing the paints on the canvas cadmium yellow, yellow ochre and white with a little of the green mixture. Towards the back of the receding face of the melon the paint gradually gets thinner until the stained canvas is left exposed. Now to work on the contrasting texture of the seed cavity. Here the paint is applied with short sharp jabs with the end of the knife. Lifting the knife up vertically from the dab of thick paint leaves a ridge each side. Having laid down the ochre pips, the greenish shadows of the cavities are added.

- 8 Building up the centre of the melon, the knife is being used to form long rich strokes of paint. Note how in this area there is a stimulating contrast between the luscious paint and the starved canvas.
- The melon is finished. You will notice that the artist has added a lighter layer of yellow to the flesh area, working it carefully into the area of bare canvas beyond so that the eye leads gently from one to the other. The depth of the cavity itself is indicated by the row of parallel strokes from the flesh down, smearing the ends of the seeds on the far side. Stepping back, the artist appraises the situation, makes a few alterations and then proceeds with the pomegranates.

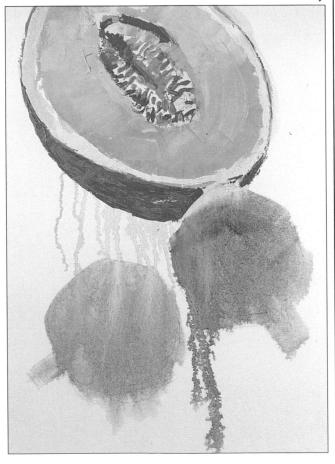

10 The juicy interior of the pomegranate is built up in the same way as the melon. The rich reds and purples are made up from different combinations of alizarin crimson, cadmium yellow and titanium white, with Payne's grey to make the deep rich burgundy. The surface is made up from small dabs and smears with the small No. 13 knife.

11 Close to, the rich confluence of paint is remarkable. Here the crimson is smeared in small dabs into the dark paint below so that they qualify each other. Note how the paint is worked into the dark seed cavities, enforcing the sense of three-dimensionality but still small patches of the stained canvas show through.

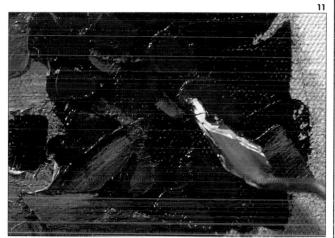

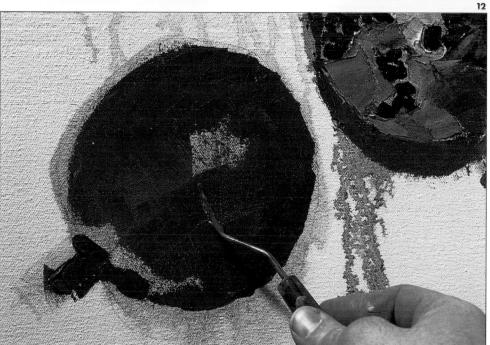

12 The gleaming leathery appearance of the whole pomegranate is captured in remarkably few strokes, glazed over the stained canvas. Using the same combination of colours as the halved fruit (but with more yellow and no white) the knife is emptied of paint on the palette and then swept across the skin area. The highlights are left as mistily scumbled patches of stained canvas. A dab of the redder colour on the skin of the halved pomegranate links the two fruit.

TEXTURE/MELON AND POMEGRANATES

13 Now only the background needs attention to complete the painting. You will observe how the patches of stained canvas act as a unifying force between these three fruit and particularly between the two quite different faces of the pomegranate.

- 14 Finally, the wooden board under the fruit is filled in with a mixture of raw umber, alizarin crimson and Payne's grey. For this task a larger painting knife of the same shape is used. Here the knife is shown cutting round the pomegranate and smearing the paint outwards.
- The job is almost finished. The paint has been applied not too thickly and in random directions. Variations are not discouraged otherwise it would be too flat and uninteresting. Most important is the thin irregular line of stained canvas left around the fruit on their lighter sides. This separates the fruit from their background and allows them to burst out in full relief.

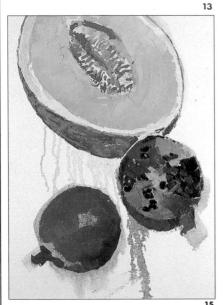

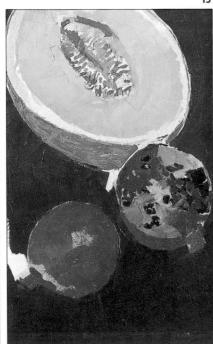

suggestion of the wood graining is achieved by etching into the background paint with the tip of the knife. This act of bravado neatly separates the background from the foreground, adding a linear dimension to the painting and reinforcing the three-dimensional shapes of the fruit. To this end as well, darker brown shadows have been added round the bases of the fruit. These are plausible but not as they appear in reality.

18

17 The tousled ends of the pomegranate halves get the sgraffito treatment too. By scratching into the paint here, the artist creates the precise texture required.

18 The canvas is now filled with luxuriant paint, creating a strong, vibrant image. The artist kept his colours fresh by minimal mixing and by simplifying the range of tones and colours.

The successful sgraffito adds a linear quality to the composition, enforcing the flatness of board and therefore throwing up the fruit in full relief.

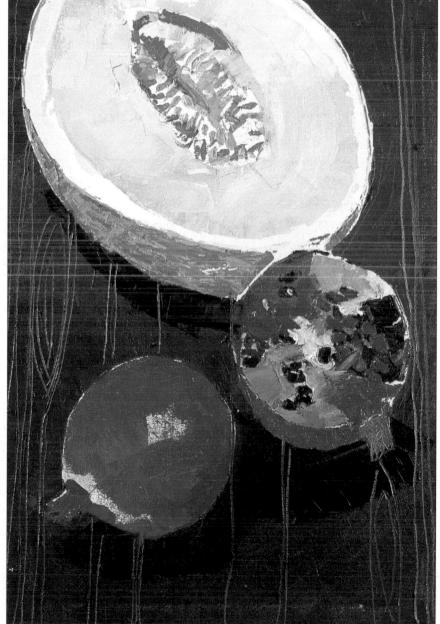

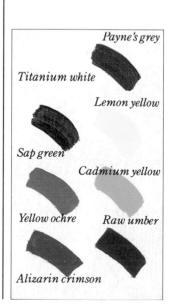

Fish

TEXTURE

Fish are wonderful to paint. Their silver scales reflect the light, producing unexpected flashes of colour. And if such understated hues do not excite you, then their powerful streamlined shapes and markings are liable to bring out the latent designer instincts in any artist. But apart from these artistic commendations, these four different types of fish from a market stall gave the artist the chance to put into practice some of the techniques demonstrated in the previous pages.

Perhaps at first glance these slippery shiny fish do not suggest the need for a textured paint surface. Indeed, most of the techniques are used to build up colour and a sense of the third dimension. Even so, the artist relies to a great extent on an inspired outline and very thin layers of paint. But, although the fish appear real enough by the time he has finished working on them, it is only when the background is added with the coarse areas of sand-laden paint that the smooth texture of the fish is brought into focus. This simple device establishes the contrast between the two surface textures, emphasizing the slippery nature of the fish.

In the early stages of the painting, the artist very much feels his way, laying down thin, but bold, areas of paint in an almost arbitrary fashion. A colour is located and exaggerated. Then this colour is applied across the surface, finding different points where this hue appears. Finally, it is a case of checking to see what works and reworking those areas that do not.

The background marble slab is altogether an important part of the composition. The artist uses the real thing purely as a starting point for an idea and produces his own pattern of striations. These flowing streaks of grey not only add a sense of movement to the painting but they also make a clear reference to flowing water. The fish — even though they are

2 With a graphite pencil, the artist has briefly drawn in the outline of the fish. Then, with strong fluid strokes from a No. 8 filbert bristle brush, these pencil outlines are reinforced with paint, mapping out areas of

strong colour where possible. The artist has chosen to represent these fish on a very large scale, allowing room for expression.

incompatibly from fresh and sea water – almost appear to be swimming together in and out of the current. Encouraging the ambiguity, their shadows cast on the marble surface are easily confused with the marble streaks and so the fish are left literally floating.

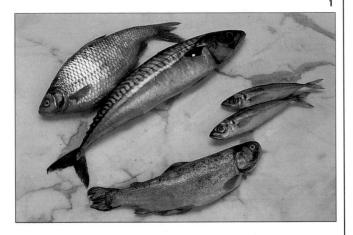

1 The artist took a while to arrange the fish so that they were pleasing to the eye. In the final solution the strong diagonals break up the landscape shape of the support and, by facing the fish in opposite directions, the focus of attention is kept in the centre of the picture space.

Materials: Flax canvas 30 in. × 40 in (75 cm x 100 cm); brushes – 2 in (50 mm), 1 in (25 mm), ½ in (12 mm) decorator's, Nos. 3 and 8 round, No. 8 filbert, No. 6 flat; graphite stick; small trowel-shaped painting knife; filling knife; newspaper; masking tape; white formica-veneered board; white spirit; cloth.

3 Now, with a ½ in (12 mm) decorator's brush, patches of very dilute colour are built up to give an idea of the form. These areas of approximate colour serve as a guide for the artist. Using this large brush will

ensure that you keep the brushwork bold and loose. This is a time to try out ideas, standing back every now and then to assess the impact and then reworking any area that looks unhappy.

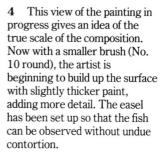

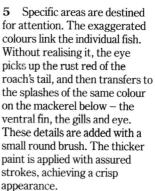

6 Standing back, we can look at the state of the fish objectively. The mackerel's striped markings have been worked wet in wet so that the black paint merges into the coloured underpaint. Notice how the paint wanders outside the outline at times, and the trout has been treated to a desultory flick with the paintbrush. This is all part of keeping the approach loose and almost arbitrary.

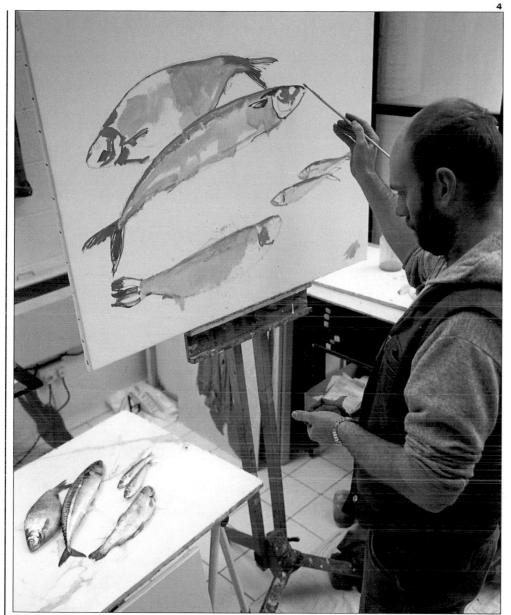

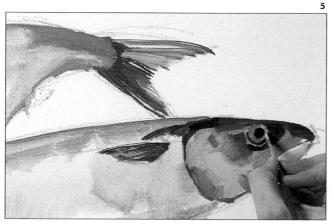

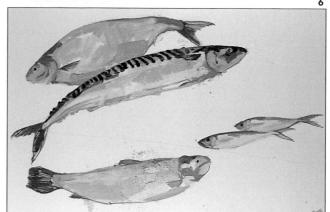

TEXTURE/FISH

7 Turning to the trout, the artist decides to spatter on the spotted markings. To confine the area of spatter to the back of the trout, a mask of torn newspaper is prepared. This is affixed with masking tape which can be stuck down on to the bare canvas without causing any damage.

- 8 First, with a small 1 in (25 mm) decorator's brush, the area is spattered with dark green paint. Now with a larger 2 in (50 mm) brush pink spots are superimposed. The brush is charged with dryish paint and held 3 in (75 mm) from the canvas. Here the artist is pulling back the bristles to release the spray of droplets.
- 9 By removing the mask, the characteristic spotted back of the trout appears as if by magic. The odd spot has escaped the mask but such accidents can be taken off with the finger or left as they are.

10 The strip of spots along the trout's back is too clearly defined so a few more arbitrary flicks with the brush charged with very dilute paint soften the gradation.

11 The spatter has successfully captured the colouring and texture of the trout. Note, too, how the artist has taken the brush laden with the pink spatter mixture (white, alizarin crimson, cadmium yellow, deadened with a little of the green mix) up to the underbelly of the roach.

12 Now, with a graphite stick, the artist livens up the surface of the fish, suggesting scales and surface texture. This assured parallel hatching along the belly of the small fish is etched into the still-wet paint with a smaller HB graphite stick.

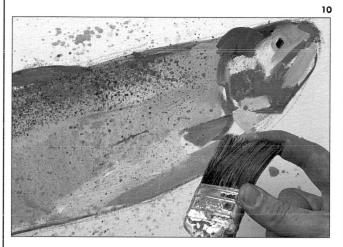

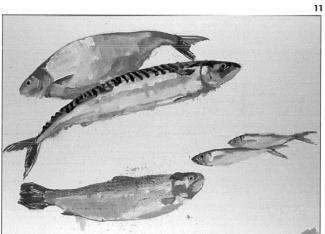

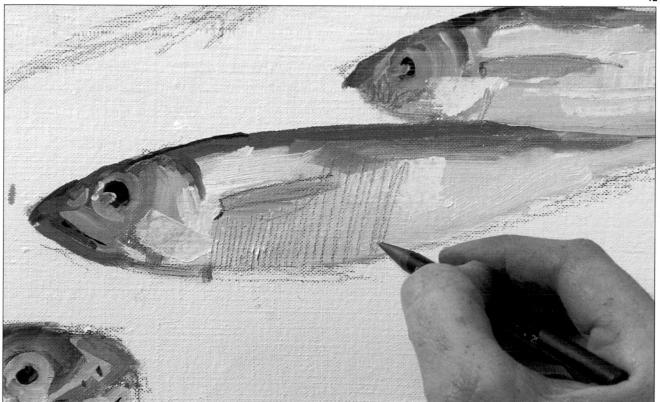

TEXTURE/FISH

- 13 The large scales of the roach are suggested with the graphite stick as well. Where the paint is thicker, this creates little ridges of paint which catch the light, capturing the silvery reflections of the scales. The flat underpaint of the fin has been built on to with a final layer of delicately traced lines of thick, almost pure, cadmium orange.
- 14 Now attention is turned to the background. To start with, a graphite stick, gently sandpapered to form a faceted stem, maps out the striations of the marble. The stem of the stick is pulled along the canvas, adjusting the angle to alter the width of the stroke.
- 15 White paint has been worked over the background with a large 2 in (50 mm) decorator's brush, working round the striations which have been built up with paint. Now the artist is blending the paint and graphite with his fingers, forming a blurred streak. To effect the subtle variations in the marble, some areas of graphite are left untouched.
- 17 This textured paint is applied to the surface with a decorator's knife, smearing it along the white areas of the marble, close to the fish. The sand particles in the pigment reflect the light, exaggerating the contrast in texture between the fish and background.

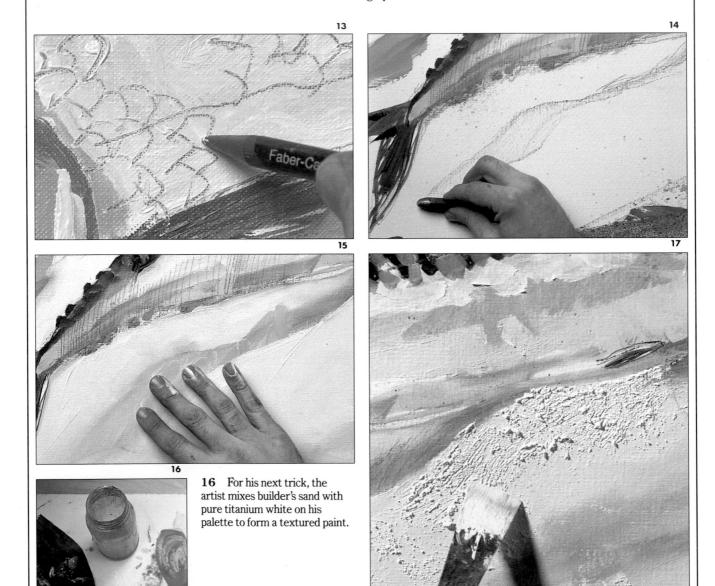

18 The final touches are added. With a small No. 18 painting knife, the texture is again worked up on the mackerel. The finely hatched lines make an area of dull paint more lively.

19 In the finished painting, you can now see how the artist has encouraged the ambiguity of the background. From a distance the fish appear to be lying on a marble slab. Closer to, the textured highlights and lively striations of grey conspire to make this into flowing water. The fish appear to be passing in the current. In addition, the background introduces an important sense of movement into the painting – always a problem with 'still' lifes. The use of the textural techniques on the fish play an important part in keeping the paint lively and in capturing the intangible reflective nature of the scales.

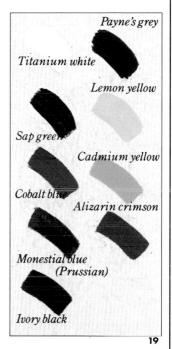

Chapter 8

Creating Depth

In Chapter 7 we studied opportunities where it was appropriate to daub the canvas with an abundance of juicy paint to produce texture. Now we will look at more delicate techniques involving very thin layers of paint. Staining and glazing are two allied methods of painting which, if mastered, will expand greatly any painter's potential.

One of the problems a painter faces is mixing an equivalent colour to one he sees or, for that matter, one he holds in his memory or imagination. To a great extent, this is because colours are rarely flat and constant because light which creates them is likewise inconstant. In fact, artists recognize that some colours are impossible to reproduce by mixing on the palette. This applies to some shades of violet blue, particularly sought after by flower painters. Nevertheless, closer approximations to colours experienced by the eye can be mixed by superimposing transparent glazes of thin paint, wet on dry, so that the colours are mixed optically, like successive layers of coloured acetate or seeing a colour through a camera filter. By producing colours in this way,

a quality of hue is achieved, which cannot be contrived in other ways.

Oil paints have always been considered highly suitable for glazing. The suspension of the pigment in an oil binder enables the artist to create colours of great purity and depth. But glazing has an infinite number of other uses in painting apart from colour creation – for modelling, building up areas of shadow and representing water, to name a few. In addition, artists from classical antiquity to modern times have used a thin glaze of paint to stain the white ground of their prepared surface, sometimes for technical reasons, or now, more commonly, to set the mid-tone of the painting or to influence the colour range towards warm or cool colours. For many this overcomes the clinical whiteness of a prepared canyas.

In this chapter, apart from demonstrating the more traditional uses of staining and glazing, a method of painting with a cloth will be shown, using the staining technique – all of which goes to prove that it takes more than the lack of a brush to stop a keen artist.

Staining and Glazing

STAINING

Paint, diluted with turpentine, can be used to stain the canvas with a wash of colour. With oil paint, the canvas itself must be primed to protect it from the harmful oils, so the pigment is applied on to the ground formed by the priming layers. Such a staining layer can be applied with a brush or rubbed into the weave of the primed canvas with a cloth, as demonstrated here.

Such a toned ground or *imprimatura* makes it easier to assess the tonal values of the superimposed layers of paint. A suitable mid-tone colour is chosen for the subject in mind and the primed canvas is systematically covered with the dilute paint applied in a thin glaze of transparent pigment. It is usual to use the earth colours, ranging from warm raw sienna, to

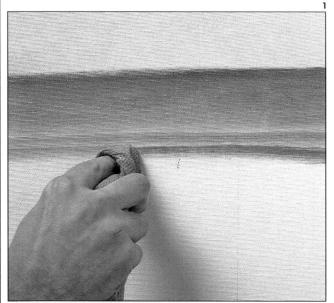

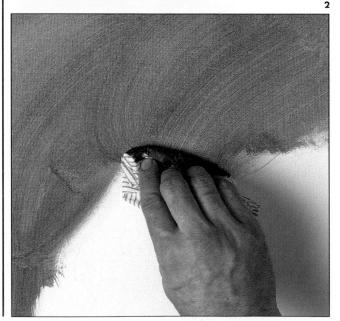

yellow ochre or burnt umber, which will dry quickly in such a dilute form. Or the paint can be applied in an opaque layer as part of the priming process. It can also act as a unifying layer of colour which is allowed to shine through the successive layers of broken paint laid on top, influencing the colours used towards a warm or cool range.

In the following projects, you will see the artist create images using a staining technique, applying the dilute pigment with a cloth and lifting off the paint for highlights.

Staining

1 To stain the canvas, the artist mixes raw umber with plenty of turps to a thin, even consistency. If a large area is to be covered you will need to do this in a shallow dish. The artist works the stain into the weave of the primed canvas with an all-purpose cloth, in a circular motion. The staining layer of paint is kept even but cloth marks are permitted.

2 The canvas can be stained with oil paint to resemble a graduated wash. A each band of dilute paint is applied with the cloth, it is spread across the canvas, working it up into the preceding application.

GLAZING

A glaze is a dilute film of transparent paint, laid over a dry underlayer. Applying the paint in this way allows the superimposed layer to qualify that beneath, so creating unequalled depths of colour. It gives the same effect as combining sheets of coloured clear film and requires a knowledge of how colours react with each other. Experiments will undoubtedly lead to surprises. A thin glaze of jewel-like viridian, for example over cadmium red will produce dark brown of great depth. The precise colour will be conditioned by the strength of the glaze.

Glazing can be used to build up rich, luminous areas of colour especially where shadows and reflections occur, as on a stretch of water. But a glaze is also used to enliven flat colour or it can be used to knock back an area which is tonally inconsistent.

Glazes are usually applied with a soft hair brush which will leave no brushmark and hold the liquid well. Oil is added to the paint to give the glaze a gloss characteristic of the medium which too much turpentine will destroy. On the other hand, excess oil will make the glaze move around on the canvas. To start with, it may be helpful to try a proprietary glaze medium which will dilute the paint to the right consistency and make it manageable.

TECHNIQUES

Glazing

- 1 First, a layer of cadmium red is applied to the canvas and left to dry. A thin glaze is mixed by adding an alkyd resin-based oil medium to a little cadmium yellow. This medium thins the paint and yet leaves it manageable. Applying the paint with a soft bristle decorator's brush covers the area quickly. The paint is applied lightly and not worked in any way.
- 2 The result is a burning translucent orange which is a long way from the flat opaque orange that cadmium red and yellow would mix on the palette. The slightly uneven application of the glaze adds to the power of this colour.
- 3 Now, using the same two colours, the system is reversed. It is more usual to apply dark over light but the results here show it is by no means essential.

The underlying layer of paint this time is applied with a painting knife, leaving impasto ridges. This will take a while to dry and even then care must be taken in applying the glaze. Keep the brush dry so that the paint underneath does not lift off, and apply the glaze one stroke at a time without reworking it.

4 The angled dabs of glaze add to the resulting frenzy. This area of orange appears to move. Compared with stage 2, it has a bolder, less misty finish, but the hue is similar.

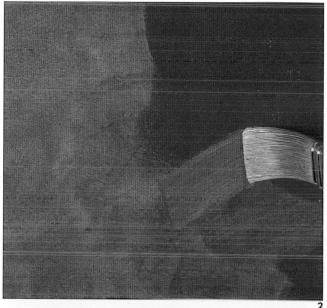

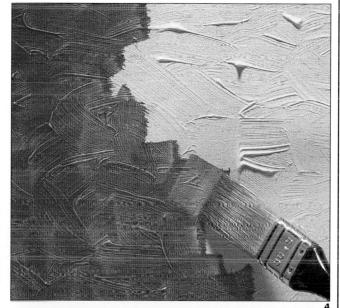

New York

CREATING DEPTH

Sometimes an artist has a idea for a painting and then has to seek out sources for the various elements of the composition. Painting can sometimes involve complicated research, but in this instance the artist quickly found a suitable window to paint in a magazine and used a photograph from his album for the New York skyline. He then combined these various elements in a sketch to make sure his idea worked. Even so, it is a painting which develops as it goes along, as they so often do. It is only when the chair is added to the foreground that sense is made of the interior space.

The artist first stains the canvas with a glowing pink which encourages the warm tones of the painting. The colours chosen for this will take a while to dry in oil paint even though applied thinly. To save time, the artist could have chosen to execute this staining under layer with acrylic paint. The effect would have been the same and such a thin layer of acrylic would take no time to dry. This staining layer is covered and lost under the red walls but it very much comes through in the central panel.

Trouble is taken in building up the colour of the walls. Several layers of paint will always produce a richer, deeper hue than a single thick layer; especially if, as in this case, the underlayers can shine through successive thin glazes of transparent colour. So in the course of the painting, the artist applies four separate glazes of colour to the wall area to achieve a rich glowing red.

There is a certain ambiguity in the lighting for this painting. The artist wanted the shadow on the walls to add interest to the otherwise flat wall space. These shadows also tease the mind into wondering about the layout of the rest of the room. What casts that angled shadow? This strong interior light is countered by the light outside the window produced by the illuminations of New York.

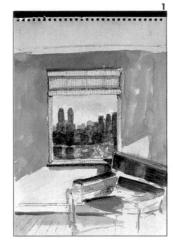

A number of sources were cobbled together for this painting of an interior with a view of the New York skyline. The window was taken from a magazine photograph and the skyline from the artist's photograph album. The chair was conveniently in the artist's studio. To try out the idea, the artist makes a pen and wash sketch, searching out the tonal balance of the composition. He crops back on his sketch aware that the window, if not given prominence, may appear to be a painting on the wall.

Materials: Small canvas 24 in × 18 in (60 cm × 45 cm); brushes – Nos. 5, 9 and 14 flat, No. 3 and 6 round; graphite pencil; tin foil palette; turpentine; cloth.

2 First the canvas is stained with a dilute mixture of cadmium red and titanium white. Mix enough to cover the whole canvas, rubbing it well into the weave of the canvas with a cloth. Use a dry part of the cloth to spread it out; it does not need to be a constant colour.

This staining needs to dry before the application of more paint.

3 The window shape has been measured up and drawn in with a pencil. Now a dilute layer of cadmium red with a touch of white is brushed on round the 'window' with a large No. 14 flat brush. The paint is applied with jabbing strokes, encouraging the irregularity. Do not worry if the

paint is not tidy round the edges of the opening; this can be put right later.

- 4 Working from the bottom of the window, the artist now adds the darker line of the foreground sketch of water (the lake in Central Park). The same tabbing technique is employed to break the paint and create an impression of ripples in the water.
- 5 Now to build up the scene viewed through the window of Central Park and the New York skyline. Starting with the sky, a mixture of white, ultramarine and Payne's grey is applied with the same flat brush. Scumble this paint over the pink staining, rhythmically impressing the flat of the bristles into the paint to
- break the surface. Add more white nearer to the horizon, working it into the darker paint above.
- 7 The first stage of painting is completed. Additional work has been done to the view where the reflections of the buildings in the lake have been added. The pink of the underpainting shines through the broken paint, giving the painting great luminosity. At this stage the painting must be left to dry again.

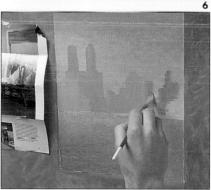

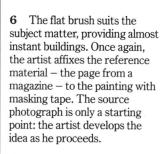

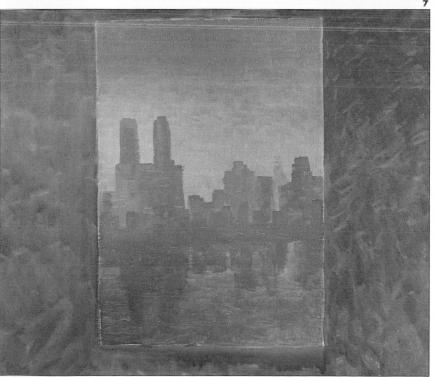

CREATING DEPTH/NEW YORK

- 8 Now, over the top of the red walls, another layer of purer cadmium red is brushed on. Superimposing layers of pigment like this helps to build up a rich depth of colour. Again the surface is worked up with a No. 9 flat brush whose tough bristles leave a good mark. The window recess has been painted in with a mixture of cadmium red, white and chrome yellow.
- 9 The recess on the other side is painted in a lighter hue where the light falls. The flat brush is suited for this narrow strip. Here, you can marvel at the full force and depth of the build up of superimposed layers of red paint.
- 10 A rolled blind is added to the top of the window in various shades of raw umber, yellow ochre and white, again using the width of the brush to make the marks. Once more, the canvas is given time to dry.
- walls, the artist lays a dark glaze of transparent paint (burnt umber and alizarin crimson). This rich glaze is worked over the red and then smoothed out with gentle strokes, retaining a slight irregularity. To tidy up the edges of the window, masking tape is gently affixed beforehand.

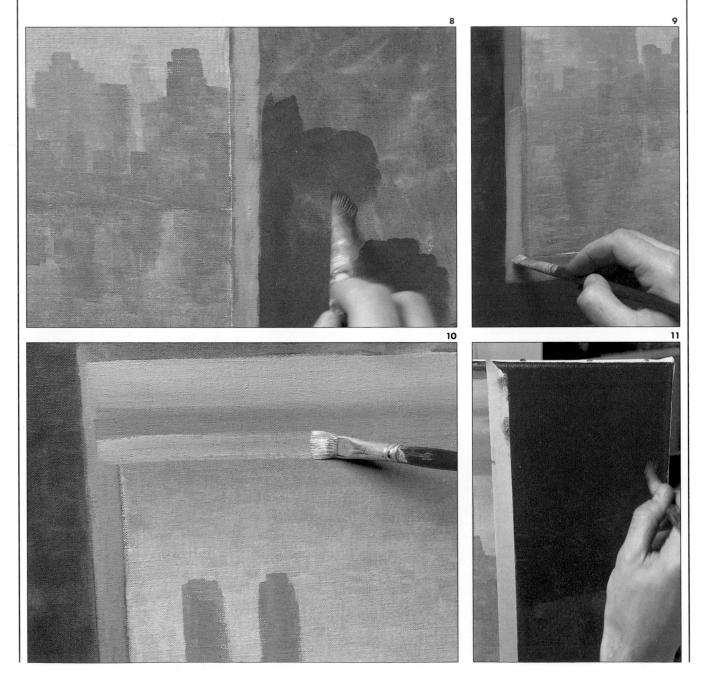

12 Now the New York skyline is given some sparkle with highlights dabbed on to the buildings with a small brush.

13 The layout of the painting is established more precisely by the addition of the corner of the chair in the foreground. This has the effect of pushing back the wall and window. Immediately, we can see that we are in a room, looking out through a window at the New York skyline. Before, there was ambiguity. The basic shape of the chair is mapped out with this dark brown (burnt umber,

ultramarine, Payne's grey and white) and the same mixture is used for the shadow and (lightened) for the sill behind.

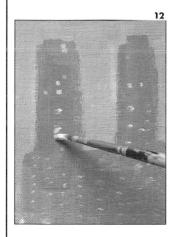

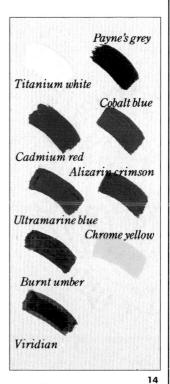

14 For the final picture, the artist has spent time tidying up the painting. The inner edge of the window is cleaned up with a strip of blue green - the wall viewed outside - and the blind with almost the same coloured edging. The recess shadow is added on the left and highlights and shadows to the blind. Finally, the chair is worked up to a finished state. The result is a stimulating painting which initially grabs the attention through its vibrant colouring. Still, at this stage, the original staining of the canvas shines through in the central panel.

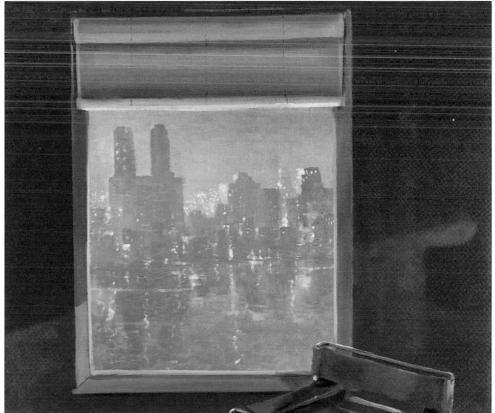

Trompe-l'oeil

CREATING DEPTH

Trompe-l'oeil is the art of visual deception where the painted object is mistaken for reality, and this is what the artist is setting out to do here. The subject of the painting is an idyllic beach scene with the sun beating down on a row of parasols. But this fantasy scene has been painted so it appears to be on a piece of unfolded paper which has been taped on to the bare canvas. It is a pastiche, a picture of a picture, expressing the artist's wish to visit such a wonderful place in the knowledge that this is just a fantasy he keeps folded up in his mind. The artist is also making a tongue-in-cheek reference to the 'too good to be true' photographs found in travel agents' brochures.

For the beach scene, the artist chooses to stain the canvas with a cloth and dilute paint, keeping the surface flat as it represents a two-dimensional piece of paper. This inner rectangle must be masked off carefully and, indeed, if you follow the steps of this painting, your masking technique is bound to improve. With the beach scene finished, the shadows caused by the folds are added with a brush with close reference to a piece of folded paper pinned on to the easel. The result is an uncanny confusion between the space created in the beach scene and the folding of the scene which forces you to view it as a two-dimensional piece of paper.

If the addition of the shadows seems too ambitious, treat the project as a simple beach scene. Alternatively, try your hand at *trompe-l'oeil* painting on a smaller scale — your signature on a piece of crumpled paper 'taped' to the bottom of a painting, for example.

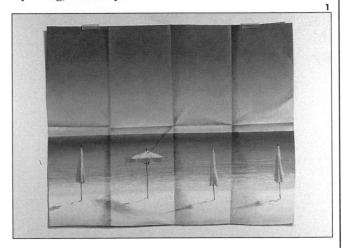

1 The inspiration for this folded beach scene comes from the artist's imagination — it is where he would like to be. The sun-drenched shore is painted before the addition of the folded paper look.

Materials: Canvas board 30 in x 20 in (75 cm x 50 cm); brushes – Nos. 5 and 6 flat, No. 3 round; tin foil palette; white spirit; all-purpose cloth; masking tape ½ in (12 mm); piece of paper.

2 The first step is to measure up the canvas for the inner rectangle. Using a ruler, the artist has marked this on the canvas with a pencil. Now, a piece of paper is folded and taped to the top of the easel so that the artist can follow the outline shape with the masking tape. Here the angled edge running from the central fold is reproduced with the tape.

3 The tape has been stuck down as firmly as possible so that the paint does not seep underneath and a clean edge will eventually be unmasked. It will require a certain amount of pressure to flatten it down as the angles at which it has been laid down cause it to wrinkle.

4 Now using an all-purpose cloth wrapped round the index finger, the artist takes up a small amount of the dilute mix of paint from the foil dish and applies a thin staining wash of paint. A patch of colour is rubbed into the weave of the canvas in a circular motion and then, with a dry part of the cloth, spread out, finishing off with wide sweeping strokes from one side of the canvas to the other. The paint is applied in bands, becoming paler as the sky comes down to the horizon. Each band is carefully blended into the one above.

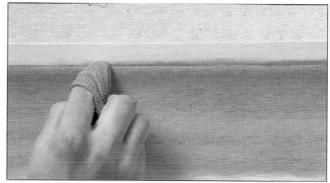

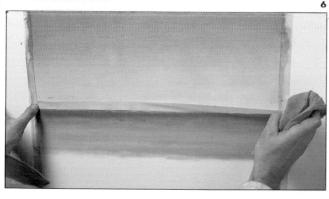

- 5 The same smooth staining method continues with the sea, starting with a strong dilution of ultramarine and cobalt and here with the addition of viridian which is blended into the blue on the canvas. The paint needs to be worked right up to and over the masking tape to achieve a stark edge.
- 6 The horizon was painted across free-hand with the cloth, but it is not straight. The artist decides to use masking tape to tidy it up. Because the tape will cover the newly stained canvas, it is stretched across with no pressure applied and anchored well at the sides.
- 7 Then, with the cloth, the paint is smoothed out over the tape. Keep the cloth dryish, as if you apply too much dilute paint, it will seep under the tape. On the other hand, the sea tends to get darker on the horizon line so you do not want to wipe the colour off.
- 8 Very gently, with a single movement, pull away the masking tape. Miraculously the line is clear and sharp and the thin layer of paint above the horizon has not been lifted off. A thicker layer of paint would need to be dry before it could be treated in this way.

CREATING DEPTH/TROMPE-L'OEIL

- 9 Finally, the horizon line is straight and clean. Now the artist continues with his graduated staining technique, filling in the beach area with very light washes of burnt umber and lemon yellow.
- 10 Next, with a clean part of the cloth, damp with spirit and tightly pulled over the finger, the nail is used to wipe off the paint, revealing the white canvas surface. In this way the artist 'draws' four sun umbrellas across the foreground of the painting.
- 11 Standing back, it is time to admire the deft clothwork (no brush has been used so far). The sky appears as an absolutely smooth graduated wash and the white ground shines through, producing a vibrant colour. As the wash comes into the foreground the colours are left more distinct, representing the patches of sand on the sea floor.

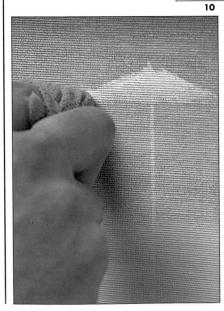

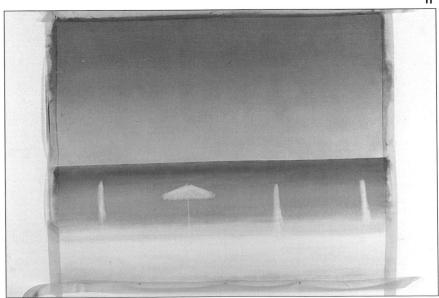

12 Now, taking up the brush, the shadows are added to the umbrellas and scrubbed on with a dry brush into the sand area. Note how the cloth has been used to lift off small patches of paint to represent waves.

13 The shadows on the parasols are further worked up with some white, burnt umber and ultramarine. A small round brush is used to draw in the umbrella stalks and wire supports with raw sienna added to the mixture. Nevertheless, the approach is kept deliberately loose and smudgy and the paint surface thin.

14 The fantasy beach scene is now finished. The artist has kept the paint surface flat as it is after all a painting of a painting. He is not striving for realism but for a rather tongue-in-cheek pastiche of the dream holiday location.

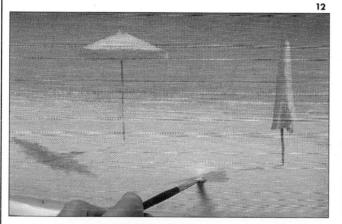

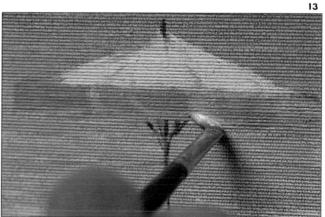

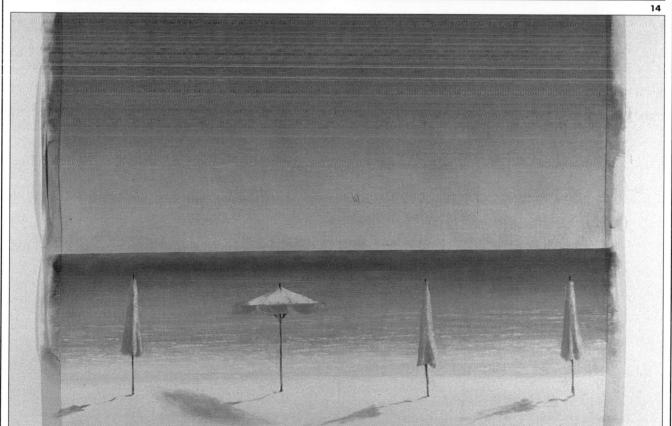

CREATING DEPTH/TROMPE-L'OEIL

15 Now to add the shadows of the folds to the painting which has been allowed to dry overnight. As before, the masking tape must be applied very lightly. The shadows are mixed as concentrated forms of the more dilute staining colours being covered. Take care — only a very little is used. The brush must be dry, so use one for each colour, stroking it on horizontally backwards and

forwards very delicately, until the paint is well spread.

16 The tape is removed in the same careful manner as before. It can be clearly seen here that the shadow colour is regulated to the colour it covers. So the shadow turns from blue to green to yellow.

17 For the horizontal fold, the shadow and opposite highlight appears in sections alternately above and below the central crease. The artist has first wiped off the highlight with the cloth. Now, the shadows are added with the brush and masking tape, a section at a time, constantly referring to the folded sheet above.

18 Now the finishing touches are added, such as these small creases running from the points where the folds meet. The artist also darts from crease to crease building up colour here, taking it away with white spirit there. (The paint is only touch dry and so will still come away if encouraged.)

Before the finishing touches, all the masking tape is carefully removed.

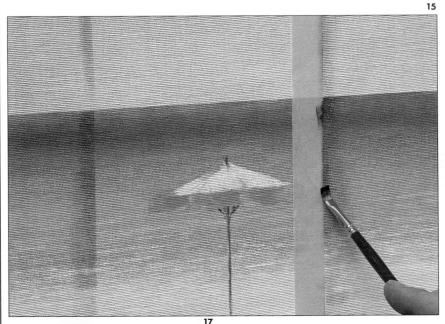

19 Now the shadows 'under' the 'painting' are added to make it appear proud of the canvas. The nearer the 'paper' is to the canvas, the deeper the shadow. These shadows are added with a No. 2 small round sable brush with shadows of Payne's grey and white. A little oil is added to the pigment to make it easier to apply to the rough canvas so that the canvas weave is filled with one coat. Even so the

weave gives the shadow a perfect fuzzy edge.

20 The final witty touch: two pieces of clear sticking tape are painted so that the folded painting appears to be fixed to the canvas. This is a very dilute layer of white and raw umber with plenty of oil to give it a shine. Start above then work into the blue. A little Prussian blue is added for the shadows.

21 The idyllic but rather bland beach scene has been transformed into a witty piece of visual deception through the addition of the paper folds. The artist has succeeded in getting across his original idea – a dream location which is kept in a pocket of the mind and every now and then taken out and unfolded. The success of the painting lies in the careful application and removal of the

masking tape and also on the attention paid to the reference piece of folded paper.

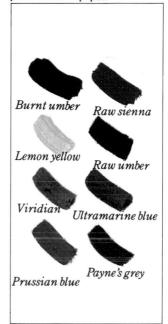

Horses Racing

CREATING DEPTH

Such a dramatic subject as horse racing requires all the ingenuity of the artist to achieve a successful result. But the artist here is not necessarily interested in the form or trappings of the horses: he is more attracted by the drama of the occasion and the race itself – it is the sensation of speed which is the central issue.

A painting is a still representation so depicting motion may seem like a contrary idea, but artists have developed many tricks to conjure up the feeling of speed. First, there is the representation of the cause of the movement - here the horses can be seen to be galloping. Second, you can show the effect of the movement on the form; for example, the horse's mane is seen flying in the wind. Third, as we have learnt from photography, a sensation of speed can be encouraged by blurring the image. To achieve this end, the artist chooses to carry out this project using the staining method introduced in the previous project - the blurred image and the loose approach it dictates both help promote the required sensation of speed.

Certainly, a finger covered with a cloth does not allow for much intricate detail and forces the artist to treat the subject broadly. The composition is first mapped out with mid-tone washes, then the form is built up with superimposed areas of shadow and finally the paint is lifted off with a turps-soaked cloth to produce the highlights.

The artist has used the brightly coloured silks to great dramatic effect. The patches of red - even in a less saturated state in the crowd - lead the eye dancing across the composition. Indeed, it is only when the jockeys' caps and the horses' blinkers are added in primary reds and yellows that the eye is taken back into the picture space.

The source for this stained painting is a press photograph of a horse race which the artist pins to the top of his easel for easy reference. The paint in this picture is applied for the most part with an all-purpose kitchen cellular cloth, staining the prepared canvas rather than painting it.

Materials: Canvas 40 in × 30 in (100 cm \times 75 cm); brush -No. 9 flat: all-purpose cloths: wooden palette; straight-edge or ruler; turpentine.

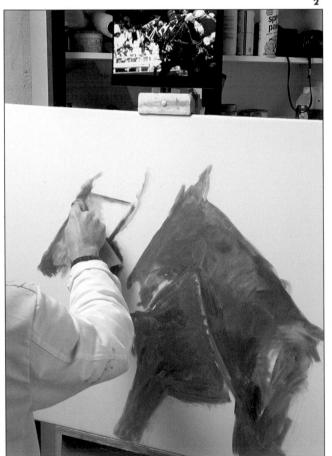

First, with this all-purpose cloth and a dilute mixture of burnt sienna, burnt umber, alizarin crimson and turps, the main outlines of the horses are blocked in boldly and quickly.

3 In a very few minutes, the foundations of the composition have been mapped out and already there is a sense of movement in the painting. The outline of the jockeys' heads and caps have been sketched in with a No. 9 flat brush, using up the paint on the horse's mane. Also. the cadmium red silks of the jockey have been blocked in. At this stage, such details of the composition are simply hinted at to get a feel for the structure of the painting.

4 Now the background colour – a rich mixture of ultramarine, alizarin crimson and burnt sienna – is rubbed on with a cloth. The paint is mixed with the cloth on the palette, applied undiluted and then spread out with some turps added to the cloth. This area of colour is built up with successive applications until the required depth of tone is achieved. Travelling down the canvas, the background colour is more dilute and some white is added.

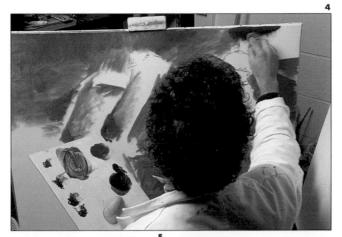

5 Still working on the background, the artist adds random dabs of burnt sienna, Prussian blue and ultramarine to represent the crowd in the stand. Then, with a clean part of the slightly turpsy cloth, the paint is lifted off to represent faces and highlights. The cloth has to be turned frequently, to present a clean side to the canvas.

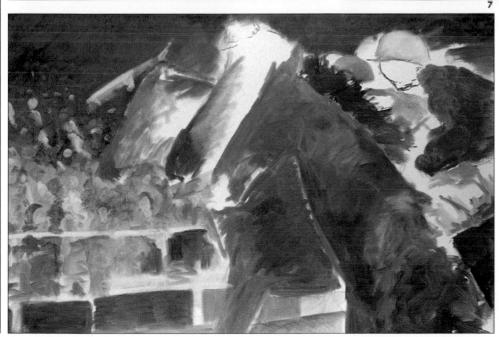

6 Continuing with the lifting-off process, the head of a grey horse is taken back, using the fingernail to get the straight line of the nose.

7 The background is filling out well. The track has been added with dilute ivory black and yellow ochre. In the foreground, the artist has added the viridian silks of the second jockey and, still using the cloth, very basic areas of shadow on the red jockey's cap and breeches.

CREATING DEPTH/HORSES RACING

- 8 Now attention is turned to the horses. A darker application of brown (burnt umber and alizarin crimson) is added over the mid-tone for the areas of shadow on the darker horses. The hood of the second horse is lifted off with a clean cloth. Attention is drawn to this area with the bold primary colours of the caps and the horse's blinkers.
- 9 Turning to the foreground jockey, the face is very broadly built up from the shadow brown mixture used for the horses, lifted off to arrive at the skin tone. With a variation of the same mixture, shadows are added to the red silks, and with the addition of Payne's grey, to the jodhpurs. Still the approach is kept very loose and blurred the cloth allows little else. Ivory black added to the boot completes this stage.

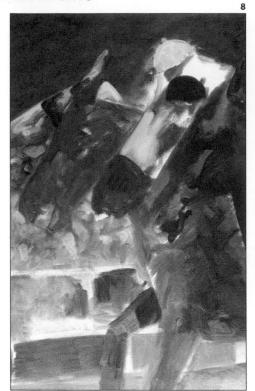

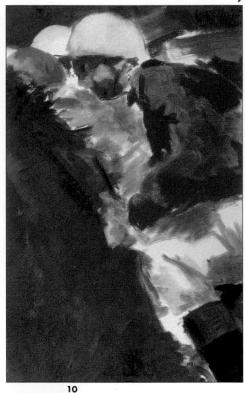

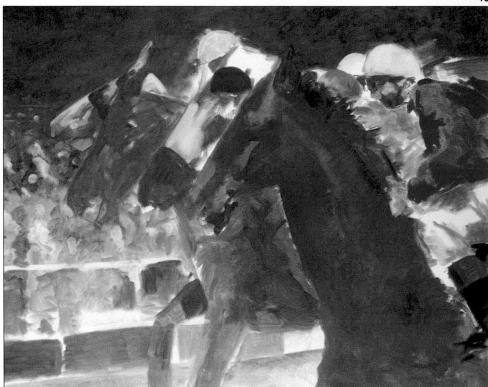

10 Standing back to appraise the situation, the forms are emerging nicely. Note how the addition of the primary-coloured caps and the far horse's blinkers takes the eye back into the picture space.

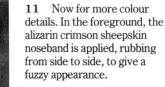

12 Stains of deep raw umber are loosely described to further model the form of the horse and as shadows, under the nose band, to the face and eye. The highlight on the under-rim of the eye is lifted off with the thumbnail. The darker shadows are carried across the painting, building up the three-dimensional form of the other horses as well.

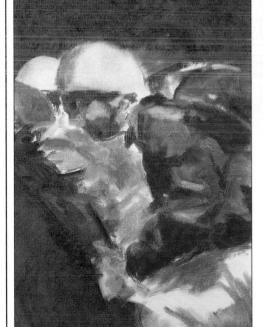

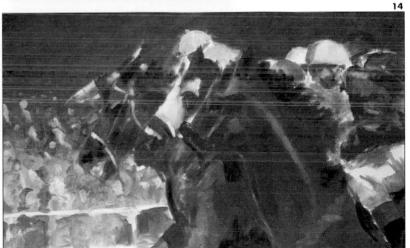

13 A few finishing touches to the foreground jockey round off the form. The shadows are softened a little with the cloth and white highlights dabbed on to the red silks.

14 Viewed from a distance, the bold approach offered with this staining technique achieves an uncanny sense of the three-dimensional. The gleaming highlight on the horses' neck has been taken off with a cloth dampened in turpentine.

CREATING DEPTH/HORSES RACING

- 15 Now for the bridles of the horses. For this more controlled work, the cloth is wrapped round the end of the paintbrush. Here the ring of the bit is encircled. Again the position must be changed on the cloth to get a clean mark.
- 16 Next the reins are picked out using the same method but with the flat of the fingernail. As the cloth picks up the paint, the mark gets less distinct, producing an ingeniously three-dimensional effect. A drier cloth is used for less distinct highlights. Note, too, the touches of ultramarine and burnt umber on the cheek-strap and reins.
- 17 With a few deft scrapes of the cloth, the boot is given a pleasing gleam and the saddle and stirrups defined. These well-placed highlights bring life and energy to this area of the painting. Yet, close to, the overall effect is still blurred and undefined.

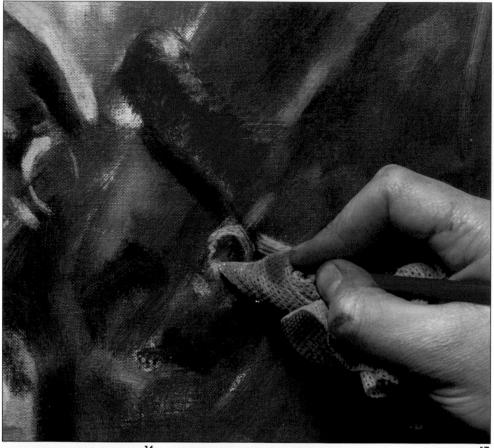

18 Final touches are added to the rails with a ruler and cloth-covered fingernail to get the straight line required.

19 The final painting is full of tension and drama encouraged by the high contrast and bright colours. It also depicts a keen sense of movement, much aided by the blurred image produced by this staining technique. The paint surface is very thin and the application almost crude. But the picture relies for its success on the immediacy of the presentation – the lively surface and quick intuitive marks.

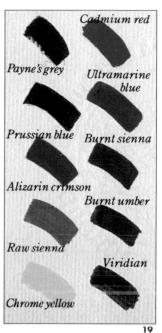

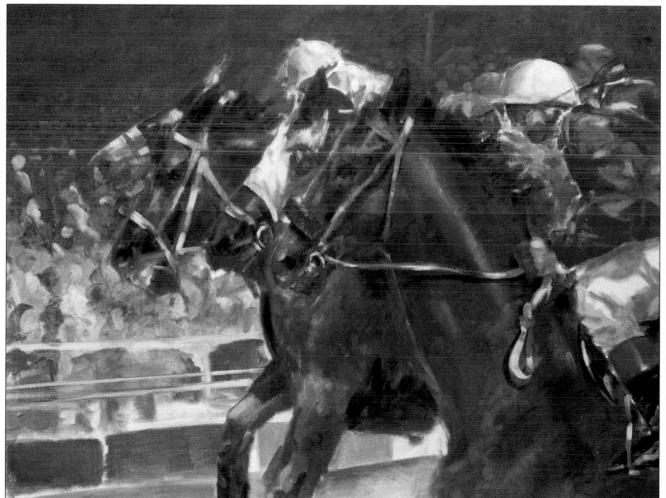

Chapter 9

The Human Figure

To some, the painting of the human figure seems a daunting prospect. To be successful involves the mastery of so many aspects of art — drawing, knowledge of anatomy, modelling of the delicate gradations of the form, creating flesh tones and so on. But, like so much in art, if you approach the project with confidence and determination you are half-way there. A painting is rarely successful first time — or at least the artist will not think so. It is this self-criticism and dissatisfaction with your own work that will cause your painting to improve. And that is not to say that sometimes you will be pleased with your work — you will be, even if only part of it.

Nevertheless, to specialize in figure painting does require the careful study of anatomy. But there are artists who include figures in their paintings who are not necessarily figure painters.

In the three projects in this chapter, one includes figures seen at a distance as part of the composition. In the second, a nude, the human figure becomes the focus of the composition. The third is a portrait where the artist zooms in even closer and seeks to capture in paint the characteristics and character

of a particular human being.

These are all different aspects of painting the human figure, requiring wide-ranging accomplishments. In addition, the artist approaches the painting of these figures in different ways, ranging from a broad approach, involving the simplification of form, to the optical mixing of pure colour on the canvas to make the flesh tones 'sing'.

But where do you start? Study figures in photographs, magazines and draw them from life as much as possible. Then eventually the form will become second nature. When you start to paint, establish the masses first and then build up the colour. You will see how, in the painting of the nude, the artist feels for the form, constantly reassessing his progress and modifying the brushwork in the light of his objective appraisal.

That is the joy of oil paints; they can be reworked without degenerating into muddiness. Even so, be aware when it is time to stop. Nothing is more annoying than spoiling a good painting by overworking it. But, again, oil paint will allow you to stop, take some rest and regain objectivity. You can then start afresh the next day, or week, or month.

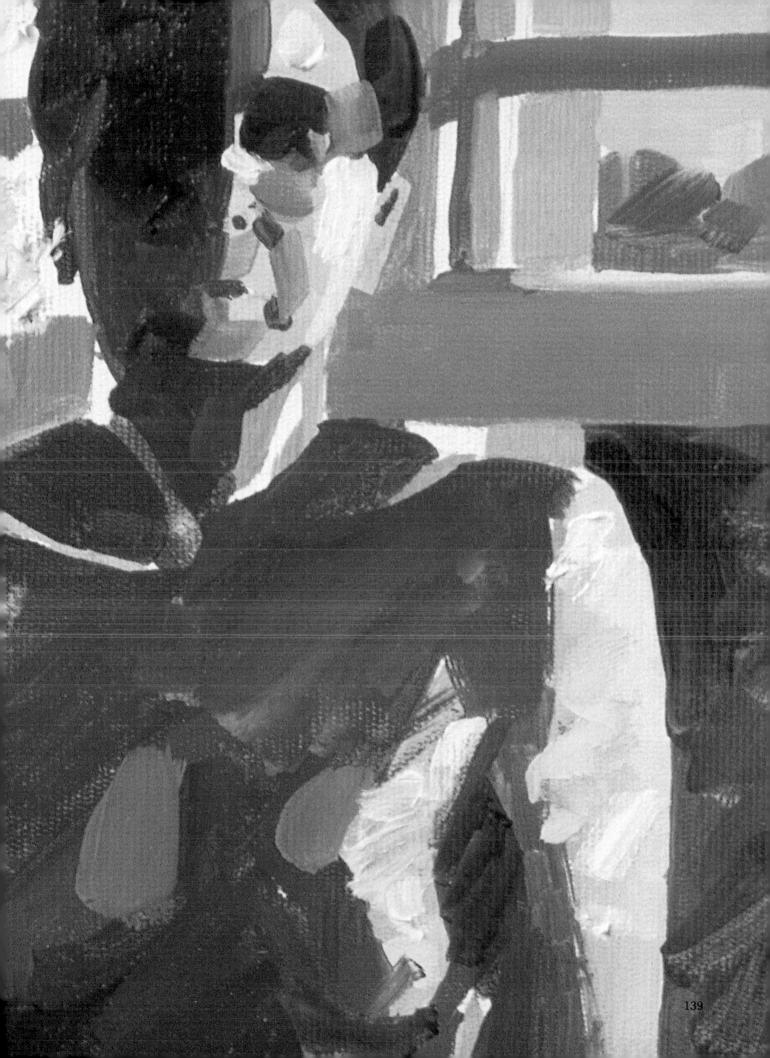

Alice in the Pool

THE HUMAN FIGURE

The systematic approach pursued in this painting requires a certain strength of mind on the part of the artist but it undeniably reduces the complications associated with figure painting and the modelling of skin tones.

Throughout the painting process, the artist resists the temptation to represent detail, keeping the approach broad and loose. This means that blocks of tone are carefully laid down with dilute paint, starting with the dark tones and working to light. Then these areas of tone are confirmed and reinforced with layers of thicker, less dilute paint. Even so, the paint layer is never very thick and, painting with a ½ in (6 mm) brush, the artist maintains a loose approach throughout.

This simplification of the subject matter is similarly pursued in the artist's treatment of the water. For compositional reasons, the water above the adult figure is made uniformly darker and that below, lighter, dividing up the painting with another diagonal corresponding with the arms of the swimmers. A sense of movement is introduced by the fragmented view of the swimmers' bodies below water and their reflections in it. You will notice that the artist adds such reflections where he expects them rather than where he can necessarily see them in the transparency.

The artist's recipes for the skin tones are given where possible but, having mixed the first few tones, these are then modified from the other colours on the palette. So, the artist's brush hovers momentarily above the palette, diving to lift a tip of yellow here, blue there. Such facility with mixing colours can only grow with experience, but a positive approach will make

sure there is a sense of spontaneity in your painting. After all, any divergences from your intended image can always be modified — by overpainting, adding a glaze or scumble. The choices are now limitless.

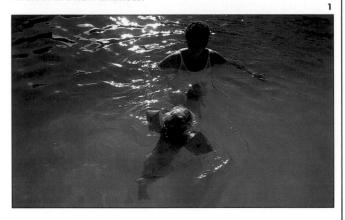

1 This photograph of a mother and daughter swimming together in a pool was chosen by the artist for its high contrast and bright colours, encouraging a loose approach. Do not be put off by the complications of the water. The broken reflections in the water add an interesting dimension which, when simplified, are a pleasure to paint.

Materials: Hardboard cut to 12 in × 14 in (30 cm × 35.5 cm), smooth side prepared with four coats of an acrylic gesso primer; white formica-veneered board palette supported on trestles; brush – ¼ in (6 mm) flat; turpentine; cloth; small viewfinder for transparency.

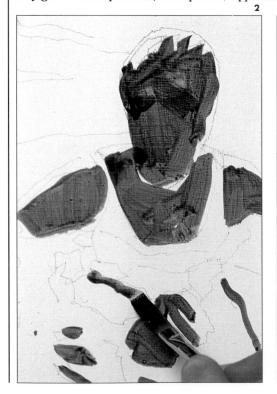

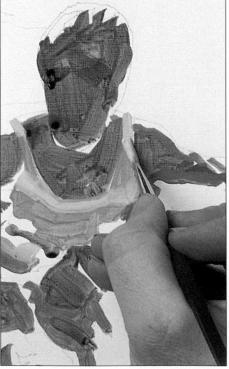

- 2 With a graphite pencil, the artist maps out the outlines of the figures and the areas of tone on the board. Then, with a dilute mixture of burnt sienna and Payne's grey, he blocks in the areas of dark skin tone (and the reflections in the water). The brushwork for this turpsy underpainting is quick and purposeful, picking out the disparate patches of dark tone. A ¼ in (6 mm) flat brush is used (as it is throughout) which would be considered large for this size of painting. But it will ensure a broad approach.
- 3 Round and into these dark tones, a pinker mid-tone is worked (cadmium red and cobalt blue with a touch of white added to the above mix). Now the yellow swimming suit is added, in two tones.

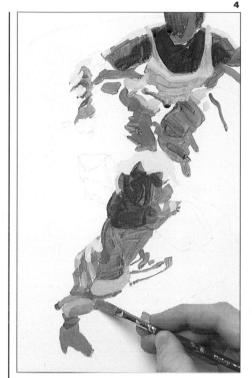

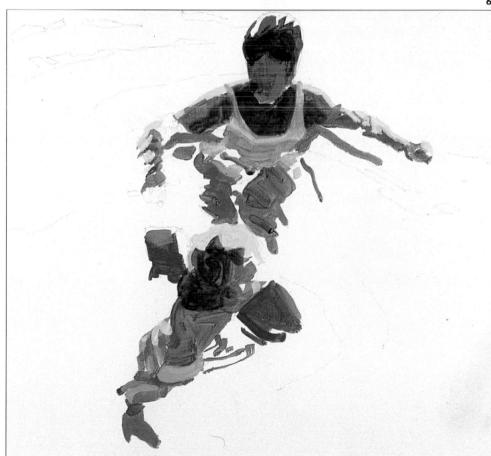

- 4 Next, the flesh tones are developed, introducing shadows and highlights in slightly thicker paint. The brush is loaded with Payne's grey and the 'swimming suit' yellow for the parts of the body seen through the water. Λ mixture of the tones already on the palette makes up the highlight colour too.
- 5 Here the immediacy of the strokes can be seen. The artist is placing his strokes at great speed, dabbing here and there with assurance. The red armbands are similarly expressed.

6 Standing back, the two figures are beginning to emerge as three-dimensional forms. The eye blends the loose brushwork and translates it into smooth gradations of tone.

THE HUMAN FIGURE/ALICE IN THE POOL

- 7 Now the background colours are added. Above, a thin turpsy layer of cobalt and Payne's grey is worked round the ripples of the same, less dilute, mix. This collects in the grooves of the gesso and drips down the board, but it does not threaten the figures and is allowed to run its course. Below, a thicker layer of cobalt, lemon yellow and white, is deftly cut in round the swimming child. The
- paint is applied from all angles to encourage an uneven appearance. Now the painting is allowed to dry.
- 8 Squinting into the viewfinder, the artist is able to check on his progress. A transparency will reproduce the colours and definition better than a photographic print, but this way of using source material takes practice and you may need a print as well.
- 9 A further layer of blue-grey has been added to the top half of the painting, roughly working it round the areas of highlight.

 Next, the figures are further built up, reinforcing the patches of skin tone with more dense paint. Any temptation to let the approach become more detailed is sharply resisted.
- 10 To capture the ripples on the darker stretch of water, first the dark tones are applied at random (Payne's grey, cerulean blue and lemon yellow). For the highlights round these soft undulations, white is added to this mix and carefully painted round the dark tones. Notice how the face has been suggested with just a few dabs of paint.

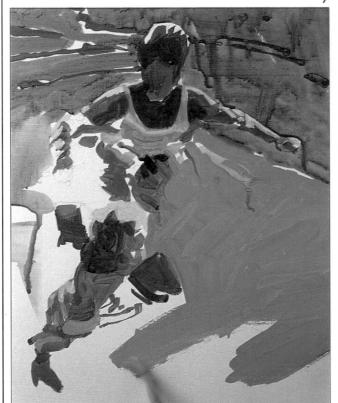

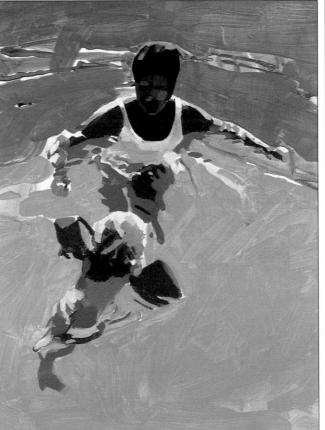

11 Finally, dabs of pure white are added to reproduce the sparkles of broken water. These are blurred with the finger tip. Even at this stage the grooves,

encouraged with the brush when preparing the board with gesso, still play their part in enlivening the surface texture. 12 The addition of the grey shadows in the blue water unite the two figures and complete the painting. The blurred white highlights in the water either side of the armbands introduce a sense of movement into the painting. Now the child appears to be kicking and splashing. From a distance it is difficult to appreciate the loose approach and lack of detail in this painting – the eye fills in the omissions from the clues supplied by the artist.

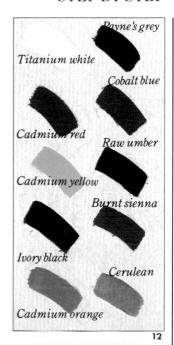

Nude

THE HUMAN FIGURE

In this study of a nude, the colours have been kept as pure as possible, applying the pigment straight from the tube in places, so that the hues appear fresh and singing. These pure reds and vellows, seen from a distance, are mixed optically, revealing the tonal modulations of the female form.

Such an approach, with a choice of warm colours, also successfully captures the heat of this sunlit scene. The nude is represented contre-jour, with the light mainly behind her but playing down her left side, producing extreme contrasts in the skin tones.

The artist first lays down the areas of dark shadow and then quickly builds up the form of the torso with bold strokes of undiluted paint, following the contours of the figure. At regular intervals, the artist stands back to assess progress, modifying strokes which appear unruly. To get a good perspective with such a bold work, it might help to view your progress in a mirror. This will instantly give you an objective view of your work and will save you having to remove yourself to some distance from your painting to achieve the optical mixing of the colours.

Note, too, that the background to this nude is mostly painted in flat dead colours in contrast with the vibrancy of those of the main subject. This has the effect of focusing attention on the figure and throwing it into relief.

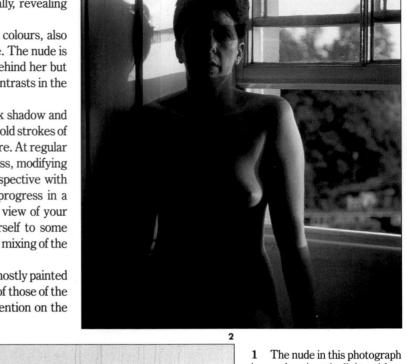

- A careful outline drawing is made of the composition but there are no tonal indications. To establish the tonal contrasts, the artist blocks in the darkest shadows on the hair and window recess, then adding the light mid-tone skin colour, where the sun falls on the face and catches the collarbones (cadmium red, orange and yellow with white).
- 3 Still laying the foundations of the composition, the face is built up with a few deft dabs of paint, wet in wet. After painting in the window frame in the background, the same colour is taken to the neck, ribcage and thigh. Note too the addition of the precisely applied patches of red on the collarbone and left arm.

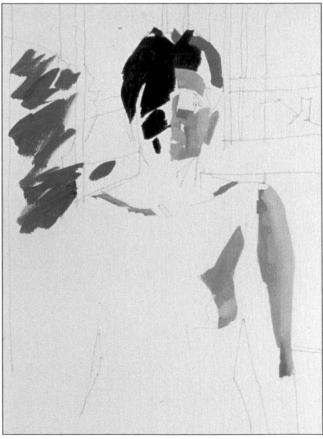

is posed against the light, with strong sunlight falling on the left side of her body. In this painting the artist applies the paint boldly, often in its pure form, so that the hues are mixed optically.

Materials: Canvas board 12 in \times 18 in (30 cm \times 45 cm); Brush ¼ in (6 mm) flat; graphite pencil; white formica-veneered board for palette, with trestles to rest on; turpentine; cloth.

4 Here, the simplified structure of the face can be seen in detail. The dark band across the eyes is the shadow from the window strut. But note how the light side of the face is made up from simplified areas of skin tone. On the right side of her face, the original ivory black shadow is modified with the skin tone, marking the features more with brushstrokes than colour.

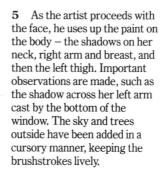

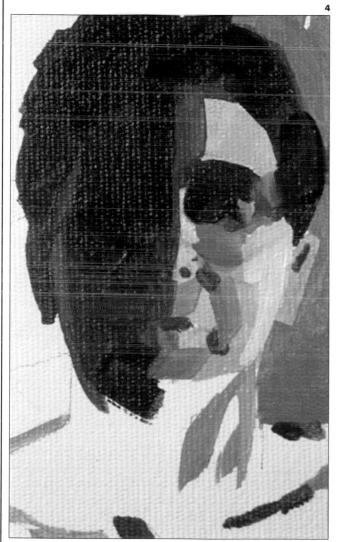

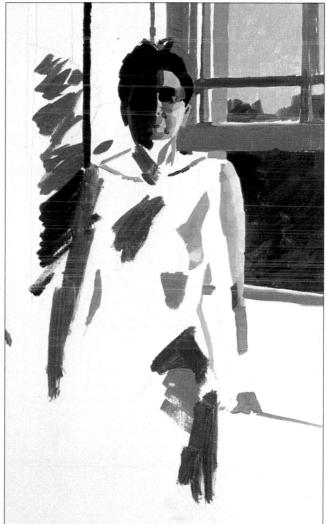

THE HUMAN FIGURE/NUDE

6 Having been skirting the issue, now the artist appears to attack the body with a shower of powerful strokes, mixtures of most of the colours on the palette – except white and Payne's grey. These are kept broad and clean, not blending these browns and reds on the canvas, simply feeling for the form. Note how the direction of the brushstrokes follows the contours of the body.

7 After the addition of a few more highlight tones, it is time to stand back and assess progress. The subtle half-tones of the shadowed part of the body are developing well. At a distance the colours blend into one another optically creating gentle gradations from what we know is a patchwork of strong colour.

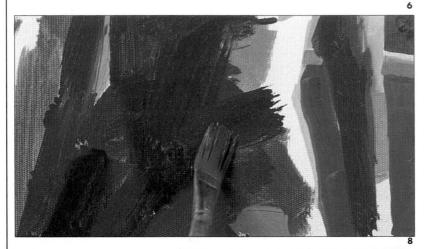

8 Now, with paint literally straight from the tube, glorious patches of lemon yellow impasto are squeezed on to the window recess, suggesting dappled sunlight.

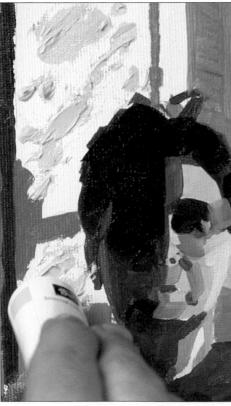

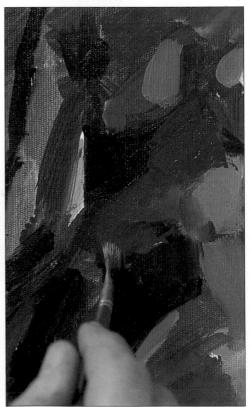

9 The torso has been built up with further layers of thick juicy paint. Looking back at step 6, you can see how the artist has modified his original strokes of colour but he is still applying the paint cleanly, wet in wet, without any attempt to blend the paint. Following the same principle, with a mix of cadmium red and alizarin crimson, the paint is laid on to the underlying browns with touches of raised impasto.

10 Standing back, you will notice the cadmium yellow has been taken down the figure with the brush and worked into the underlying layers, wet in wet — on the face, arm, breast, rib cage, thigh — even a small glistening touch highlights the end of the neck bone. Striations of this pure yellow, like the red, are left unblended.

11 Establishing an even more long-distant view, the success of this undiluted broken colour can be assessed. Indeed the reds and yellow are absorbed by the underlying browns, yet it is with these strong colours that the warmth and intensity of the sunlight has been captured.

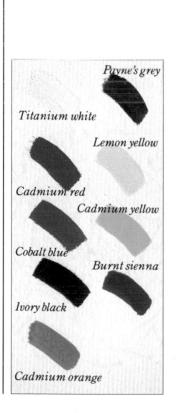

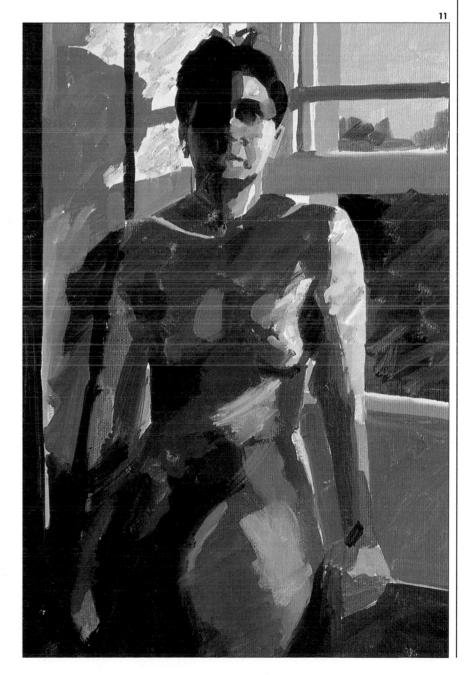

Portrait of Cyclist

THE HUMAN FIGURE

A portrait, like any subject, can be treated in a number of ways. To a great extent this depends on the sitter. Is the character focused in the face or are the clothes and personal belongings important for a completed picture of the personality? Here the artist chooses to concentrate on the head and upper torso of his subject, a keen amateur racing cyclist. The shirt, hat and shades are enough to characterise the sport.

The artist knows the subject of his portrait well but to help him with his painting he takes a number of transparencies. It is useful at this stage to make some sketches too. Exploring the facial features with a sketch will help familiarise you with the subject. In this case, the artist chooses what he considers the best transparency and has an enlarged print made. The colour and definition of this print will not be good but the artist has the transparency for reference.

The print image is transferred to the canvas using the grid method. Equally, this method could be used to transfer the outline of a sketch to the canvas. Having established the outline, the artist tackles the subject with the same systematic approach he follows for more mundane subjects, for example, the peppers and lemons on pages 60-65. A small area is isolated and carefully painted, usually starting with the dark tones and working to highlights. Frequently the overall effect is appraised and, if necessary, moderated in the light of the whole.

2 Most portrait painters prepare very precise preliminary drawings of their subjects before they start painting. In this way the form and character of the sitter can be absorbed. This is important groundwork on which you will need to rely to a great extent. If you wish to transfer your sketch to the canvas, or the proportions of the sitter from a photograph, try using the grid method shown

here. A sheet of clear acetate is drawn up with a grid of ½ in (1 cm) squares and this is placed over the photograph. The canvas is then likewise squared up with 2 in (5 cm) squares using a graphite pencil. By carefully observing and marking off where features intersect the grid and transferring these points to the grid on the canvas, the likeness can be reproduced.

Even though the print and transparency are constantly consulted, the artist's general experience, his knowledge of human anatomy, as well as his acquaintance with the subject, allow him to add to the information supplied by the photograph and create a lively portrait.

1 Painting a portrait is always a challenge. There is no straight recipe for success: a good portrait depends on so many things. But capturing a likeness is the first step. The artist started by taking a number of photographs of the subject, choosing one to help him with

his portrait. The sunlight is bright, bleaching out the mid-tones. This is more obvious in the print from the transparency used by the artist which has lost much of its definition. But such blurred prints are sometimes useful in helping to simplify the image.

Materials: 10 oz (285g) white cotton duck canvas, stretched and primed; brushes - ¼ in (6 mm), No. 14 flat, No. 3 round; white formica-veneered board with trestles for palette; graphite pencil; sheet of clear acetate; white spirit; cloth.

3 Your subject's clothes are important if you are tying to capture a likeness. This cap with its upturned brim characterizes the sitter, so the artist takes some trouble with it. The markings are carefully observed and painted in. But, although the logo appears to be precise, closer inspection reveals how only the impression of the lettering has been captured. The artist has taped the print

over the face to stop his hand smudging the drawing.

The careful drawing can be fully appreciated here, and also the finished cap. The artist is only applying one layer of paint, so it is diluted as little as possible - just enough to allow it to brush on easily. It is applied with assurance, not moving it around on the canvas. So, with a 1/4 in (6 mm) flat brush the artist has filled in the shadow on the brim, delicately cutting in round the lettering with the corner of the brush. This shadow is a subtle mix of ivory black, cobalt blue, yellow ochre and white. The rest of the cap is blocked in with white deadened with a little of the shadow mixture.

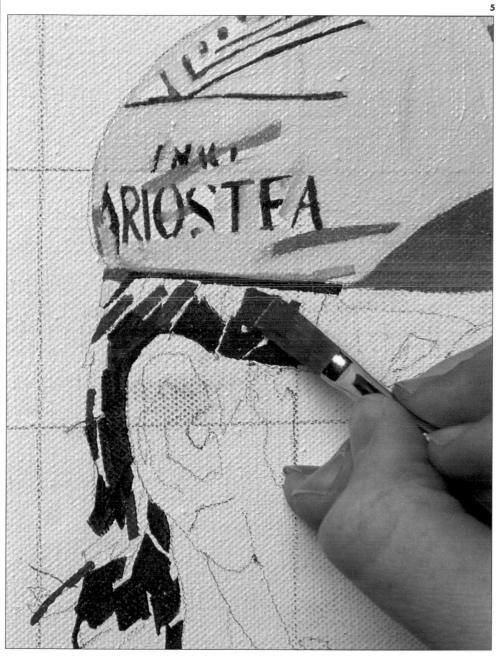

5 Next, the artist works on the hair, filling in the areas of dark tone with broken ivory black and now bordering these areas with a mid-tone colour of yellow ochre added to the other ready-mixed colours. This is cut round the first colour, blending it slightly at the edges but no more.

THE HUMAN FIGURE/CYCLIST

- 6 Before starting on the ear, the light tone has been added to the hair, again carefully placing it round the darker tones. This is a good example of refining detail which is the hallmark of a good portrait. The artist is following the reference, but not slavishly as long as it 'looks right'. This is why the artist needs to get to know the subject through his drawings before he starts. Now the ear is built up in
- the same way, working from dark to light. It may seem as though the red/orange mid-tone is strong. But ears are often quite a startling red. Look at the artist's in step 1.
- 7 Now the dark glasses are filled out in murky tones based on ivory black. The edges of the frames are here carefully encompassed making a series of imprints with brush end.
- 8 For the flesh tones, the artist mixes a mid-tone of cadmium red, cadmium orange, chrome yellow, titanium white and cobalt blue, darkening it with cobalt blue and cadmium red and lightening it with chrome yellow and white. Now the artist studies the cheek, painting in all the important patches of light and shadow, starting with the dark, which is also blended into the glasses.
- 9 Another few dabs and the nose comes into existence. See how the mid-tone marks out the forward plane of the nose but the bright illumination removes the tonal details of the side plane of the nose, reducing it to a patch of highlight tone.

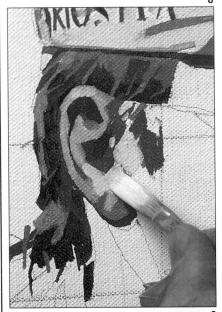

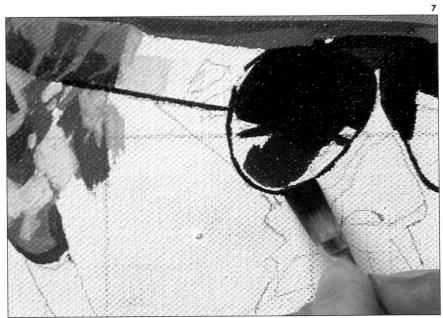

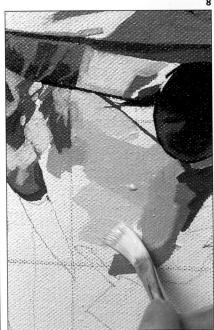

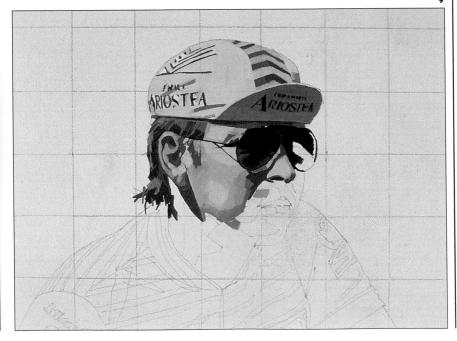

10 It is necessary to stand back constantly to assess progress, adding a dab here or there to modify the image. Even though the artist is tackling the portrait area by area, he is checking to see that these isolated patches fit into the overall likeness, which is already beginning to grow out of the canvas.

Next, he paints the mouth, which is a very elusive feature. Working on the same system, the dark tones are located first – very dark where the two lips meet; slightly lighter, shown here, on the forward plane in the centre of the lower lip.

11 Now the mid-tones are carefully built up, including a touch of the red/orange tone used for the ear, but also to be seen on the tip of the nose. The artist searches for patches of the same tone using the paint on the brush, moving from the subject's left cheek and upper lip to his chin.

12 To finish the mouth and lower part of the face, the light tones are added. Now this patchwork of tone emerges as a three-dimensional face – and not just any face but an excellent likeness of the cyclist.

13 The low definition print neatly shows the areas of highlight, but the gradations of tone are lost. These are added by the artist from knowledge gained from experience, keeping the surface of the painting lively when viewed from close to as well as from far away.

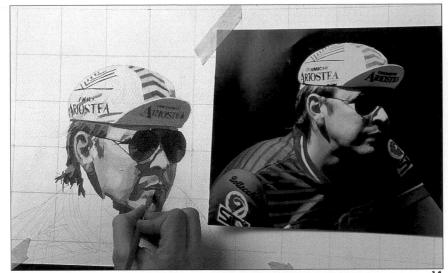

14 With the same precise approach, the artist fills in the red stripes of the T-shirt. First with the mid-tone; the darker red shadow will be added along the folds next.

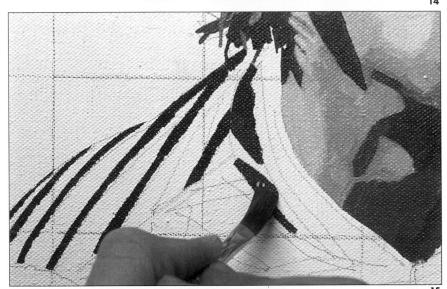

15 Now the green stripes are added, cutting in along the red. Here is a perfect example of complementary colours in action. You can see how these two fully saturated complementary colours affect each other. The red stripes still bordered with the primed canvas appear darker and less bright than those bordered with the complementary green on the cyclist's back.

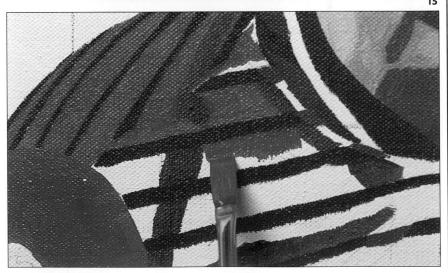

16

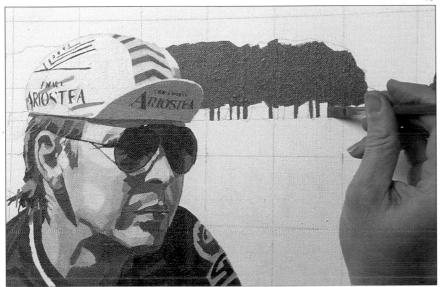

16 With the cyclist finished, the artist turns to the background. This is speedily completed in a very stylized manner so as not to divert attention from the main subject. The trees are blandly filled in with a mixture of sap green, cobalt and white, then adding the trunks in the same colour.

17 In the final painting, the background has been completed in the same stylized way, although the expansive area of grass and sky has been applied with a lively slightly broken stroke. An objective view of this portrait reveals a remarkable likeness. Although the artist relied on the photograph as a

physical reference, he was able to use his knowledge of the human form, his preliminary drawings, and his appreciation of the subject as a friend, to guide him in his painting.

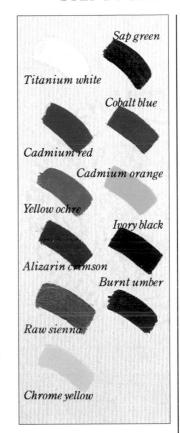

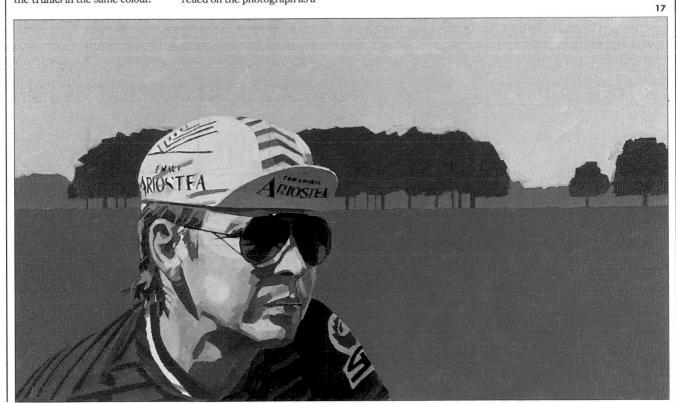

Index

A *		**
A	interpreting 42–3	Н
Acrylic paints 86, 90, 122	mixing 38-9, 40-1, 46-7	Hamilton, Donald, Still Life with
Advancing colours 43	neutrals 41	Flowers and Mirror 13
Aerial perspective 50	perspective 43	Hardboard 26, 27
Alice in the Pool 140-3	tinting and shading 40-1	
	Complementary colours 39, 152	Hat and Denim Jacket 76-9
Alizarin crimson 36	Composite 'woods' 27	Hatching 115
Alkyd-based drying agents 86, 90	Composition 16–17	Hawker, Susan, Reflected Trees 13
Alkyd-based oil mediums 25	colour 34, 43	The Haywain 94
Alla prima painting 12, 19, 68, 70	outlines 18–19	Highlights 74
Artists' oils 22, 23	Constable 94–9	Hockney, David 14
Atherton, Barry, Allegory of the Sea 13		Hog's hair brushes 28-9
Atmospheric perspective 50	Constable, John 12, 18	Human figure 138-53
	The Haywain 94	Alice in the Pool 140-3
В	Cool colours 38–9, 43	Nude 144-7
	Copal varnish 25	Portrait of Cyclist 148-53
Bacon, Francis 100	Corot, Jean Baptiste Camille 41	
Blending 68-71	Crabs 90-3	I
optical 40, 71, 144, 146		1
wet in wet 70, 80	D	Impasto 25, 100, 102-3
Blockboard 27		Impressionists 39, 40, 42, 66
Bonnard, Pierre 18	Dammar varnish 25	Imprimatura 120
Bristle brushes 28-9, 31	Depth, trompe-l'oeil 126-31	Interpreting colour 42–3
Broken paint and colour 86–99	Diluents 24	Ivory black 37
Constable 94-9	Dippers 32, 46	IVOLY BLACK 37
Crabs 90-3	Directional brushwork 76	17
	Drawing 18-19	K
dry brush 88	Dry brush technique 88	Kettle 72–5
scumbling 88	Drying agents 86, 90	Klee, Paul 18
stippling 89	Dubuffet, Jean 105	Knife painting 100, 102–3, 106–11
Bruegel, Pieter the Elder 43	Dubunet, Jean 103	Time painting 100, 102 0, 100 11
Brushes 28-9, 31	T.	т
care of 30-1, 47	E	L
control of 49	Easels 18, 32-3	Landscape format 17
Brushwork 48-9	Egg tempera 86, 90	Lemon yellow 36
directional 76	Equipment, see Materials and equipment	Lifting off 133-4
Burnt sienna 37	Equipment, see Waterials and equipment	Lighting
Burnt umber 37	T.	0 0
	\mathbf{F}	blending techniques 68-71
C	Fan blender brushes 29	and composition 17
	Figure painting 138–53	Hat and Denim Jacket 76-9
Cadmium red 36	Alice in the Pool 140-3	Kettle 72–5
Cadmium yellow 36		light and shade 66-85
Canvas 26, 27	Nude 144-7	Pool House 80-5
priming 27, 120	Portrait of Cyclist 148–53	studio 18
stretching 32	Filbert brushes 28, 29	Linseed oil 24, 25
Canvas boards 27	Finger blending 69	glazes 74
Cardboard 27	Fish 112-17	Luke, Eric, Still Life with Hat 12.
Cerulean 36	Fixatives 18	
Chalk, underdrawing 18	Flat brushes 28	M
Charcoal	French ultramarine 36	
sketches 72	Fugitive colours 23	Magritte, René 39
underdrawing 18		Masking 104, 114, 126-31
9	G	Mastic varnish 25
Chipboard 26		Materials and equipment 20-33
Cleaning brushes 30–1, 47	Glazing 40, 74, 118–23	brushes 28-9
Cloths, staining with 30, 127–8, 132–7	mediums 24, 120	canvas 26, 27
Cobalt blue 36	New York 122-5	diluents 24
Colour	with a painting knife 103	dippers 32
basic palette 36-7	Gore, Frederick, Val d'Entre Conque 12	easels 32-3
blending 68-71	Graphite pencils 18-19	mediums 25
broken 86–99	Graphite sticks 115-16	painting knives 30, 31
colour wheel 38-9	Greys 41	painting knives 30, 31 paints 22–3
complementary 39, 152	Grid method 148	palette knives 30, 31
composition 34, 43		parette kinves 50, 51

INDEX

palettes 32	S	Viewpoints 16-17
surfaces 26-7		Viridian 36
varnishes 25	Sable brushes 28–9, 31	Thatan 00
Mediums 25, 120	Safflower oil 25 Sand, adding texture with 100, 112, 116	\mathbf{W}
Melon and Pomegranates 106-11	Sand, adding texture with 100, 112, 116 Sap green 36	
Misty Mountains 50-3	Scumbling 88, 92, 94, 99	Warm colours 38-9, 43
Mixing colours 34, 38–9, 40–1, 46–7	Secondary colours 38, 39	Water, reflections 140
Monet, Claude 66	Sgraffito 105, 111	Watson, John, Carnation and Astronomer 13
Monochrome underpainting 19, 66, 72-3	Shading 40-1	Wet in wet 70, 80
Mynott, Derek, Evening Light, Bembridge 12	Sketchbooks 14	White spirit 24, 30–1, 46 Wood
	Sketches 72, 148	composite 27
N	alla prima19	panels 27
Neutrals 41	Skin tones 140-1, 144-5, 150	plywood 27
New York 122-5	Source material 14	pry wood 21
Nude 144-7	Spattering 104, 114-15	Y
	Sponges 30	
0	Squaring-up 19, 60, 148	Yellow ochre 36
	Staining 106, 110, 118–20	Yellow tulips 54-9
Oil, glazing 120	New York 122-5	
Oil paper 27 Optical blending 40, 71, 144, 146	Race Horses 132-7	
Outlines 18–19	Trompe-l'oeil 126–31	
Overpainting 140	Still life 60	
Overpainting 140	Stippling 89, 92, 96–7, 103 Stretching canvases 32	
P	Students' colours 22, 23	
	Subjects, choosing 14	
Painting knives 30, 31	Surfaces 26, 27	
Paints 22-3	shape 17	
mixing 34, 38-9, 40-1, 46-7		
permanence 23 see also Colour	T	
Palette knives 30, 31	Tempera 86, 90	
Palettes 32	Texture 88-9, 100-17	
Paper 27	Fish 112-17	
Paynes grey 37	impasto 25, 100, 102-3	
Pencils	knife painting 100, 102–3, 106–11	
sketches 72	Melon and Pomegranates 106-11	
underdrawing 18	sgraffito 105, 111	
Peppers and Lemons 60-5	spattering 104, 114-15	
Perspective 43, 50	tonking 105	
Phillips, Tom 60	Tinting 40–1	
Photography 14, 60, 72	Titanium white 37	
Pigments 22, 36	Tonal drawings 66	
Plywood 27 Poisonous pigments 26	Tonal values 66, 72, 120	
Poisonous pigments 36 Polaroid photographs 60, 72	Tonking 105 Tonks, Sir Henry 105	
Pool House 80-5	Toothbrushes, spattering 104	
Poppy oil 25	Transferring outlines 19	
Portrait of Cyclist 148-53	Trompe-l'oeil 126-31	
portrait format 17	Turner, Joseph Mallord William 66	
primary colours 38, 40, 41	Turpentine 24, 46, 120	
Priming 27, 120	Two-colour mixing 41	
Prussian blue 36		
n n	U	
R	Underdrawing 18-19	
Russian Horses 132-7	Underpainting 19, 66, 72–3	
Raw sienna 37	1	
Raw umber 37	V	
Receding colours 43		
Reflections 140	Van Gogh, Vincent 14 Varnishes 25	
Round brushes 28–9	Varnishing 25	
Rubens, Sir Peter Paul 68	varmannig 20	

Acknowledgements

The author would like to thank all those who have helped in the preparation of this book. Special thanks to the artists Ian Sidaway and Lincoln Seligman for their work on the techniques and Step by Step demonstrations and to Winsor & Newton for their advice and prompt supply of all materials.

Photography
Studio and Step by Step photography by
John Melville

Other Photographs

pp 12/13 Business Art Galleries, London

For Sports Editions

Art Direction: Richard Dewing and Mary Hamlyn Design and layout: Sharon Smith, Jason Claisse and Adrian Waddington Editor: Geraldine Christy Finished Art: Rob Kellard Origination: South Seas International Press Ltd., Hong Kong

751.45 Seligman, Patricia Oils

\$12.98]]]

SEP 2.7 1989 DATE

SE 12 '01

AN 2 7 1992 MAR 24 '03

PR 1 8 1992 JAN 5 '04

JAN 9 1992 JAN 5 '04

JAN 1 3 '99 MR 1 3 '99

NR 1 3 '98 MR 0 4 '5

Linesville Community
Public Library

Linesville, PA. 16424